The Idea of Cultural Heritage
Revised Edition

The idea of cultural heritage has become widespread in many countries, justifying government regulation and providing the background to disputes over valuable works of art and architecture. In this book, Derek Gillman uses several well-known cases from Asia, Europe and the United States to review the competing claims that works of art belong either to a particular people and place, or, from a cosmopolitan perspective, to all of humankind. Noting the importance of cultural roles and narratives in shaping heritage, he looks at the ways in which the idea of heritage has been constructed. He focuses first on Britain and the writings of Edmund Burke and then on China and its medieval debate about the nature of "our culture". Drawing on a range of sources, including the work of Ronald Dworkin, Will Kymlicka and Joseph Raz, Gillman relates debates about heritage to those in contemporary political philosophy and offers a liberal approach to moral claims and government regulation.

Derek Gillman is Executive Director and President of the Barnes Foundation. A former president of the Pennsylvania Academy of the Fine Arts, deputy director of the National Gallery of Victoria, Melbourne, and keeper of the Sainsbury Centre for Visual Arts at the University of East Anglia, he is a member of the Association of Art Museum Directors and is currently President of the International Cultural Property Society.

The Idea of Cultural Heritage

Revised Edition

DEREK GILLMAN

CAMBRIDGE UNIVERSITY PRESS
Cambridge, New York, Melbourne, Madrid, Cape Town,
Singapore, São Paulo, Delhi, Tokyo, Mexico City

Cambridge University Press
32 Avenue of the Americas, New York, NY 10013-2473, USA

www.cambridge.org
Information on this title: www.cambridge.org/9780521122573

First published in Great Britain in 2006 by the Institute of Art and Law
Revised edition first published 2010
Reprinted 2011 (twice)

A catalog record for this publication is available from the British Library.

Library of Congress Cataloging in Publication Data
Gillman, Derek.
The idea of cultural heritage / Derek Gillman. – Rev. ed.
p. cm.
Includes bibliographical references and index.
ISBN 978-0-521-19255-2 (hbk.) – ISBN 978-0-521-12257-3 (pbk.)
1. Antiquities – Collection and preservation. 2. Historic preservation. 3. Historic
preservation – Political aspects. 4. Cultural property – Protection. 5. Cultural
property – Protection (International law) I. Title.
CC135.G54 2010
363.69–dc22 2009053439

ISBN 978-0-521-19255-2 Hardback
ISBN 978-0-521-12257-3 Paperback

In memory of my parents, Esther and Abraham Gillman,
and Stephen E. Weil

Contents

List of Illustrations

Acknowledgements

Deep thanks are due to Norman Palmer and Ruth Redmond-Cooper at the Institute of Art and Law, which first published this work. Both have played a major role in stimulating the academic study of the relationship between art and law, and the latter's wise and careful oversight of the first edition is truly appreciated. At Cambridge University Press, I owe a particular debt to Beatrice Rehl for supporting this revised second edition; I am grateful also to James Dunn, and to Ken Karpinski for his editorial supervision.

The direct origins of this book lie in a thesis undertaken at the University of East Anglia while at the Sainsbury Centre for Visual Arts, under the sympathetic guidance of Gareth Miller and with the encouragement of David Pearl. The late Martin Hollis offered typically incisive comments, artfully encouraging me to think more broadly about social action. I owe an especial debt to his fellow philosopher Timothy O'Hagan, who first pointed me towards the parallels between debate in the fields of cultural heritage and contemporary political philosophy. He has continued to offer friendship and counsel as the project unfolded from thesis into book; his 1998 article 'The Idea of Cultural Patrimony' set a high bar for work on the subject. Stephen Urice and Stan Katz have been especially supportive, as was the late Stephen Weil. Others who have generously shared their thinking over the years include Max Anderson, Alex Bauer, Elisabeth de Bièvre, Don Caldwell, Howard Caygill, Craig Clunas, Michael Conforti, Dennis Donnelly, Alan Fern, Evelyn Friedlander, John Herring, Martha Hurt, Ian Jenkins, Jo Joslyn, Deborah Klimburg-Salter, Philip Nowlen, John Onians, Timothy Potts, Jessica Rawson, Herbert Riband Jr, Gresham Riley, Theodore Rogers,

Kim Sajet, Charles Saumarez Smith, Peter Saylor, Veronica Sekules and Diane Bernoff Sher. David Barrie, Richard Hodges, Simon Jervis, Barbara Katus, Sheryl Kessler, Johann Kräftner, Cheryl Leibold, Deborah Lenert, Jeremy Warren, Alison Whiting, Verena Widorn and Jonathan Ziss have helped me source material and images; while John Gatti, Martha Lucy, Jennifer Moszczynski and Audrey Poplawski assisted with their reactions to the Gong Kai painting in Chapter 4. The *Melbourne Art Journal* and the Sterling and Francine Clark Institute kindly gave permission to publish papers in *Art Antiquity and Law* that are incorporated into the present text. Peter Bol's work on medieval China provided the title of Chapter 4.

With the thought that one theme of this book is relationships, I want to acknowledge my late parents as a source of inspiration; my brother for his friendship; and also my children, for their more than occasional tolerance. Finally, my gratitude to my wife Yael goes deeper than words. With abiding companionship and constant encouragement through two editions, she has made the writing of this book possible.

Introduction

During the past two decades, heritage has become a feature of the con‐
temporary cultural landscape in many countries. People feel that their
heritage is distinctive if often hard to define. They are proud of their
past and also keen to capitalise on it, and thus tourist literature is full of
references to the heritage of the nation, of the region, of the city. As Sir
Nicholas Goodison notes in his review of funding for Britain's museums,
"Recent surveys have suggested that nearly 30 per cent of all visitors are
attracted by our heritage, in which museums and country houses play a
large part. Tourism is one of the biggest earning services in the country".[1]
Heritage justifies governmental regulation and now provides an import‐
ant part of the background to discussions about private rights, common
ownership and general welfare. But the idea of heritage is not imme‐
morial, and we can reasonably ask questions about its origins and about
how much weight we should give to this idea, aside from the economic
benefits just noted.

During recent decades, two parallel debates have occurred with respect
to public policy on heritage. The first has involved cultural officials,
museum administrators, archaeologists, anthropologists, collectors and
lawyers. It has been notably framed by the Stanford jurist John Merryman
as 'two ways of thinking about cultural property', represented respect‐
ively by cultural cosmopolitans, who seek to promote the idea of 'the
heritage of all mankind', and cultural nationalists for whom art, architec‐
ture, theatre, music and food are always a part of someone's particular

[1] Sir Nicholas Goodison, *Goodison Review: Securing the Best for our Museums: Private
Giving and Government Support* (London: HMSO, 2004), 7.

heritage. Merryman proposes that these two ways are enshrined in the preambles to two UNESCO conventions, dating from 1954 and 1970. Certainly, versions of these positions have been employed to make the case for preserving and controlling cultural sites and objects. The second debate takes place between political philosophers, especially liberal and communitarian thinkers of various shades, who argue about human agency and whether the individual or community has primacy in the political arena. The present work relates these two debates to each other.

The book is divided into three parts, each of two chapters, which are intended to address the issues raised by these overlapping debates. The first part deals with how we talk and write about heritage; the second with how we construct it; and the third with the tension between private rights and a feeling of common ownership, and how, in liberal democratic nations at least, we might make sense of the idea of heritage. They are ordered in this way because the discussion of rights and valuable practices in Part III is, I believe, best informed by some understanding of the idea of heritage, its rhetoric and its construction.

Part I addresses claims made about heritage objects and buildings, and the importance they are seen to have for communities and individual lives. It introduces a theme that runs throughout the book: local ownership and the sense of belonging that attaches to cultural objects and customs. This is never simple. So Chapter 1 leads off with the tragic case of the Bamiyan Buddhas, destroyed by the Taliban in 2001, and immediately raises the question of whose culture these remarkable statues belonged to, if anyone's. It then offers three further well-known examples of 'national treasures' on which people have made claims in the name of heritage: Pablo Picasso's *Guernica*, the Parthenon/Elgin Marbles and Gilbert Stuart's 'Lansdowne Portrait' of George Washington. The *Guernica* section concludes with thoughts about basic values, from John Rawls and John Finnis, the latter providing a list of intrinsic values to which I refer throughout the book.

The strongest moral claim – which may come in rhetorical, diplomatic or legal form – argues that, because of their associations, certain cultural properties (works of art, other artefacts and parts of the built environment) are crucial to the well-being of all individuals in a particular community. Hence there are collective rights to them, such as the right formally claimed in 1983 by the Greek government to the sculptures removed from the Parthenon and sent to England by Lord Elgin in the early nineteenth century. Chapter 2 reviews John Merryman's influential assessment of cultural property debate. His 'two ways of thinking'

are, respectively, the retentionist approach, which makes strong moral claims to cultural properties that are deemed to belong in some sense to a people, and the internationalist approach (his own), which defends against collectivist claims.[2] These 'two ways' have their origin in an originally eighteenth-century dispute about the respective merits of particularism and cosmopolitanism that I sketch out here, and to which I return in the final chapter.

If claims on 'national treasures' are predicated on 'national heritage', then we need to ask what we mean by this term, and how the idea has come to seem important. Part II addresses the construction of national heritage in different places at different times. There are certainly commonalities across cultures, one of which is the significance of cultural narratives to our individual and collective lives. Heritage is profoundly associated with the stories we tell about ourselves, and these stories usually elevate our achievements. We assign ourselves the best roles and marginalise others. Since the relationship between narrative, ideology and identity is a huge subject, I limit my discussion here to Britain and medieval China. Chapter 3 begins with the sale, twice over, of a grand Medici cabinet ordered in the early eighteenth century by the Duke of Beaufort, and then turns to the role of Protestant narratives and customary law in the construction of British heritage. I argue that the Anglo-Irish political thinker Edmund Burke had a highly influential hand in shaping current ideas about national heritage, ideas that now have a currency far beyond Britain. Lastly, I consider Alasdair MacIntyre's communitarian thesis about narrative and personal identity. Although supporting the idea of national heritage, it raises problems for liberals worried about supporting practices that restrict opportunities for citizens.

Chapter 4 continues the theme of constructing heritage, which excludes as much as includes. Here I focus on the competition between cultural narratives, with a particular focus on late medieval China, where neo-Confucianists argued for a particular version of 'our culture' and fought a strong rearguard action to promote the value of indigenous custom against 'foreign' Buddhist religious relics, images and practices. This leads

[2] There are large areas pertaining to cultural property and heritage debate that I exclude from the present work. For example, I do not cover export controls in general, other than those discussed in Chapter 5, nor laws designed to protect archaeological sites from illicit plundering, nor the requirements for passing good title under common and civil laws. Current laws will be covered by Stephen Urice and Alexander Bauer in their forthcoming text, *Cultural Heritage Law & Policy*. See also Barbara T. Hoffman, ed., *Art and Cultural Heritage: Law, Policy and Practice* (Cambridge: Cambridge University Press, 2005).

to a discussion of how value is assigned, and how it relates to changing social conventions and expectations. I then consider two significant Chinese paintings in the American national collections. We are reminded that practices and values can cross cultural boundaries without losing their integrity. This nicely complicates the question of national heritage and of what belongs to any particular people.

Part III returns to the tension between individual and community, and to those claims and rights raised by the cases in Chapters 1 and 3. Are there collective rights to cultural objects? And how far may democratically elected state and regional governments regulate cultural objects and buildings that are privately held? Private owners of culturally important objects and buildings are prone to cry foul when moral claims conflict with established property rights. In Chapter 5, because of their strong private rights regimes, I concentrate on regulations in three common law countries (Britain, the United States and Australia). Suppose, for example, the Liberty Bell had ended up as the private property of a Philadelphian family, who now decide to sell it to a new Japanese 'museum of liberty'. Since there are no export controls in the U.S. to prevent such an act, Americans would be left to worry about the merits of defending the national heritage over private rights. The threatened removal of a Tiffany mosaic from Philadelphia to another American city, perhaps Las Vegas, leads to a discussion of whether there are rights to the integrity of works of art and architecture.

In the final chapter, I attempt to resolve some of the issues raised above. To set the stage, I rehearse a debate between strong versions of Merryman's cosmopolitan and particularist positions. What I omit from this, however, is a liberalism that acknowledges the social dependence of individuals, which I introduce in the second section of the chapter. A feature of recent political thinking is that liberals now lean not only towards cosmopolitanism (as Merryman does), but also towards community, offering a more socially located individual. Ronald Dworkin and Will Kymlicka signal the importance of language to the members of cultural groups, the latter arguing for group rights to spoken and written languages. But can other valuable cultural practices (architecture, painting, music, dance, etc.) be similarly privileged? I suggest that the case for this is thin.

Lastly, I discuss how state and regional governments can justify regulating privately held buildings and works of art. Here I draw on the thinking of Dworkin and Kymlicka, and particularly of Joseph Raz. I find that they can do so precisely because, as individuals, we are dependent for

our well-being on the social forms that surround us. That helps answer the question, conventionally beyond these debates, about the extent to which liberal democratic states should support cultural life from the public purse. I believe they should, for the same reasons that the state may regulate art and buildings, even when, as Dworkin puts it, programming is controversial and the arts appear to benefit only a relatively small proportion of the population. A liberalism that acknowledges our dependence on socially sustained practices offers more resources than liberal cosmopolitanism here. Debates over cultural heritage should, at the least, make us look more closely at the relationship between individual well-being and the opportunity to engage with a wide range of valuable cultural goods.

PART ONE

CLAIMS ABOUT HERITAGE

Heritage and National Treasures

Heritage creates a perception of something handed down; something to be cared for and cherished. These cultural manifestations have come down to us from the past; they are our legacy from our ancestors. There is today a broad acceptance of a duty to pass them on to our successors, augmented by the creations of the present.

Lyndel V. Prott and Patrick J. O'Keefe[1]

1. The Bamiyan Buddhas

"It is not a big issue. The statues are objects only made of mud or stone". Thus spoke Qudratullah Jamal on 3rd March 2001 as the militia began its systematic annihilation of the Bamiyan Buddhas, the second and third largest surviving early Buddhist figures in the world. The elimination of the two Buddhas by the Taliban regime in Afghanistan shocked many people and especially those who highly value the material culture of Asia. "The destruction work is not as easy as people would think. You can't knock down the statues by dynamite or shelling as both of them have been carved in a cliff".[2] Destroying the 'gods of the infidels' was evidently a pious act for Taliban soldiers drafted from outside the Bamiyan valley when local members refused, yet one cannot but think that the chief of the Taliban Foreign Ministry press department, Faiz Ahmed Faiz, was

[1] '"Cultural Heritage" or "Cultural Property"?' (1992) 1 *International Journal of Cultural Property* 311.

[2] See *New York Times*, 4 March 2001, and M. Darrol Bryant, 'The Tragedy of Bamiyan: Necessity and Limits of the Dialogue of Religions and Cultures', in K. Warikoo, ed., *Bamiyan: Challenge to World Heritage* (New Delhi: Bhavana, 2002), 185.

being somewhat disingenuous when he commented that "this decision
was not against anyone. It was totally a domestic matter of Afghanistan.
We are very disappointed that the international community doesn't care
about the suffering people but they are shouting about the stone statues
of Buddha".[3] As indeed they were.

These extraordinary images had always been objects of wonder in
the Buddhist world, visited by the celebrated Chinese pilgrim Xuan-
zang in the early part of the seventh century only decades after their
construction.[4] Bamiyan was then part of a pan-continental Buddhist cul-
ture that stretched from west Central Asia to China, lasting in Afghanistan
until the early eleventh century when Central Asia was overrun by Islamic
tribes and the long-standing commercial routes to western China were
severed. The two (originally three) colossi were a focus of individual
worship and ceremonial practice and, though now faceless, appear to
have represented the historical Buddha, Shakyamuni, in the manner of
a recently lost, life-size stele from Shotorak, depicting the Dipamkara
Buddha (Fig. 1, 2).[5] They were not only inordinately impressive but also
highly important to the documentation of Central Asian material culture.

[3] *New York Times*, 26 March 2001. See Andrew Solomon, 'Art in Jeopardy', in Kate
Fitz Gibbon, ed., *Who Owns the Past? Cultural Policy, Cultural Property and the Law*
(New Brunswick: Rutgers University Press, 2005), 243, and Richard MacPhail, 'Cultural
Preservation and the Challenge of Globalisation', in Warikoo, *Bamiyan*, 164–5.

[4] Deborah Klimburg-Salter, 'The Meaning and Function of Bamiyan in the 7th-8th Centur-
ies', in Warikoo, *Bamiyan*, 33–9. Xuanzang came at the invitation of the western Turkic
ruler probably responsible for the construction of the Buddhas, Tong Shi hu Yabghu
Khaqan, who was murdered before the pilgrim arrived.

[5] Each face was constructed from a wooden mask inserted above the lips, overlaid with a
metal – probably brass – skin that was likely gilded and also set with coloured glass or
semi-precious stones; the arms were built up over wooden armatures, as was the right leg
of the larger figure, which also had shoulder flames like the Shotorak image. See Deborah
Klimburg-Salter, *The Kingdom of Bamiyan: Buddhist Art and Culture of the Hindu Kush*
(Naples and Rome: Instituto Universitario Orientale and Instituto Italiano per il Medio ed
Estremo Oriente, 1989), 87–92. The monuments were damaged by Genghis Khan in 1222.
Earlier schools of Buddhism focused on the historical Buddha Shakyamuni, who lived
during the sixth to fifth centuries BCE in northeast India. A major development occurred
around the beginning of the first millennium in which Shakyamuni was understood to be
a particular manifestation of the cosmic Buddha principle. Northern India and Central
Asia embraced this new school, which called itself the Great Vehicle (Mahāyāna), and
witnessed a proliferation of Buddhist texts and images of cosmic Buddhas ruling over
myriad universes. Yet larger than the Bamiyan figures is the 70 m. seated Maitreya
(Future Buddha) at Leshan, south-west China, carved during the eight century CE to
protect Sichuanese sailors and merchants on the Min and Dadu rivers, the face of which
was recut during the twentieth century; see Angela Falco Howard, Li Song, Wu Hung,
Yang Hong, *Chinese Sculpture* (New Haven: Yale University Press, 2006), 319 and 322.
Mt. Emei and Leshan together have constituted a UNESCO World Heritage site since
1996.

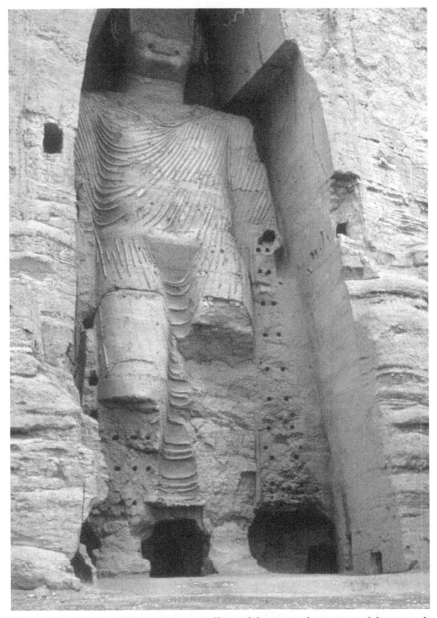

FIGURE I. *Great Buddha, Bamiyan Valley, Afghanistan, beginning of the seventh century CE, carved into cliff-face, 55 m. Photograph by Deborah Klimburg-Salter © 1975. Courtesy of the Western Himalaya Archive, Vienna.* The larger of the two monumental figures at Bamiyan, a centre of Buddhist activity on the trade route connecting Central Asia and northwest India during the 1st millennium CE, both of which were destroyed by the Taliban in March 2001.

As the world was to learn, it wasn't just the Bamiyan Buddhas that were destroyed. All over Afghanistan, and within the Kabul Museum itself, Taliban authorities were endorsing a systematic iconoclasm to remove as much pre-Islamic sculpture as possible. The desire to maintain a context for this material was rapidly becoming less important than simply saving it from obliteration. An 'Afghanistan-Museum in Exile' at Bubendorf, near Basle, had been set up to serve as a repository in trust for the country's material culture. It was defeated in its attempt to save much, however, by the technicalities of arranging for Afghanistan's artefacts to enter Switzerland in contravention of the 1970 UNESCO Convention (on the Means of Prohibiting and Preventing the Illicit Import, Export and Transfer of Ownership of Cultural Property). In March 2007, the some fourteen hundred items were sent back to Afghanistan and deposited at the National Museum in Kabul.[6] One outcome of the awful saga was the adoption by UNESCO in June 2001 of a resolution that strongly condemned these acts as "crimes against culture".[7] Further, it invited competent bodies, including the World Heritage Committee, to identify the means of ensuring better protection of the "common heritage of humanity".[8] How can one argue against such noble sentiments, which see the Bamiyan Buddhas and other major monuments as a part of the common heritage? And yet this language leads us directly into a discussion that embraces not only the Bamiyan Buddhas but also the contest over the Parthenon/Elgin Marbles, as well as issues of export controls and of what goods countries should attempt to protect and promote.

Does the Afghani heritage comprise the heritage of all those who have ever lived there, or the heritage of those who live there now, or the heritage of some of those who live there now? It is clear that the Taliban didn't consider the Buddhas to be part of their heritage. Indeed, given the continuance of 'Great Vehicle' Buddhism in both cultures, Tibetan and Japanese Buddhists might reasonably think that the Buddhas were more a part of their heritage. Thus there arises a question about the degree to which 'other people's heritage' is also part of one's own. Certainly we can ask this about the Bamiyan Buddhas. After all, papers from the

[6] On the Museum in Exile, see also Kwame Antony Appiah, 'Whose Culture Is It?', in James Cuno, ed., *Whose Culture? The Promise of Museums and the Debate over Antiquities* (Princeton: Princeton University Press, 2009), 80–2.

[7] 'On the Protection of the Cultural Heritage of Humanity'.

[8] The World Heritage Committee is the intergovernmental organ established under the aegis of the 1972 UNESCO Convention (Concerning the Protection of the World Cultural and Natural Heritage); see Jean Musitelli, 'World Heritage, between Universalism and Globalization', (2002) 11 *International Journal of Cultural Property*, 323–36.

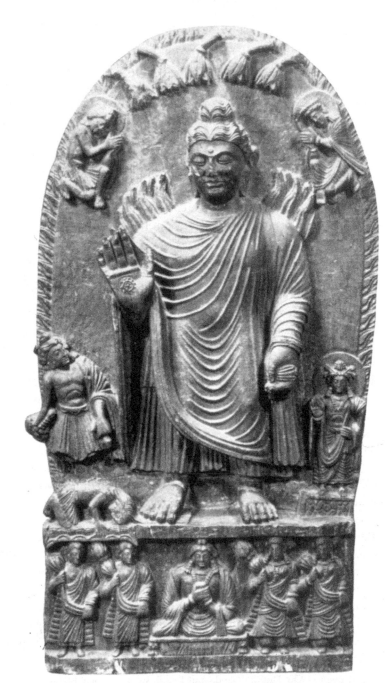

FIGURE 2. *Buddha stele from Shotorak, Kapisa, Afghanistan, sixth century CE, schist; Kabul Museum (in 1976), present whereabouts unknown. Photograph by Deborah Klimburg-Salter © 1976. Courtesy of the Western Himalaya Archive, Vienna.* Deborah Klimburg-Salter suggests that Kapisa images such as this give an indication of the original appearance of the now-destroyed Bamiyan Buddhas.

Beyond Bamiyan conference made much of the importance to Afghanistan's present Muslim population of the region's Buddhist heritage, even though the religion has not been practised there for a millennium. Related to this particular discussion is the fate of an important hoard of early Buddhist manuscripts from Bamiyan, smuggled out during the Civil War and now in the Schoyen Collection in Oslo; these were possibly part of a "Buddhist genizah", as Richard Salomon puts it (referring to repositories of discarded Jewish religious objects).[9] Although the manuscripts are available to international scholars, calls have been made for them to be returned to Afghanistan as soon as the country is sufficiently stable to conserve them safely.

Ironically, only four months before the Buddhas were razed, the Taliban had demanded from Britain the Koh-I-Noor diamond, held during much of the eighteenth and early nineteenth centuries by the Afghan royal family and surrendered when Britain conquered the country in 1850. Faiz Ahmed Faiz was then quoted as saying that the diamond should be returned with "many other things stolen from Afghanistan" and put on display in Kabul. Unlike the Koh-I-Noor (and numerous images from the early Buddhist cultures of Afghanistan and Pakistan), many culturally valuable things have only a modest market value. An exhibition mounted in Europe during the 1990s offered another dimension to this problem. Entitled *Genizah: Hidden Legacies of the German Village Jews*, it displayed religious artefacts ritually deposited in the attics of former south German synagogues and rediscovered during the late 1980s when the buildings were restored to commemorate the fiftieth anniversary of the Kristallnacht pogrom.[10] Local organisations undertaking the restorations were keen to recognise publicly what had been done, and title to the buildings and repositories generally passed to them under the German civil code. Given the desire of these organisations to make more visible the nightmares of the past, the title transfer was not about maximising financial benefit from the stored material, which had a relatively low economic value, but of taking property into trust for the educational benefit of present and future generations. Is this material only a part of the Jewish heritage, or also of south Germany, or of Europe at large? Similarly, is the

[9] Richard Salomon, 'Why Did the Gandhāran Buddhists Bury Their Manuscripts?', in Stephen C. Berkwitz, Juliane Schober and Claudia Brown, eds., *Buddhist Manuscript Cultures: Knowledge, Ritual and Art* (Abingdon: Routledge, 2009), 19–34.

[10] Falk Wiesemann et al., *Genizah: Hidden Legacies of the German Village Jews* (Vienna: Hidden Legacy Foundation, 1992). These synagogues had been converted to other uses under the Nazis.

remaining Buddhist material culture in Afghanistan a part of the heritage of the now exclusively Muslim population, as present Afghan officials argue? If it is, then it cannot be important whether practices of the past are currently practised within the local communities.

Claims that a particular work of art or building or archaeological site belongs to some particular heritage are usually made when there is a perception of danger, either because something is going to happen (such as destruction, or looting or sale overseas) or conversely something is failing to happen (such as conservation or upkeep). Calling on the 'heritage of all mankind' is certainly useful if we want to stop destruction, looting, decay or benign neglect, and where we want to signal to the agents of such change that they should think about values other than their own. But although claims to preserve important cultural things on behalf of all mankind may be noble and worthy of our support in principle, they frequently conflict with two other potentially competing social facts: that many things are claimed by particular cultures, and that many things are privately owned. The quick answer would be that all things are equally part of 'world heritage' and a particular national or local heritage. But that is too fast. It satisfies symmetry but at the expense of the realities of possession and control.

2. *Guernica*

Early in January 1937, a Republican delegation led by the architect Josep Lluis Sert asked Pablo Picasso to create a mural for the Spanish Pavilion at the World's Fair, which was scheduled to open in Paris on 24th May. Picasso had still to begin work when, on 26th April, the Basque town of Guernica was set ablaze. Five days later he began a series of sketches, and in early June told Sert that the mural could be collected (Fig. 3).[11]

Now widely acknowledged as one of the great paintings of the twentieth century, *Guernica* was a political statement from the start, responding to an appalling atrocity in which a town and its citizens were relentlessly

[11] Officially designated *L'Exposition internationale des arts et techniques dans la vie moderne*. For histories of the painting from which the following account is derived, see Herschel B. Chipp, *Picasso's Guernica: History, Transformations, Meanings* (Berkeley: University of California Press, 1988), 137–91, and Russell Martin, *Picasso's War: The Destruction of Guernica and the Masterpiece that Changed the World* (New York: Dutton, 2002). For the Spanish Pavilion, see Marko Daniel, 'Spain: Culture at War', in Dawn Ades, Tim Benton, David Elliot and Iain Boyd White, eds., *Art and Power: Europe under the Dictators 1930–45* (London: Hayward Gallery, 1995), 63–8.

bombarded by Nazi planes to no military purpose other than to shock the remainder of the Spanish Republican army into submission. Something of the horror was captured by George Steer of the London *Times* who, together with the *Daily Express* and Reuters correspondents, arrived at the town shortly after the bombing:

Guernica, the most ancient town of the Basques, and the centre of their cultural tradition, was completely destroyed yesterday afternoon by insurgent air raiders. The bombardment of the open town far behind the lines occupied precisely three hours and a quarter . . . Junkers and Heinkel bombers and Heinkel fighters . . . did not cease unloading on the town bombs . . . and . . . incendiary projectiles. The fighters, meanwhile, plunged low from above the centre of the town to machine-gun those of the civil population who had taken refuge in the fields.[12]

When installed, *Guernica* was all but ignored by the press (as was the Spanish pavilion as a whole, which opened seven weeks late). According to Le Corbusier, it was because the Fair was devoted to entertainment and most of the visual arts to *la belle peinture*. In November, after the pavilion was disassembled and the accompanying mural by Joan Miro was shipped back to Valencia (and not seen again), *Guernica* was returned to Picasso, who apparently said on a number of occasions that it should eventually go to Madrid. Under the prevailing circumstances he undoubtedly meant a Republican Madrid.[13] In the event, it was pressed into political service in England; first at the New Burlington Galleries, London, where together with sixty preparatory sketches it was shown in aid of the Joint Committee for Spanish Relief in October 1938; then at the Whitechapel Art Gallery, at which the price of admission was a pair of reusable boots; and finally, during February 1939, in a rented automobile showroom in Victoria Street, Manchester. On 1st May 1939, two years after the first sketch was drawn, *Guernica* arrived in New York. Picasso wished that the painting continue to serve the Republican cause, in particular Spanish refugees, but the tours arranged netted under $3,000, very much less than the $10,000 the artist had hoped for, despite its impact. The painter Leon Golub recalled *Guernica*'s showing at the Chicago Arts Club: "It was a shocker, colossal! Like 'Les Demoiselles d'Avignon', a revolutionary act".[14] Working in conjunction with the Spanish Refugee Relief

[12] Anthony Blunt, *Picasso's 'Guernica'* (Oxford: Oxford University Press, 1969), 7.

[13] Picasso was honorary director of the Prado and hence a member of the Republican Government; see Chipp, *Picasso's Guernica*, 154.

[14] Leon Golub, 'On the Day Clement Greenberg Died', in Hans-Ulrich Obrist, ed., *Leon Golub: Do Paintings Bite?* (Ostfildern: Cantz, 1997), 9.

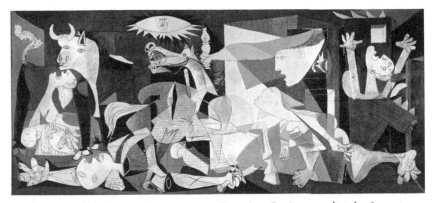

FIGURE 3. *Pablo Picasso (1881–1973)*, Guernica, *Paris, completed 4 June 1937, oil on canvas, 349.3 × 776.6 cm., Museo Nacional Centro de Arte Reina Sofia, Madrid, Spain. Photograph by Erich Lessing, Art Resource, New York. © 2005 Estate of Pablo Picasso, Artists Rights Society (ARS), New York. Picasso's stated wish was for Guernica to reside permanently in Spain, but only if there was a Republican Government.*

Committee, Alfred Barr of the Museum of Modern Art promised the artist that MoMA would reimburse shipping costs and return the picture to France as a condition of securing it for their major Picasso retrospective in November. The intention was honourable, but the Second World War intervened. Apart from two overseas tours, to Milan and Sao Paulo in 1953–4, and to Paris, Munich, Cologne, Hamburg, Brussels, Amsterdam and Stockholm in 1955–6, *Guernica* stayed in the United States until 1981.

The means by which Picasso represented the massacre was by no means widely approved.[15] Not only was the appropriateness of the painting queried but its meanings and sources have since been relentlessly debated. Do the individual images relate directly to the parties involved in the Spanish Civil War, to an understanding of the universality of violent struggle, or to Picasso's own turbulent relationships? The politically symbolic and personal references can hardly be disengaged, and in the postwar period *Guernica* has come to be seen as perhaps the last great history painting. Although it could also function as a symbol of twentieth-century art, so might thousands of other major paintings, sculptures and objects. As a symbol of the Spanish Republican cause and of Spanish liberal and

[15] Anthony Blunt, for example, criticised it at the time as "abstruse circumlocutions" with no meaning for serious people, the implication being that the revulsion of millions around the world was not being intelligibly articulated; see Chipp, *Picasso's Guernica*, 158–9.

democratic hopes, it was unique. One review of MoMA's retrospective included the following sympathetic observation:

He has found his soul not in the studio, not in the laboratory of plastic research, but in his union with the people of his native land, Spain. In the painting, *Guernica*, he functioned not only as a son of Spain but as a citizen of the democratic world.[16]

The image is poignant and relevant. The finding of the soul, not by personal renunciation of sin but in the context of communal order, is an idea that reverberates through cultural property debate.

The campaign to recover *Guernica* for the new museum of contemporary art in Madrid, launched by the Caudillo himself (who regarded such art with contempt) and stimulated by the construction of the Fondacion Sabartes in Barcelona (now the Museu Picasso), only highlighted the absurdity of allowing it into Spain under Franco's regime. In October 1969, Spain's director-general of fine arts announced that "the government of General Franco deems Madrid to be the place for *Guernica*, Picasso's masterpiece", a sentiment supported by the pro-Franco paper *El Alcázar*. "*Guernica*, given by Picasso to the Spanish people, is a part of the cultural patrimony of this people and should be on exhibition in Spain".[17] Picasso's lawyer Roland Dumas was quoted as saying that "the painting shall be turned over to the government of the Spanish Republic the day when the Republic shall be restored to Spain". In November of the following year, in a letter to MoMA, Picasso corrected the latter clause to "when public liberties shall be restored", but then in April again declared that *Guernica* and its accompanying studies "are destined for the government of the Spanish Republic".

The artist died in April 1973, but it was not until Franco's death two and a half years later that a transfer to Spain could be taken at all seriously. From then onwards, William Rubin at MoMA worried over Picasso's precise intentions and the proper construal of 'republic'. Transfer was further complicated by the labyrinthine nature of the estate settled on the artist's widow Jacqueline and seven children; the size of their apportionment was determined by whether they were legitimate or not. Alerted to their moral rights, several of the heirs imposed severe conditions on the nature of the state to which *Guernica* might be given. The knots were partially untied in 1980 by the location of several documents retrieved from the archives of the former Ambassador to Paris, Luis Araquistain,

[16] Elizabeth McCausland, *Springfield Republican*, 19 November 1939, ibid., 163.
[17] Martin, *Picasso's War*, 192–3.

which proved that the true owner had always been the government of the Spanish Republic. So, although no such entity had existed since the 1930s, Dumas was persuaded that the present Spanish state had the best claim to *Guernica* and agreed that it should now leave New York.[18] On 24th October 1981, a day before the centenary of the artist's birth, the picture was unveiled within the refurbished Cason del Buen, an annex of the Prado. The transfer of *Guernica* was clearly saying something very public about the liberal nature of contemporary Spanish society. It now resides in the Reina Sofia, Madrid's modern art museum.

Guernica was conceived within the tradition of history painting, which for centuries had been regarded as the highest of the European genres. Its theme had a lineage that stretched from Guido Reni's *Massacre of the Innocents* and Nicholas Poussin's *The Abduction of the Sabine Women* to J.L. David's *Intervention of the Sabine Women* of 1799, the latter two both hanging in the Louvre, with the David bearing a formal relationship to *Guernica*. Picasso seems to have appreciated the reading of David's picture as a representation of the people's struggle for liberation from oppressive and tyrannical regimes.[19] Although *Guernica* obviously has value as a great Picasso, it also has enormous political value as a symbol of the Spanish Republican struggle against fascism, and of national self-determination against outside intervention. Such symbolic value – for Spaniards, Basques, democrats and liberals – is instrumental, pointing toward the value of individual liberty.

Liberty is certainly one of the values put into play when self-determination is linked to cultural heritage. So let me introduce here some thoughts about value. For John Rawls, liberty is among the basic liberal goods required by citizens in order to frame and execute a rational plan of life, access to which allows people to form and revise conceptions of other goods.[20] John Finnis regards Rawls's thin restriction

[18] The most important of the documents was a letter written in 1953 by the former prime minister J.A. del Vayo to Araquistain, informing him that he held a receipt for the sum of 150,000 fr., signed by Picasso, "to cover the expenses Picasso underwent in the creation of his work *Guernica* that he was donating to the government of the Spanish Republic", ibid., 177.

[19] Anita Brookner argues that in showing the central figure of Hersilia as making peace between Romulus and Tatius, David is intent on demonstrating the desirability of bringing together the warring factions in post-revolutionary Paris; see her *Jacques-Louis David* (New York: Thames and Hudson, 1980), 137–40.

[20] The list is as follows: "Basic rights and liberties, also given by a list: freedom of movement and free choice of occupation against a background of diverse opportunities; powers and prerogatives of offices and positions of responsibility in the political and economic institutions of the basic structure; income and wealth; and finally, the social bases of

of primary goods to liberty, opportunity, wealth (i.e., not the state of poverty) and self-respect as a 'radical emaciation' of human good, suggesting that they are instrumentally rather than intrinsically valuable. Finnis offers a thicker set of basic values, which he thinks are irreducible to others: life, knowledge, play, aesthetic experience, sociability (especially friendship), practical reasonableness and religion, each of which "can be participated in, and promoted, in an inexhaustible variety of ways and with an inexhaustible variety of combinations of emphasis, concentration, and specialization".[21] There is no objective hierarchy or priority of value among these seven. Within our individual lives, however, we are inclined (or encouraged, or forced) to place more importance on certain of them than others (e.g., religion over aesthetic experience, or vice-versa).[22] An essential element of this account is, as Neil MacCormick puts it, that

> It comprises a plurality of basic goods which are mutually incommensurable. For an individual or a community to achieve a good life, or a good way of life, there is required a balance among several goods, not a simple aggregation of a single good.[23]

Unlike Finnis, Rawls eschews any attempt to provide a broader index of primary goods, which he sees as an insoluble task.[24] Rawls's liberal goods do indeed represent vital conditions for individual well-being, yet I don't believe that there is a necessary contradiction between seeking

self-respect". John Rawls, *Political Liberalism* (New York: Columbia University Press, 1996), 180–81. See also Will Kymlicka, 'Dworkin on Freedom and Culture', in Justine Burley, ed., *Dworkin and His Critics* (Oxford: Blackwell, 2004), 115.

[21] John Finnis, *Natural Law and Natural Rights* (Oxford: Clarendon Press, 1980), 81–90, 100, 105–6. Another contemporary list of prudential values ("a general profile") comes from James Griffin: accomplishment, the components of human existence, understanding, enjoyment, and deep personal relations; see Griffin's *Value Judgement: Improving Our Ethical Beliefs* (Oxford: Clarendon Press, 1996), 29–30.

[22] Finnis, *Natural Law and Natural Rights*, 92–3.

[23] Neil MacCormick, 'Natural Law and the Separation of Law and Morals', in Robert George, ed., *Natural Law Theory: Contemporary Essays* (Oxford: Oxford University Press, 1992), 125; MacCormick questions Finnis's inclusion of practical reasonableness within the seven, because of the tension between it being both a basic good and also the source of the principles required to order our pursuit of any goods (128). Finnis acknowledges this condition in Chapter 5 of his *Natural Law and Natural Rights*. In *Engaging Reason: On the Theory of Value and Action* (Oxford: Oxford University Press, 1999), 191, Joseph Raz questions whether 'life' is less an intrinsic value than a precondition for doing anything valuable, whereas for Finnis it signifies "every aspect of the vitality (*vita*, life) which puts a human being in good shape for self-determination"; Finnis, *Natural Law and Natural Rights*, 86.

[24] Rawls, *Political Liberalism*, 180–1, note 8.

them and also recognising Finnis's intrinsic values. In providing such a thoughtful explanation of why those seven are indeed basic, Finnis makes an important contribution to our understanding of value. He underlines the point that although there are countless other objectives and forms of good, they all relate back to the seven listed above.

I suggest that these other objectives and forms of good will be found, on analysis, to be ways or combinations of ways of pursuing (not always sensibly) and realizing (not always successfully) one of the seven basic forms of good, or some combination of them. Moreover, there are countless aspects of human self-determination and self-realization besides the seven basic aspects which I have listed. But these other aspects, such as courage, generosity, moderation, gentleness, and so on, are not themselves basic values; rather, they are ways (not means, but modes) of pursuing the basic values, and fit (or are deemed by some individual, or group, or culture, to fit) a man for their pursuit.[25]

Works of art possess combinations of these values for different peoples. So, for example, the Bamiyan Buddhas could speak to the values of life, knowledge, aesthetic experience and religion; and *Guernica* to life, knowledge, aesthetic experience and friendship. Knowledge, aesthetic experience and religion, three of Finnis's basic values, appear again and again within debates about cultural heritage and the rights to cultural property.

Now there are those who think heritage itself is a basic good (whom we shall meet below and in Chapter 2), but in my opinion this proposition is generally unconvincing. I would suggest that 'heritage' stands in front of Finnis's basic values, and, for those cultures that strongly emphasise liberty and opportunity, Rawls's values also, especially the social bases of self-respect. Heritages (or cultures) are ways of thinking and talking about communities of people in space and time, related by shared practices, conventions and norms (which I discuss in Chapters 3 and 4). These practices, conventions and norms manifest Finnis's basic values (such as knowledge, aesthetic experience, play, friendship and religion) in particular ways. Knowing about cultural histories is intrinsically valuable, because knowledge is a basic good. Knowing about our own cultural histories and those of other peoples will also be instrumentally valuable.[26] Indeed, one of the themes of the present work is that debates over heritage should, in the end, be about the well-being of individuals.

[25] Finnis, *Natural Law and Natural Rights*, 90–1.
[26] Assisting us in engaging with basic goods or realizing instrumental liberal goods such as Rawls's, either for ourselves or for others.

3. The Parthenon/Elgin Marbles

1981 might have seemed something of an *annus mirabilis* to a significant number of Greek citizens, particularly the disenfranchised. At the beginning of the year Greece officially joined the European Community, and in October the Panhellenic Socialist Movement was elected on a platform of national self-determination and change during the same month as the internationally publicised transfer of *Guernica*, which surely gave impetus to the idea of recovering the Parthenon/Elgin Marbles as the symbol of a more equitable society.[27]

The Parthenon sculptures are widely regarded as the finest surviving examples of early Greek art, the temple featuring prominently in the later stages of the battle fought from the mid-eighteenth century over the superiority of Greek over Roman sculpture, since when opinion has echoed Plutarch's sentiment:

As the works rose, shining with grandeur and possessing an inimitable grace of form, and as the artisans strove to surpass each other in the beauty of their workmanship, the rapidity with which the structures were executed was marvellous... There is a certain bloom of newness in each work and an appearance of being untouched by the wear of time. It is as if some ever-flowering life and unaging spirit had been infused into the creation of them.[28]

Although the intellectual models of Renaissance Europe were found in Greece and Rome, prior to the late eighteenth century artists had little thought to imitate the actual sculptures of ancient Greece, taking as their models the remains of imperial grandeur scattered around Rome that, at best, copied much earlier and now lost Greek originals.[29] Since the 1750's, however, the convention that Roman art represented the most appropriate model for inspiration and copying had been challenged by a new attention to the achievements of early Greece. Aesthetic value aside, Periclean Athens is promoted as an ideal civilisation and the source of Western democracy. Within this dual context, it is understandable why the sculptures acquired from Lord Elgin by the British Museum should have become a *cause celebre* (Figs. 4, 5). In an interview given

[27] Richard Clogg, *A Concise History of Greece* (Cambridge: Cambridge University Press, 1992), 183, 205.
[28] From Plutarch's *Life of Pericles*; see J.J. Pollitt, *Art and Experience in Classical Greece* (Cambridge: Cambridge University Press, 1972), 66.
[29] Richard Cocke discusses anxiety accompanying the incorporation of classical architectural and sculptural components into churches in his *From Magic to High Fashion: The Classical Tradition and the Renaissance of Roman Patronage, 1420–1600* (Norwich: Mill Hill, 1993), 1–8.

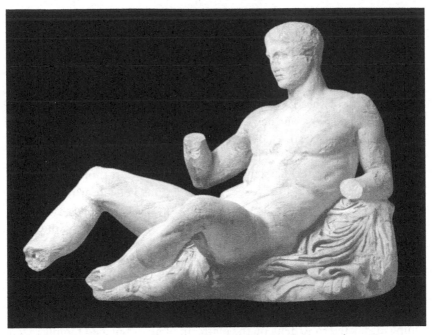

FIGURE 4. *Dionysos, from the east pediment of the Parthenon, Athens, Greece, ca. 438–32 BCE, marble.* © *The Trustees of the British Museum.* The Parthenon/Elgin sculptures remain the best-known example of cultural objects requested from a nation, institution or individual by another state, in this case the Greek government, which first sought restitution in 1983.

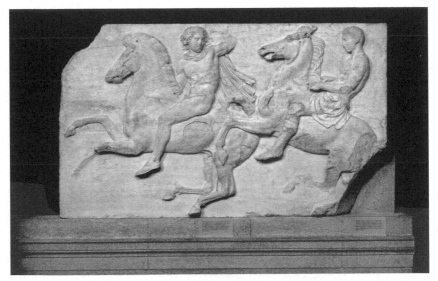

FIGURE 5. *Horsemen from the west frieze of the Parthenon, Athens, Greece, ca. 438–32 BCE, marble.* © *The Trustees of the British Museum.*

shortly before her visit to London in May 1983, the late Melina Mer-
couri, then Greek minister of culture, told the *Sunday Times* that "the
marbles are part of a monument to Greek identity, part of the deepest
consciousness of the Greek people: our roots, our continuity, our soul.
The Parthenon is like our flag".[30]

At this point it seems helpful briefly to describe the construction of
the Parthenon complex in the fifth century BCE. The Greeks won a fa-
mous victory over the Persians at the battle of Marathon on the east
coast of Attica in 490. In revenge, Xerxes led his Persian armies against
the Spartans at Thermopylae in 481, and then sacked Athens.[31] After a
further two decades of war, the Persian threat was effectively eliminated
and Athens emerged as the hegemonic power among the Greek city-
states. Around 450 Pericles persuaded the popular democratic assembly
to enrich the city's temples and public buildings, not only as monuments
to the victory over 'barbarism' but as a physical manifestation of Athenian
ascendancy; and so approval was given in 448 for construction of a Doric
temple dedicated to Athena on the platform of an unfinished temple razed
by the Persians in 480.[32]

Standing within the Parthenon's *cella* was a monumental ivory and
gold statue of the warrior maiden Athena Parthenos, symbol of the
city's might, created by Phidias, who was generally responsible for the
sculptural programme. The high-relief *metopes* on the exterior (carved
ca. 440 BCE) celebrated the triumph of civilisation and order over chaos
and barbarism, represented through warring gods and giants, Centaurs
and Lapiths, and Greeks and Trojans, and Greeks and Amazons (on the
east, south, north and west sides respectively). The triangular pediments
at the east and west ends contained images of both the birth of Athena
and her contest with Poseidon for the patronage of Athens. Within the
colonnade and high up on the walls of the temple was a low-relief frieze
(like the pediments, carved ca. 438–32 BCE) depicting gods, horsemen
and horse-drawn chariots led by figures walking in peaceful procession

[30] Interview with Susan Crosland, *The Sunday Times*, 22 May 1983. Mercouri recom-
mended to the PASOK Cabinet the formal call for return. She was amongst those who
had campaigned openly against the Colonels' dictatorship, for which she was stripped
of her nationality. Her husband, film director Jules Dessin, had himself experienced
right-wing suppression when blacklisted by McCarthy.

[31] The turning point in the Persian-Greek wars was a naval battle at Salamis in 480, after
which Xerxes's land-based troops were annihilated in Plataea. Within two years the
League of Greek states had ousted all remaining Persian forces from the northern and
eastern seaboard; Pollitt, *Art and Experience in Classical Greece*, 12–14, 25.

[32] Ibid., 64–95.

that pays homage to Athena and the gods, originally painted in vivid colours as was customary.[33]

In religious systems where the domain of the gods and ancestors is only thinly separated from humans, as was the case in ancient Greece, the realms connect not only through oracular or shamanistic communication but also through relics, cultic images and sacred places. During the fifth century BCE, the ritual focus of the festival shown in the frieze was not the great chryselephantine figure of Athena in the Parthenon itself, but rather an ancient olive-wood figure of Athena Polias, housed eventually in the Erechtheion (the tomb of Erechtheus, built from 421–04 BCE to replace an earlier structure destroyed by the Persians).[34] To think of Pericles and his followers acting only from humanistic and religious motives is to underestimate the degree to which civic order was predicated on military success. John Boardman is pointed about this: "In no way could the Parthenon be regarded as a monument to democracy and freedom, rather than to the military prowess of her people and the political and financial acumen and ruthlessness of their leaders".[35]

As much as the Periclean assembly is regarded as a paradigm of early democracy (although, as John Rawls notes, it actually represented an autocracy of 35,000 male members over a population of about 300,000), the message of militarism was close indeed – not only in Sparta, where it was celebrated, but also among the philosophers of ancient Athens, including Socrates and Plato.[36] Although the Athena Parthenos did

[33] The traditional interpretation is that the frieze represents the quadrennial Panathenaic festival in honor of Athena's birthday. John Boardman suggests that the horsemen and charioteers in the Parthenon frieze represent not living participants in the Panathenaic festival but the 192 Athenian warriors killed by the Persians in the great Greek victory at Marathon (and, excluding gods and secondary images, the number of figures on the frieze is just that); see 'The Parthenon Frieze – Another View', in U. Höckmann and A. Krug, eds., *Festschrift für Frank Brommer* (Mainz, 1977), 39–49, cited in Paul Cartledge, 'Archaeology in Greece', in Tom Winnifrith and Penelope Murray, eds., *Greece Old and New* (London: Palgrave Macmillan, 1983), 145–8. A more recent interpretation by Joan Breton Connelly draws on fragments from a lost play by Euripides, *Erechtheus*, to argue that the frieze depicts the myth of the sacrifice to Athena of the three daughters of Erechtheus, king of Athens; 'Parthenon and Parthenoi: A Mythological Interpretation of the Parthenon Frieze', (1996) 100 *American Journal of Archaeology* 53–80. See also Robert Graves, *The Greek Myths* (Harmondsworth: Pelican, 1960), 1:168–9.

[34] See Betty Radice, *Who's Who in the Ancient World* (Harmondsworth: Penguin, 1973), 71–2; and Graves, *The Greek Myths*, Section 25.

[35] John Boardman, 'The Elgin Marbles: Matters of Fact and Opinion', (2000) 9 *International Journal of Cultural Property* 235.

[36] John Rawls, *The Law of Peoples, with 'The Idea of Public Reason Revisited'* (Cambridge, MA: Harvard University Press, 1999), 28–9, note 27. See also John Onians, *Classical Art and the Cultures of Greece and Rome* (New Haven: Yale University Press, 1999),

indeed represent another, more glorious world beyond the mundane, the Parthenon as a whole seems to have been a great votive offering to the gods, which was also used as the city treasury, rather than a cultic building, hence the charge recorded in Plutarch that in building it Pericles was diverting funds allocated by the confederation of equal allies who came together to protect against the Persians, and "gilding and beautifying our city, as if it were some vain woman decking herself out with costly stones and statues and temples worth millions of money [*sic*]".[37]

The first move on restitution of the sculptures removed to England by Elgin was made at the 1982 Mexico World Conference on Cultural Policies, organised by UNESCO and attended by various ministers of culture.[38] A recommendation was made that member states should view the return of the Marbles as an instance of the application of the principle that elements abstracted from national monuments should be returned to those monuments. During the summer of the following year, a senior official from the Ministry made the following statement to the General Assembly of the International Council of Museums (ICOM):

We consider it right and just that the Parthenon marbles and those taken from the Erechtheum should be returned to Greece, the country in which they were created, in application of the principle – to quote – "that all countries have the right to recover the most significant part of their respective cultural heritage lost during periods of colonial or foreign occupation".[39]

The Greek government formally requested the return of the Parthenon/ Elgin Marbles on 12th October 1983, and the case has tested cultural

Chapter 2. One example of continued reverence for the Greeks as originators of Western humanist values is the replica of the Parthenon in Nashville, Tennessee, conceived for Centennial Park in 1897 and erected ca. 1931.

[37] Boardman, 'The Elgin Marbles: Matters of Fact and Opinion', 235, and Robert Browning, 'The Parthenon in History', in Christopher Hitchens, *Imperial Spoils, The Curious Case of the Elgin Marbles* (New York: Hill and Wang, 1987), 17. As William St. Clair notes, "for many fifth-century non-Athenians, we may confidently conjecture, the Parthenon was not a monument to the glories of contemporary Hellenic civilization, but a humiliating reminder of the recent assumption by Athens of a hegemony over their own cities" ('Imperial Appropriations of the Parthenon', in John Henry Merryman, ed., *Imperialism, Art and Restitution* [Cambridge: Cambridge University Press, 2006], 66).

[38] 26 July to 6 August.

[39] Made by the director of the Department of Antiquities; the General Assembly sessions were held over 1–2 August; see Jeanette Greenfield, *The Return of Cultural Treasures* (Cambridge: Cambridge University Press, 1989), 77–8.

relations between Britain and Greece since.[40] It is also regarded by many museums as a battleground between the cosmopolitan and the particular (or the global and the regional). Others see it as a contest between colonisers and the colonised, or the art poor and the art rich. By any definition the Marbles are a treasure, but a treasure of one or many nations?

A major focus for proponents of return is whether good title did indeed pass to Elgin, the more so since the common law does not recognise 'good faith' acquisition. As David Rudenstine observes, "it almost seems as if the moral fervor that characterizes the dispute is largely – but not exclusively – dependent upon whether the Ottomans did or did not convey to Elgin legal title to the marbles".[41] I am going to pass on the detail of this for two reasons. Firstly, there now exists an extensive literature relating to the legitimacy of the *firman* (permission) that Elgin obtained, and to the removal of the Marbles and their subsequent history in England, to which I would refer readers interested in assessing the likely direction of a court decision.[42] If a court determined that title did not pass to Elgin, then the question still remains of the validity of the Greek claim under the English statute of limitations.[43] Secondly, I want to focus on the moral

[40] The request was rejected the following year (ibid,. 84). A further request was made in January 1997; see Theodore Vrettos, *The Elgin Affair: The Abduction of Antiquity's Greatest Treasures and the Passions It Aroused* (New York: Arcade, 1997), 212.

[41] David Rudenstine, 'The Legality of Elgin's Taking: A Review Essay of Four Books on the Parthenon Marbles', (1999) 8 *International Journal of Cultural Property* 356–76. Rudenstine points out the formal difference between ownership and trusteeship (ibid., 371). The trustees of the British Museum are a body corporate with perpetual succession and a common seal, with duties towards the collections as adumbrated in the British Museum Act 1963.

[42] See also William St. Clair, *Lord Elgin and the Marbles* (Oxford: Oxford University Press, revised ed, 1983); B.F. Cook, *The Elgin Marbles* (London: British Museum, 1984); John Henry Merryman, 'Thinking about the Elgin Marbles', (1985) 83 *Michigan Law Review*, 1881–1923; John Henry Merryman, 'Who Owns the Elgin Marbles?', (1986) 85 *ARTnews* (September) 100–9; William St. Clair, 'The Elgin Marbles: Questions of Stewardship and Accountability', (1999) 8 *International Journal of Cultural Property* 397–521; Claire L. Lyons, 'Cleaning the Parthenon Sculptures', (2000) 9 *International Journal of Cultural Property* 180–4; Ian Jenkins, The Elgin Marbles: Questions of Accuracy and Reliability', (2001) 10 *International Journal of Cultural Property* 55–69; Ian Jenkins, *Cleaning and Controversy: The Parthenon Sculptures 1811–1939* (London: British Museum Occasional Paper 146, 2001); Kate Fitz Gibbon, 'The Elgin Marbles: A Summary', in Fitz Gibbon, *Who Owns the Past?*, 108–21; Ana Filipa Vrdoljak, *International Law, Museums and the Return of Cultural Objects* (Cambridge: Cambridge University Press, 2006), 30–3.

[43] John Henry Merryman suggests that the Greek government has recently set aside its claim to title, now arguing only that the marbles belong in Athens, 'Whither the Elgin Marbles?', in Merryman, ed., *Imperialism, Art and Restitution*, 99–100; see also the

rather than the legal claim. If the circumstances of acquisition are such that it cannot clearly be determined that the possessor does not have good title, or alternatively if the possessor evidently has good title, then the claim is a moral one with the following form: because the claimant has a greater moral right to the property than the present individual or corporate owner, their claim should be enforceable through political channels or at international law. Such a claim might have several grounds, including remedying historical inequity, or that the overall utility will be greater in one place than another, or that there is a collective right to the property.

Over and above the economic benefit to the tourist industry of returning these sculptures to a new museum proximate to the Acropolis, the Parthenon/Elgin Marbles evidently represent an important political symbol for Greece.[44] The demand for restitution has continued for over quarter of a century, now to the fore, now muted. At two conferences in 2000, in Athens and Sydney, the case continued to be made that the sculptures were an inalienable part of Greek history and inherently belonged to Greece and the Greek people.[45]

John Moustakas has proposed that certain things – the Parthenon/Elgin Marbles being the case in point – manifest the *personality* of a group, separate as it were from property merely owned by it. To qualify, "property for grouphood" must bear "substantial earmarks of relatedness to the relevant group". It must be substantially bound up with group identity and its retention must not constitute "bad object relations" (fetishism).[46] He

Introduction, 11, where Merryman notes a general principle of property law that transactions which are legal at the time remain legal if the law subsequently changes; and also Merryman, 'Thinking about the Elgin Marbles', at 1900. There remains uncertainty about the Greek position, Culture Minister Antonis Samaras responding thus to comments made by a British Museum spokesperson that the institution would consider lending the marbles to the new Acropolis Museum for several months as long as the Greek government acknowledged the Museum's title: "Accepting it [the loan] would legalise the snatching of the Marbles"; *BBC News*, 12 June 2009, and Michael Kimmelman, 'Elgin Marble Argument in a New Light', *The New York Times*, 24 June 2009.

[44] In March 2004, the newly elected New Democracy government delayed work on the Acropolis Museum, designed by Bernard Tschumi and Michael Photiades, on the grounds that its construction was adversely affecting the archaeological record; the building opened in the summer of 2009.

[45] Daniel Shapiro, 'The Restitution of the Parthenon Marbles and the European Union: A Historical-Cultural-Legal Approach', (2000) 9 *International Journal of Cultural Property* 354–8; see also The Hon. E. G. Whitlam A.C., Q.C., *The Acropolis, The Parthenon, Elgin and the Marbles*, Seminar Papers (Sydney: Powerhouse Museum, 2000).

[46] John Moustakas, 'Group Rights in Cultural Property', (1989) 74 *Cornell Law Review* 1184.

has a strong sense of what Samuel Scheffler calls "perceived obligations deriving from inherited affiliations".[47] This is a sense that underlies much thinking about heritage. Moustakas predicates his argument on certain observations in Margaret Jane Radin's article 'Property and Personhood', in which wholly fungible (interchangeable) property is contrasted with the intensely personal.[48] A person, argues Radin, cannot fully be a person without a sense of continuity of self over time. To maintain that continuity one must have an ongoing relationship with the external environment (things and people). Certain objects are "closely bound up with personhood because they are part of the way we constitute ourselves as continuing personal entities in the world".[49] Whereas governments take fungible assets without compensation, as they do through taxation in order to generate higher overall welfare in which the individual can expect to share, for other losses at the personal end of the spectrum no compensation could be just. As Jeremy Waldron notes, this understanding of property and personhood carries an echo of Jeremy Bentham:

Every part of my property may have, in my estimation, besides its intrinsic value, a value of affection – as an inheritance from my ancestors, as the reward of my own labor, or as the future dependence of my children... Thus our property becomes a part of our being, and cannot be torn from us without rending us to the quick.[50]

Radin also remarks that "some fragmentary evidence suggests that *group* property rights, if connected with group autonomy or association, are given enhanced protection" by courts in the United States, and she notes the evolving stance of federal and state governments toward Native American claims.[51]

From Radin's cue, Moustakas argues that group personalities are substantial, the people as a whole having personality in like manner to an

[47] Samuel Scheffler, *Boundaries and Allegiances: Problems of Justice and Responsibility in Liberal Thought* (Oxford: Oxford University Press, 2001), 127–8.

[48] Margaret Jane Radin, 'Property and Personhood', (1982) 34 *Stanford Law Review* 957–1015, reprinted in Margaret Jane Radin, *Reinterpreting Property* (Chicago: The University of Chicago Press, 1993), 35–71.

[49] Ibid., 36, 64.

[50] From Jeremy Bentham, 'Security and Equality of Property', extracted from *Principles of the Civil Code*; see Jeremy Waldron, 'Property, Honesty, and Normative Resilience', in Stephen R. Munzer, ed., *New Essays in the Legal and Political Theory of Property* (Cambridge: Cambridge University Press, 2001), 27.

[51] Radin, *Reinterpreting Property*, 66–7, and note 132, where she cites the case of *Pillar of Fire v. Denver Urban Renewal Authority*, 181 Colo. 411, 509 P.2d 1250 (1973). The Colorado state court ruled that a condemnor could not take a parcel sacred to a religious sect unless it could show no adequate alternative.

individual. He takes the line that 'the people' are the proper claimant
to cultural things (as in 'the Greek people'), seeing art and artefacts as
a crucial link between group members and their ancestors and heirs,
comprising a relationship that satisfies a basic need for identity and also
symbolises shared values:

> The absence of works representing an "irreplaceable cultural heritage" is psy-
> chologically intolerable. Just as the destruction of the Statue of Liberty would
> diminish the bond between immigrants who shared the same first glimpse of the
> United States, or the toppling of Jerusalem's Wailing Wall would wound the
> spirit of world Jewry, Lord Elgin's removal of the Parthenon Marbles injures
> Greek groupness by having emasculated the greatest of all Greek art – the
> Parthenon. By destroying the Greeks' mana, the embodiment of their highest
> humanistic hopes and a measure of their existence, Lord Elgin harmed Greek
> grouphood by irreparably diminishing an integral part of the celebration of "being
> Greek".[52]

He is right – people would be very wounded by such acts, as they were
by the destruction of the Mostar Bridge during the Yugoslavian civil
war. There is a fear of disrespect towards such valuable properties, and
hence to the people for whom they are especially meaningful. But does
woundedness justify group rights? And who should represent the group?
In restitution claims it tends to be states, and yet, although states are as
much legal *personae* as natural persons, it is a major next step to regard a
cultural group, or a people, as having the character of a natural person by
either metaphor or analogy. *Guernica* and the Parthenon/Elgin Marbles
may both be seen as cases where nation is set against nation, or a people
against a people, but it is often the case that national representatives are
set against a private individual or corporation. When the Spanish govern-
ment was seeking the return of *Guernica* from the Museum of Modern
Art in New York, the case was further complicated by the intervention of
the Picasso estate (a legal person). Although the Parthenon/Elgin Marbles
case appears to be a government-to-government dispute, not least to
Greek supporters of restitution, it is as much between the Greek govern-
ment and the British Museum (a legal person), the Trustees of which are
constrained by an Act of Parliament that forbids deaccessioning except
where works are duplicates. While British ministers have the capacity to
put political and economic pressure on Trustees, the institution remains
at arms' length from government.

[52] Moustakas, 'Group Rights in Cultural Property', 1195–6.

4. The Lansdowne Portrait

To many advocates for their return to Greece, the Elgin Marbles have become an important symbol of the Greek contribution to political thought. In the United States another such symbol is the image of George Washington, who as general and then president of the world's first large-scale experiment in liberal democracy continues to appear widely on banknotes and other goods. Among the most renowned early images is Gilbert Stuart's 1796 full-length portrait of Washington, commissioned by Senator and Mrs. William Bingham for presentation to William Petty, first Marquess of Lansdowne (formerly Lord Shelburne).[53]

When America's newly founded National Portrait Gallery was approaching its opening in 1968, the primary version of Stuart's picture was hanging within Dalmeny House in West Lothian, Scotland, seat of Lord Primrose, son of the then-octogenarian sixth Earl of Rosebery. The Smithsonian approached the earl both about lending the painting and also the possibility of a sale to the NPG. They were turned down at first, but in response to a letter from Lord Mountbatten, with whom his father had served during the war, Primrose finally agreed to lend the Lansdowne Portrait to the new gallery, and the committee responsible for export licences awarded him a six-month temporary permit. In breach of its terms, however, the picture stayed on loan at the Smithsonian for over three decades.[54] Such was its significance to the NPG that in reflecting on what the Smithsonian should own, the Gallery's second director Marvin Sadik stated that

It is my considered opinion that the Lansdowne Washington is *the* American portrait, and would constitute an incomparable cornerstone for the collection of

[53] The circumstance of the commission is discussed by Ellen Miles in Carrie Rebora Barratt and Ellen G. Miles, *Gilbert Stuart* (New York: The Metropolitan Museum of Art and Yale University Press, 2004), 166.

[54] For more on the Reviewing Committee, see Chapter 5, section 1. In its Thirty-first Report (1985), the Committee made these remarks: "In general there have been very few problems with temporary exports. It is therefore with regret that we have to report the failure of a renewed attempt to obtain an undertaking from the Earl of Rosebery that the Gilbert Stuart portrait of George Washington will be returned to this country should he decide to sell it. The Earl of Rosebery was granted a temporary export licence for six months in 1969 to enable the painting to be exhibited at the Smithsonian Institute, Washington, where it has since remained on indefinite loan. We regard it as highly unsatisfactory that Lord Rosebery should persist in declining to give the required undertaking some sixteen years after the licence was granted". Cited in *Export of Works of Art 2000–2001, Forty-seventh Report of the Reviewing Committee appointed by the Chancellor of the Exchequer in December 1952* (London: HMSO, 2002), 8.

the National Portrait Gallery. I have no hesitation in saying that the picture is the one American portrait above all others this nation would most like to own.[55]

Sadik is referring to the primary version (Fig. 6). Two other versions that are indisputably by the hand of Stuart exist, in the collections of the Pennsylvania Academy of the Fine Arts and the Brooklyn Museum of Art. The Philadelphia version was commissioned by the Binghams for their own country house outside Philadelphia and bequeathed by William Bingham to the Pennsylvania Academy, where it was accessioned in 1811. The third, Brooklyn, version was ordered for his new house on Broadway, New York, by the Irish-born merchant William Constable, who had seen the Lansdowne Portrait in Stuart's Philadelphia studio while having his own picture painted. Another version has hung in the President's House since 1800, but Stuart denied authorship of it and its attribution has long been a subject of debate.[56]

Gilbert Stuart was one of the first major artists to emerge in the United States, and like other members of his generation he received much encouragement from Benjamin West, the Philadelphian who succeeded Sir Joshua Reynolds as president of the Royal Academy. Moving to London in 1775, Stuart stayed there until 1787 before travelling on to Ireland to escape debts he had accumulated, and then in 1794 returned to America, where he established a successful practice painting portraits of the newly independent American gentry and merchant classes. In England his mastery of portrait skills had earned him high praise, and he was seen as equal to any painter working in London, with the exception of Gainsborough and Reynolds himself (who died in 1792).[57] That he was commissioned in 1796 to paint the president's portrait for Lord Lansdowne was entirely natural.

After leading the government for little more than six months, Lansdowne had resigned as prime minister in February 1783 when his articles of peace with the American colonists were rejected. He then devoted himself to a range of causes, including the promotion of unfettered trade,

[55] Margaret C.S. Christman, 'The Story of the Lansdowne *Washington*', in Richard Brookhiser, Margaret C.S. Christman and Ellen G. Miles, *George Washington: A National Treasure* (Washington, D.C.: Smithsonian Institution, 2002), 72.

[56] Whether the fourth version in the White House is by the hand of Stuart or not, Christman observes that the Lansdowne image of Washington is nonetheless "a fixture in the nation's patrimony". See also Bonnie Barrett Stretch, 'If Stuart Didn't Paint It, Who Did?' (2004) 103 *ARTnews* (October), 162–3.

[57] By the time Stuart arrived in London, the major contemporary British portraitist Sir Allan Ramsay had reduced his activity mostly to reproducing his coronation portraits of George III and Queen Charlotte.

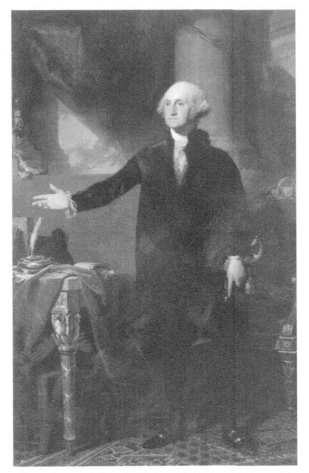

FIGURE 6. *Gilbert Stuart (1755–1828)*, George Washington *(the Lansdowne Portrait), 1796, oil on canvas, 247.7 × 158.8 cm. Courtesy of the National Portrait Gallery, Smithsonian Institution, Washington D.C. Acquired as a gift to the nation through the generosity of the Donald W. Reynolds Foundation (NPG.2001.13).* The Lansdowne Portrait was probably commissioned to commemorate the restoration of Anglo-American trading relationships in 1795.

in which William Bingham had a serious financial interest.[58] As Ellen Miles suggests, it seems likely that the Lansdowne Portrait commemorates the signing of the Anglo-American Jay treaty 'of Amity, Commerce

[58] William Bingham had been agent for the Continental Congress at the French-controlled island of Martinique, at which time he had created considerable personal wealth through shipping, banking and land speculation; the couple lived in London during 1783–6, and continued to correspond with Lansdowne when back in Philadelphia. The Jay Treaty allowed Bingham to sell land he owned in Maine to the Baring banking family in 1796.

and Navigation' which Washington drove through the Senate by a slim margin in June 1795 in the face of Republicans determined to promote continuing accord with France. That the portrait refers to Washington's seventh annual message to Congress in December that year is supported by the following comment in a London newspaper article of 1797: "The figure is standing and addressing the Hall of Assembly. The point of time is that when he recommended inviolable union between America and Great Britain".[59]

Anne Willing Bingham's successful persuasion of Washington to sit for Stuart served a spectacular act of courtship: delivering to the Whig grandee an image of "the greatest man living" (his words), to hang in his splendid Robert Adam town house alongside paintings by Reynolds, by the American artist recognised as his near rival in the field. This practice of giving paintings as tribute was undertaken by Lansdowne himself, who'd commissioned Gainsborough to paint his portrait in 1787 for Louis XVI of France.[60]

Although probably drawing principally on an engraving of Hyacinthe Rigaud's portrait of Bishop Jacques-Benigne Bossuet, the manner in which Stuart presents Washington as a republican statesman perhaps also echoes a more recent political image: of William Pitt the Elder, Earl of Chatham, depicted as a Roman consul in 1768 by the Philadelphian Charles Willson Peale during his tutelage in London under the neo-classicist West (Figs. 7, 8). Peale's depiction of the man who repealed the Stamp Act seems a striking, if crude, precursor to Stuart's elegant Washington, which made the record price for a contemporary painting when it was sold the year after Lansdowne's death in 1805 (£540).[61] In 1889 the picture was acquired

See Christman, 'The Story of the Lansdowne *Washington*', 50–53, and Barratt and Miles, *Gilbert Stuart*, 170–3.

[59] Ibid., 172.

[60] See William Thomas Whitley, *Thomas Gainsborough* (London: Smith, Elder & Co., 1915), 272. Lansdowne House was partly dismantled around 1930 and its dining and drawing rooms reinstalled, respectively, at the Metropolitan and Philadelphia museums (the latter room perhaps where the Lansdowne Portrait originally hung).

[61] The Peale painting was commissioned by Richard Lee and other Virginia planters, and is now in the Westmoreland County Museum, Montross, Virginia; see Robert Hughes, *American Visions: The Epic History of Art in America* (New York: Harvill, 1997), 95. Like the Stuart portrait it ultimately references the Apollo Belvedere, as does David Allen's similarly posed portrait of Sir William Hamilton (1775) in the collection of the National Portrait Gallery, London. The 1723 engraving after Rigaud is identified by Dorinda Evans and Charles Henry Hart as a likely source for the Lansdowne Portrait; see Dorinda Evans, *The Genius of Gilbert Stuart* (Princeton: Princeton University Press, 1999), reproduced in Brookhiser, Christman and Miles, *George Washington*, 87. The

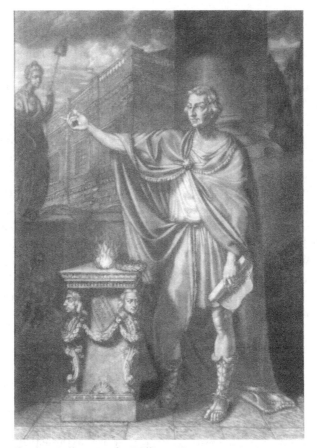

FIGURE 7. *Charles Willson Peale*, William Pitt, *ca. 1768, mezzotint and engraving, 21.7 × 14.8 cm.; Courtesy of the Pennsylvania Academy of the Fine Arts, Philadelphia, John S. Phillips Collection.* Pitt the Elder, first Earl of Chatham, was admired by American colonists for his opposition to the Stamp Act of 1765. In showing Pitt as an orator, Peale foreshadows Stuart's Lansdowne image of Washington.

by the fifth Earl of Rosebery, inheritor of the Rothschild collections at Mentmore through his marriage to Hannah, only child of Baron Meyer de Rothschild. A century later, in 1992, the seventh earl (formerly Lord

Lansdowne Portrait passed first to the Massachusetts-born banker Samuel Williams, who lived in Finsbury Square, London, then to the Lewis family. It was reported that, prior to 1836, an approach had been made to Congress for the portrait to be purchased for the nation (for about "seven or eight hundred guineas"), but the proposal was rejected.

Primrose) passed title to his son Lord Dalmeny, who informed the NPG in October 2000 that he intended to sell it.

Now while America has many import and export controls, it has yet to implement one that constrains the flow of art on the grounds of national interest, and it is unaccustomed to rhetoric over the loss of national treasures. It looked, however, as if this portrait "above all others" might elude the national collection. The NPG was given first option to purchase, with a six-month deadline that extended to 1st April, after which, if the Gallery had failed to come up with the purchase price of $20 million, the Lansdowne Portrait would be placed on the open market. NPG Director Marc Pachter recalled that, although the presence of the Stuart painting had come to be taken for granted, in fact the Smithsonian had attempted to purchase it over the years. Private appeals in late 2000 and early 2001 failed to produce the necessary funding, and so Pachter went to the nation on Washington's birthday, four months after the clock had started, to alert people to the potential loss of a national treasure: "This is not the universe of art collectors but the universe of patriots. There are many patriots who are not associated with museums". In 2001 the Donald W. Reynolds Foundation became the nation's benefactor, in particular the chairman Fred Smith, who, in Pachter's words, "brought this wonderful resolution to a patriotic emergency", encouraging his fellow trustees "to give back to the American people". Smith recalled their decision thus:

We felt, as I am sure every American did, that it would be tragedy to lose this original portrait of our founding father . . . Our benefactor, Donald W. Reynolds, believed that every American owed a debt of gratitude to those that came before us. He also felt that we have an obligation to keep the symbols of our country's principles for those in the future.[62]

The Reynolds Foundation–funded exhibition of the Stuart portrait and related works that the NPG sent around the country was entitled *George Washington: A National Treasure*, which in its ambiguity neatly captured the interrelationship between painting and subject. Washington as the father of the country, Stuart's Lansdowne image and the primary version of that image were all national treasures. In phrases that are redolent of Edmund Burke, principal progenitor in the English-speaking world of much cultural heritage language, Marc Pachter summed up the larger significance of the portrait for American citizens: "With the display of this portrait, we celebrate Washington's role in history, of course, but

[62] Ibid., 74.

FIGURE 8. *Benjamin West*, The Regret of Caesar While Reading the Life History of Alexander's Exploits, *1769, oil on canvas, 94 × 99.5 cm. Courtesy of the Virginia Museum of Fine Arts, Richmond. © The Adolph D. and Wilkins C. Williams Fund.* The neo-classicist West encouraged other expatriate and visiting Americans, including Peale and Stuart, and strongly supported the British Museum's acquisition of the Parthenon/Elgin Marbles.

more than that, his effect on our own lives today, on the nation, and on the system we have all inherited. It is a precious legacy. And none of it must ever be taken for granted".[63]

Thinking over this case, a seasoned observer of the art world might surmise that even if the Lansdowne Portrait had been offered at auction, it may well have stayed in the United States. In the previous two decades Japanese collectors had been enthusiastic buyers of Western painting, but in 2000 and 2001 their economy was depressed and there was a paucity of major Japanese collectors in the market. It was also rare for Europeans

[63] Ibid., 9.

to pay so much for a painting, especially by a painter whose market was essentially in the United States. Given that it was commissioned for a house in London and remained in England or Scotland for close to two centuries, there might, however, have been a call for the portrait to be returned as a part of the British heritage.[64]

The danger to the NPG was two-fold: of the portrait departing the government's official portrait collection for a wealthier museum or private collector, and of it leaving the country. For Americans concerned about patrimony the principal danger was surely the latter. But what *was* unusual for Americans was this call to arms over a potential loss and the strong use of heritage language, which suggests that the perceived danger was exile of the painting overseas. Did the great portrait of Washington need to stay in Washington D.C., embedded in the national collection, and how important was the integrity of that collection as a collection? Could it be in another city or even in a private collection within the nation's boundaries? What if this celebrated picture was in Chicago at the Art Institute, as the two other versions definitively by Stuart are in Philadelphia and Brooklyn within public collections? I interpret Sadik's comment – that this was a crucial image for the national collection – to mean that, as the primary version, it had an even greater historical significance for America than the second and third versions. Yet, the historical significance of the painting wouldn't change in Chicago or Los Angeles. Indeed, if we were seeking to calculate the overall utility for all Americans, then the concentration of the three versions within a 250-mile radius on the East Coast surely makes this utility less than if they were more widely distributed. Its tour of the country compensated for that, even if on a temporary basis.

[64] In 2000–2001, the Reviewing Committee commented on the "good, if sad" capacity of the export regulations to evolve "as a result of the reported decision of Lord Dalmeny to sell probably the greatest portrait of George Washington to the Smithsonian Institute...We can only reiterate our regret that the seventh Earl of Rosebery did not comply with the terms of the original temporary export licence. Whilst we have been advised that there are no legal proceedings that can be taken at this juncture, we are glad to record that, as a result of changes in the law, if similar action was taken today, criminal charges could be preferred against those involved...We would add that the vendor, Lord Dalmeny, has informed the Minister of State that he had no knowledge of the past history relating to the temporary export of the portrait and had acted in good faith. He apologised for any embarrassment inadvertently caused. The Minister, rightly in our view, has accepted his explanation and apology". *Export of Works of Art 2000–2001, Forty-seventh Report of the Reviewing Committee*, 8–9, and *A Review of the Current System of Controls on the Export of Works of Art* (London: HMSO, 1991), 56.

Certainly people in Washington might view its loss from a utilitarian perspective, claiming that the arts of Washington were thereby diminished, but calculating such utilities is difficult at best. Can the city be seen as a distinct culture with unique social practices? Only in political satire. Although its status as a region with local conventions cannot be doubted, Washington hardly represents a different culture within America. So, if the painting had been transferred to another American public collection, its value to citizens would be maintained, as would that of public collections in general. What about the possibility of ownership by a private collector? America has the strongest regime of natural property rights, which allows individuals greater license than almost anywhere else to do what they will with privately owned, culturally valuable things, including buildings. Millions of visitors have access to the picture in a public collection which they wouldn't if it was held in a private house. But is a private house in America preferable to a public collection overseas, for example, the National Galleries of England and Scotland, both countries in which the picture had hung? Former NEA Chairman John Frohnmayer signalled that these are relatively new questions for Americans. In 1991 he described a recent public auction at which a Delaware businessman had bought a contemporaneous copy of the Declaration of Independence. Noting that the buyer could have been from overseas, he asked that if the original document had turned up at auction "would we be distressed by that?"[65] Going by the case of the Lansdowne Portrait, the answer is clearly "yes".

Cultural symbolism derives from relationships between people, values, practices, places, events, memories, records, stories and objects; consequently, particular objects may have symbolic but not much monetary value, as I noted above with respect to Jewish artefacts discovered prior to the fiftieth anniversary of Kristallnacht. Without any notable historical context, a mid-eighteenth-century English bronze bell would command relatively little on the market, even with the hortatory inscription "proclaim liberty throughout all the land". But if the Liberty Bell itself came to auction, institutional and private bidders would compete vigorously for this principal symbol of democratic freedoms. From the cases discussed above it is evident that certain important works of art and architecture are symbolically valuable to nations; or, as Rawls puts it, to peoples. *Guernica*, the Parthenon/Elgin Marbles and the Lansdowne Portrait have

[65] David McKean, *Should the United States Protect Cultural Resources?* (Washington, D.C.: Annenberg Washington Program, 1992), 13.

all come to symbolise democracy and liberty to the Spanish, Greek and American peoples, respectively. They may also symbolise them for other peoples. Beyond that, they have histories which connect them to Spain, Greece and America, and in the latter two cases also to Britain. Certainly there are countless objects and buildings that relate to specific cultures, but the focus at present is on important ones – those that stand out as exceptionally valuable. The important question to address, then, will be whether there is justification or not for moral claims to such symbols.

"Two Ways of Thinking"

In science of every kind, men should consider themselves as citizens of the world.

Benjamin Rush[1]

Distrust those cosmopolitans who, in their books, seek to find far away those duties which they disdain to fulfil around them. A philosopher loves the Tartars in order to be excused from loving his neighbour.

Jean-Jacques Rousseau[2]

1. Heritage and International Conventions

I want to focus now on the work of John Merryman, whose articles over the past two decades have helped shape a significant part of the cultural landscape where art and law meet. In 'Two Ways of Thinking about Cultural Property', Merryman promotes a strong cosmopolitan position with regard to cultural nationalism, seeing the widespread recent legislative emphasis on local cultural heritages as having little virtue; and, where they do have virtue, Merryman suggests they do so only in respect to certain religious objects and human remains.[3] He therefore contests the

[1] To Richard Price. See Thomas J. Schlereth, *The Cosmopolitan Ideal in Enlightenment Thought: Its Form and Function in the Ideas of Franklin, Hume, and Voltaire, 1694–1790* (Notre Dame: University of Notre Dame, 1977), 26.

[2] *Emile, or on Education* (1762), 1:249/39, cited in Timothy O'Hagan, *Rousseau* (London: Routledge, 1999), 160.

[3] John Henry Merryman, 'Two Ways of Thinking about Cultural Property', (1986) 80 *American Journal of International Law* 831–53; see also those articles cited in Chapter 1, notes 37, 42 and 43, and note 5 below.

primacy of heritage over the ambassadorial role of objects, and seeks a
relatively free trade in art and artefacts. From the tragic example of the
Bamiyan Buddhas alone it is evident not only that objects and buildings
may cease to be valued in their place of origin, but also that they may be
greatly valued by people who live elsewhere.

Merryman's recurring contention is that the wording of two interna-
tional Conventions drafted by UNESCO captures these broadly different
approaches: the 1954 Hague Convention (for the Protection of Cultural
Property in the Event of Armed Conflict), and the 1970 Convention (on
the Means of Prohibiting and Preventing the Illicit Import, Export and
Transfer of Ownership of Cultural Property). Merryman sees the Pre-
amble to the 1954 Convention as embodying a nobility of purpose while
also serving as a charter for internationalism:

Being convinced that damage to cultural property belonging to any people what-
soever means damage to the cultural heritage of all mankind, since each people
makes its contribution to the culture of the world;

Considering that the preservation of the cultural heritage is of great importance
for all peoples of the world and that it is important that this heritage should
receive international protection.[4]

The key phrases are "cultural heritage of all mankind", "culture of the
world" and "the cultural heritage". In Merryman's opinion, the 1954
Hague Convention exerts an influence that extends beyond the obliga-
tions imposed on and accepted by its parties. It is a piece of legislation
that exemplifies "cultural internationalism" and expresses the cosmo-
politan notion of a general interest in cultural property apart from any
national interest. Cosmopolitanism encourages the sharing of cultural
objects beyond the source country and the exhibition of achievements
of earlier cultures to a wider audience. Cultural particularism, however,
militates against this: "the international agencies that might be expected
to represent the more cosmopolitan, less purely nationalist, view...are
instead dominated by nations dedicated to the retention and repatriation
of cultural property". He sees this second, particularist way articulated

4 The Convention grew from the nineteenth-century Lieber Code, devised for the behaviour
 of military forces in a theatre of war. It demanded that classical works of art, libraries
 and scientific collections be secured against all avoidable injury but also allowed them
 to be removed by the conquering state; in no case might they be privately appropriated.
 Instructions for the Governance of Armies of the United States in the Field, issued by the
 Union command as General Orders No. 100, 24 April 1863; see Richard Shelley Hartigan,
 Lieber's Code and the Law of War (Chicago: Precedent, 1983); also Merryman, 'Two
 Ways of Thinking about Cultural Property', 833–5.

in the following proposition (one of eight) from the Preamble to the 1970 UNESCO Convention:

Considering that cultural property constitutes one of the basic elements of civilization and national culture, and that its true value can be appreciated only in relation to the fullest possible information regarding its origin, history and traditional setting.

Merryman argues that Byron is culpable for the romantic nationalism which colours cultural property and heritage debate. So, though respecting the seriousness of Moustakas's approach to the Parthenon/Elgin Marbles, Merryman regards it "at bottom" as "Byronism all over again".[5] As Merryman frames it, the particularist way of thinking foregrounds national cultural heritages, the world dividing into source and market nations, where source nations are often Second or Third World and market nations First. The concern then is about net outward flows of cultural property from economically disadvantaged countries which in earlier centuries were frequently targets of colonial exploitation. Out of economic and historical imbalance comes a package of worries: about stopping the covert and damaging leakage of archaeological material (always subsequently unprovenanced), about building a sense of national achievement and about redressing the wrongs of the past.

The desirability of contextualisation applies, Merryman suggests, only to a small though important proportion of the total trade in stolen and illegally exported cultural objects. Such an intense focus on the primacy of context for everything encourages retentionist thinking (disguised as a concern to 'protect') that does a disservice to the potential of cultural artefacts to act as ambassadors. Nor does it necessarily restrict illicit traffic – it determines merely the form and the routes followed.[6] Congruent with

[5] For Byron, who together with Schiller and Keats had a profound admiration for classical Greece, the removal of the Parthenon sculptures by Elgin symbolised the plight of the Greek nation; he excoriated Elgin, who had never felt the "sacred glow" reserved for those with "polish'd breasts". Charles Taylor suggests that what the *Stürmer und Dränger* saw in the early Greeks was less a pre-modem consciousness and more what they themselves sought: unity with self and communion with nature; see Charles Taylor, *Hegel* (Cambridge: Cambridge University Press, 1975), 26–7. For the remark on Moustakas, see John Henry Merryman, 'Note on the Elgin Marbles', in his *Thinking About the Elgin Marbles: Critical Essays on Cultural Property, Art and Law* (Alphen aan den Rijn: Kluwer Law International, second edition, 2009), 22.

[6] This latter point is contested by Peter Cannon-Brookes, who sees U.S. ratification of the 1970 UNESCO Convention as having had a very marked impact on the trade, especially with respect to Central American antiquities; see Peter Cannon-Brookes 'The Movement, Location and Tracing of Cultural Property', (1992) 11 *Museum Management and Curatorship* 3–18.

this shift towards 'retentionism' are moves made to repatriate cultural objects to nations of origin, with the assumption that numbers of works presently abroad in museums and collections are wrongfully there. He argues, however, that

It is not self-evident that something made in a place belongs there, or that something produced by artists of an earlier time ought to remain in or be returned to the territory occupied by their cultural descendants, or that the present government of a nation should have power over artifacts historically associated with its people or territory.[7]

He suggests that concerns about the 'loss' of objects with such symbolic value are overstated, since the majority of them are already publicly held.[8] He also believes that archaeologists, ethnographers and art historians lean toward particularism, because they emphasise cultural context and appear to require that all objects imported into market nations should be accompanied by export permits from the countries of origin.[9] Allowing the validity of both ways of thinking, he nonetheless wants to see the cosmopolitan position take priority when there is a conflict. Sharon Williams also finds this way of thinking admirable:

From a doctrinal point of view, the newly emerging concept in international law of the "common heritage of mankind" provides a good foundation for the panoply of measures to be taken by states individually or collectively in order to protect the cultural heritage of mankind . . . This concept . . . could also justify the establishment of a concrete *international* cultural heritage, a new sort of property, owned by the international community as such, administered by an international agency.[10]

Jean Musitelli has suggested that the 1972 UNESCO Convention Concerning the Protection of the World Cultural and Natural Heritage helped

[7] John Henry Merryman, 'Thinking about the Elgin Marbles', (1985) 83 *Michigan Law Review* 1912. He suggests that the final wording of the UNIDROIT Convention reflects "bare retentionism", 'The UNIDROIT Convention: Three Significant Departures from the *Urtext*', (1996) 5 *International Journal of Cultural Property* 17.

[8] John Henry Merryman, 'Cultural Property Ethics', (1998) 7 *International Journal of Cultural Property* 28, and John Henry Merryman, 'The Nation and the Object', (1994) 3 *International Journal of Cultural Property* 70.

[9] Ibid., 31, and John Henry Merryman, 'A Licit International Trade in Cultural Objects', (1995) 4 *International Journal of Cultural Property* 32–8.

[10] Sharon A. Williams, *The International and National Protection of Movable Cultural Property: A Comparative Study* (Dobbs Ferry, N.Y.: Oceana Publications, 1978), 201–2.

form the concept of world heritage. Certainly I think it has been important in spreading the idea, but the construction itself derives from a variety of earlier sources that I shall explore below.[11]

In 'The Nation and the Object' Merryman argues that because people care deeply about cultural things for a variety of natural and laudable reasons, an object-centred public policy towards them is both desirable and unavoidable, the general goals of which should be preservation, truth and access.[12] If there is a conflict between preservation and access, preservation will take priority; if between truth and access, truth trumps access:

In an object-oriented cultural property policy, the emphasis is on three conceptually separate but, in practice, interdependent considerations: preservation, truth and access, in declining order of importance. The most basic is preservation: protecting the object and its context from impairment. Next comes the quest for knowledge, for valid information about the human past, for the historical, scientific, cultural and aesthetic truth that the object and its context can provide. Finally, we want the object to be optimally accessible to scholars (for study) and to the public (for education and enjoyment).[13]

As he puts it elsewhere, the essential ingredient of any cultural property policy is, firstly, that things themselves be physically preserved: "if we don't care about its preservation, it isn't, for us, a cultural object".[14]

However, I think we need to be careful about the difference between instrumental and intrinsic values. Merryman's policy is led by instrumentalism, where preservation and access serve other intrinsic goods, and 'truth' can be either instrumentally valuable (providing information that assists preservation) or intrinsically valuable (relating to Finnis's 'knowledge'). But if these are instrumental values, then the highest value – preservation – is still only serving intrinsic goods, including knowledge, aesthetic experience and religion, the three with which we are most concerned with respect to heritage objects. I should state the obvious here, that if the object is destroyed (other than as part of shared ritual practice), then no intrinsic goods are served, and to the extent that objects are in

[11] Jean Musitelli, 'World Heritage, between Universalism and Globalization', (2002) 11 *International Journal of Cultural Property* 324.

[12] Merryman, 'The Nation and the Object', 64–5.

[13] Ibid. In prioritising preservation, Merryman concurs with Paul Bator: "The preservation of art constitutes our fundamental value" (Paul Bator, *The International Trade in Art* [Chicago: University of Chicago Press, 1983], 19–20).

[14] John Henry Merryman, 'The Public Interest in Cultural Property', (1989) 77 *California Law Review* 355.

intermittent or continuing danger, it certainly make sense to prioritise preservation. But even if preservation trumps knowledge as an instrumental good, it can't trump it as an intrinsic good (which Finnis argues can be done only subjectively, not objectively). That leaves much room for individuals to prioritise the relative importance of knowledge, aesthetic experience and religion, whether for themselves, or as part of groups or institutions. Merryman might counter that such value relativism gives the Taliban and others of a like iconoclastic disposition (e.g., Puritans in Reformation England, anti-Buddhist factions at the Tang Chinese court) the licence to destroy anything they regard as contravening their own religious beliefs and practices. I return to this problem in Chapter 5, drawing on Joseph Raz's thoughts about value and respect.

If interested individuals were asked to rank values, it is probable that collectors would often place aesthetic value above the value of knowledge, whereas archaeologists, appropriately concerned about illicit excavation, are likely to put the value of knowledge higher. There are two ways of understanding this: as a personal ranking, where individuals consider one or more basic values to be more important to them than others; or as an instrumental ranking, where in order to achieve a particular purpose (such as preserving objects from destruction), one believes that it is more useful to give precedence, for example, to knowledge over aesthetic experience.

In *The Return of Cultural Treasures* Jeanette Greenfield takes an opposite approach to Merryman. She also identifies conservation as a key and ongoing concern, alongside illicit trading (a contemporary issue) and the physical return of cultural property (which may be associated with illicit trading but is also an historic issue).[15] Her particularist focus is on equity, to see justice done in cases where cultural things have been taken by force, unequal treaty, theft or deceit. Since property is the subject of ownership, cultural property must belong to someone. The 'common heritage of mankind' therefore has less weight in the context of returns. But there needs to be a set of constraints defining the sorts of things that might properly be considered for return, achieved through a 'narrow frame of reference' that sifts out what are truly cultural treasures, such as exceptional or unique landmark objects.[16] At the heart of her book is a conviction that a great unfairness is involved in the alienation of objects

[15] Jeanette Greenfield, *The Return of Cultural Treasures* (Cambridge: Cambridge University Press, 1989) 254-5.

[16] Ibid. Greenfield wishes to see accepted at international law the premise that title is deemed not to have passed for three other classes of properties: (i) historic records or manuscripts of a nation, including the narrative representation of its history in an art

with a profound meaning for specific groups of people, often under conditions of war or colonial occupation, which should be remedied through the instruments of law. More occupied by the historic than the contemporary, which she feels is adequately covered by widespread national and international legislation, Greenfield puts much emphasis on the force of moral claims. Since the return of cultural treasures and cultural identity are tightly bound together, however, problems of settling the 'country of origin' follow. These recede, she argues, when cases are evaluated individually with due regard to the people for whom the object was made, by whom, for what purpose and place and the manner of subsequent acquisition.

In September 1983, a month before the request for restitution of the Parthenon/Elgin Marbles was made at governmental level, the Parliamentary Assembly of the Council of Europe called "on governments of Member States to recognise that the European cultural heritage belongs to all Europeans and to ensure that the diversity of this heritage remains easily accessible in each country". Greenfield responds thus: "This argument [the Council's] also ignores the additional factor of geography, since objects may sometimes belong not so much *to* a people as *within* a particular landscape".[17] More simply, the Council put commonality before national difference:

The marbles are part of an Athenian ancient monument, and the Greek people are the indigenous descendants and inheritors of the Athenian republic. The link between Greek civilization, Athens and the marbles appears to be inexorable, and does not even bear comparison with any possible link that Britain may have with pieces of classical Greek sculpture, transported thousands of miles from their home.[18]

Merryman counterbalances this with a British claim:

They help define the British to themselves, inspire British arts, give Britons identity and community, civilize and enrich British life, stimulate British scholarship. While one may argue that in these terms the Greek claim is more (or less) powerful than that of the British, it is not unreasonable to perceive the two positions as roughly equivalent.[19]

Other authors have sought a parallel with debates about the environment. In 1992, Lyndel Prott and Patrick O'Keefe argued that the term 'cultural

form which has been dismembered; (ii) objects torn from immovable property forming part of the sovereign territory of the State whence they were taken; and (iii) human relics.

[17] Ibid., 79–83. See also above, Chapter 1, note 43.

[18] Ibid.

[19] Merryman, 'Who Owns the Elgin Marbles', (1986) 85 *ARTnews* (September) 107.

property' should be superseded by 'cultural heritage', not only the larger intellectual concept, but more generous and less restrictive in scope.[20] Prott called for a new category of law, 'cultural heritage law', to parallel environmental law:

> Many issues are common to both of them. The deep concern with pollution, is an example: degradation of archaeological sites by industrial activities, and the rapid deterioration of monuments (marble disease is a particularly current concern). Another issue in common is the need to achieve a proper balance between public use and preservation and a proper consideration of heritage values in urban and other planning.[21]

For most of us, no conflict is involved in wanting to preserve a species of koala, an attractive animal. We feel that by so doing we are contributing to the common good of mankind. On the other hand, there may well be conflicts between protectors of rainforests and tree-dependent industries. Karen Warren has similarly proposed a 'non-renewable resource' argument that sees cultural properties as if they were environmentally endangered species, non-renewable and not anyone's property, so that our relationship to them is that of steward, custodian, guardian, conservator or trustee, and their protection and preservation is the collective responsibility of all of us. We should speak of endangered cultural heritages, endangered cultural pasts or endangered cultures. Like Merryman, Warren emphasises preservation as cardinal, and also mutual stewardship of the past (although their understanding of how to achieve this differs). Like Greenfield, she favours the restitution of legitimate 'cultural heritage' to countries of origin.[22] Yet works of art and cultural practices are neither trees nor koalas, and Martin Hollis makes a good argument that human social life and the laws of nature require different approaches.[23]

While there are those who would protect cultural practices because they are like endangered species, others are glad to see certain 'oppressive'

[20] Lyndel V. Prott and Patrick J. O'Keefe, '"Cultural Heritage" or "Cultural Property"?' (1992) 1 *International Journal of Cultural Property* 311.

[21] Lyndel V. Prott, 'Problems of Private International Law for the Protection of the Cultural Heritage', (1989) 217 *Recueil des Cours de l'Académie de la Haye* 310.

[22] She underscores the diversity of values and perspectives, and the importance of non-litigious compromise and consensus models for resolving disputes. Karen J. Warren, 'A Philosophical Perspective on the Ethics and Resolution of Cultural Property Issues', in Phyllis Mauch Messenger, ed., *The Ethics of Collecting Cultural Property: Whose Culture? Whose Property?* (Albuquerque: University of New Mexico Press, 1989), 1–26.

[23] See, for example, Martin Hollis, *The Cunning of Reason* (Cambridge: Cambridge University Press, 1987); see also below, Chapter 4, Section 2.

practices disappear. And, as Michael Brown notes, attempts to preserve and control tribal cultures can lead to unintended consequences, which sometimes happens in the wake of well-meaning legislation. He cites as an example the 1997 United Nations report *Protection of the Heritage of Indigenous People*, also known as the Daes Report; its authors accepted the idea of cultural integrity and proposed the concept of 'Total Heritage Protection', wherein a society is deemed to own its heritage: "everything that belongs to the distinct identity of a people and which is theirs to share, if they wish, with other peoples".[24]

There is another way of understanding this debate over the use and control of valuable resources, which is to see it in terms of disagreements between libertarians, liberals and communitarians. The three 'camps' are not themselves homogenous – for example, there are liberal cosmopolitans and also liberals who see individuals as more socially dependent; and 'left' and 'right' communitarians. I return to this alternative landscape in Chapters 3 and 6, but for the moment I want to remain with Merryman's framework since his voice is so influential in the literature.

To see the debate as Merryman does, between cosmopolites and particularists, continues a late eighteenth-century contest to which I now want to turn. In practice, however, the 'two ways' have often lodged together. So within the Preamble to the 1972 UNESCO Convention we find the phrases "world heritage of mankind as a whole", "heritage of all the nations of the world" and "world's heritage" accompanying the observation that "this unique and irreplaceable property" nonetheless belongs to specific people ("to whatever people it may belong").[25]

2. Cosmopolitanism and Particularism

Generally speaking, Enlightenment cosmopolites not only regarded the notion of national cultures with disdain but actively condemned the idea that local communities or nations might have a prior claim on individual actions and loyalties. To the cosmopolitan mind, the belief that nations and local cultures have value to their members over and above a universal community of citizens was simply unsustainable. The Marquis de Concordet saw the cosmopolitan position as a natural concomitant of the individual's freedom from received roles and identities. The more

[24] See Michael F. Brown, *Who Owns Native Culture?* (Cambridge, MA: Harvard University Press, 2003), 209–18.
[25] Seventeenth Session of the General Conference of UNESCO (Paris, 1972).

someone asserted their individual autonomy to choose the rational life they wished to lead, the more they would gravitate to a cosmopolitan sensibility. Eventually they would seek to participate in a universal language, an ideal Concordet shared with Descartes, Leibniz, Franklin and Voltaire.[26]

From the seventeenth century onwards, a cosmopolitan mindset was encouraged by the emerging commitment to experimental knowledge coupled with ever-greater opportunities for international trade. Many Enlightenment *philosophes* belonged to scientific societies in other countries, contributing ideas in mechanics, biology, natural history, geography, geology and anthropology. Collecting was a means of grasping the world and simultaneously measuring and ordering it. It gave rise to a new type of institution – the public museum – first formed in the late seventeenth century around the Tradescant collection in Oxford, in which curators and visitors alike shared the experience of rationally ordered access to and control of the myriad aspects of a comprehensible world.[27] One reason given by cosmopolitans for keeping the Parthenon/ Elgin Marbles in the British Museum is that they contribute more to learning by being proximate to major artistic achievements from other cultures. The counterargument to Moustakas made by officers of the British Museum and others, including James Cuno and John Boardman, is that aesthetic experience and knowledge are furthest advanced by bringing to one location the 'best' of cultures.[28] Boardman reminds us that "the fact that museums worldwide can be and are centers for education, at all levels for all ages, depends on the dissemination of works of art far from their homelands".[29]

The Enlightenment promotion of knowledge as both instrumentally and intrinsically valuable continues strongly to inform attitudes within the museum community. On 8th December 2001, a group of museum

[26] See Will Kymlicka, *Politics in the Vernacular: Nationalism, Multiculturalism, and Citizenship* (Oxford: Oxford University Press, 2001), 203–5.
[27] See Eilean Hooper-Greenhill, *Museums and the Shaping of Knowledge* (London: Routledge, 1992), Chapter 7; Charles Taylor, *Sources of the Self: The Making of the Modern Identity* (Cambridge: Cambridge University Press, 1989), Chapters 8 and 9.
[28] See James Cuno, ed., *Whose Culture? The Promise of Museums and the Debate over Antiquities* (Princeton: Princeton University Press, 2009), 1–35; James Cuno, *Who Owns Antiquity? Museums and the Battle over Our Ancient Heritage* (Princeton: Princeton University Press, 2008); and John Boardman, 'The Elgin Marbles: Matters of Fact and Opinion', (2000) 9 *International Journal of Cultural Property* 233–62.
[29] Ibid.

directors responsible for such major, diverse collections issued a *Declaration on the importance and value of universal museums*, within which it was remarked that

Although each case has to be judged individually, we should acknowledge that museums serve not just the citizens of one nation but the people of every nation. Museums are agents in the development of culture, whose mission is to foster knowledge by a continuous process of reinterpretation. Each object contributes to that process. To narrow the focus of museums whose collections are diverse and multifaceted would therefore be a disservice to all visitors.[30]

That is an extremely important point to make. Under slightly different circumstances, however, the Parthenon/Elgin Marbles might have been housed not in a universal institution but in a dedicated private museum in Mayfair, a mile or two from the British Museum.[31] Or, hypothetically, they might have gone to the Royal Academy, an institution then under the presidency of Benjamin West, a leading proponent of the Marbles' purchase by the government for the British Museum. Though possessing a fine collection of British art and Michelangelo's marble tondo of the Virgin and Child, the Academy can hardly be called encyclopedic. Returning the Marbles to Athens is surely as much about their departure from London as from the British Museum. So there might be a 'metropolitan' argument that underlines the benefits which accrue when major cities support a broad range of cultural institutions, including encyclopedic museums. Many large cities have developed as cultural *loci*, and the metropolis represents a further layer within the debate. Hence another way of looking at the collections of the British Museum (or the Smithsonian Institution) is to see them embedded within the diverse cultural life of London and Washington.

[30] *The Art Newspaper* (January 2003). In Cuno, *Whose Culture?*, 165–82, where the first chapter of the present work is included in shortened form, the editor ascribes to me the following question (at 177): justification for moral claims to culturally valuable and symbolic objects comes at what expense to the encyclopedic museum? This is an important question, because the consequences of restitution requests for such museums should indeed be considered, and one with which Cuno has been occupied and to which he himself gives an answer (as did Stephen Weil, cited below in Chapter 4, note 15), but not one actually posed in Chapter 1. My principal concern has been to understand the cosmopolitan-particularist debate in general, and to come to a position on the justification or otherwise for moral claims made on particularist grounds.

[31] The scheme was found to be impracticable because the museum would probably had to have been pulled down at the end of the lease. See William St. Clair, *Lord Elgin and the Marbles* (Oxford: Oxford University Press, revised ed. 1983), 180–1.

Merryman's support for publicly funded museums suggests that it is fair to see him as a liberal cosmopolitan, sympathetic to Jeremy Waldron's description:

The cosmopolitan may live all his life in one city and maintain the same citizenship throughout. But he refuses to think of himself as *defined* by his location or his ancestry or his citizenship or his language. Though he may live in San Francisco and be of Irish ancestry, he does not take his identity to be compromised when he learns Spanish, eats Chinese, wears clothes made in Korea, listens to arias by Verdi sung by a Maori princess on Japanese equipment, follows Ukrainian politics, and practices Buddhist meditation techniques. He is a creature of modernity, conscious of living in a mixed-up world and having a mixed-up self.[32]

In this individual portrait, Waldron captures something of the spirit of exploration associated with Western nations during the seventeenth and eighteenth centuries, where, alongside deeply competitive, exploitative and selfish motives, there existed (and not necessarily in the same individuals and institutions) a genuine interest in and curiosity about the larger world that led to the cataloguing of knowledge and the encyclopedia. Willingness to attempt to understand and engage with the unfamiliar is characteristically cosmopolitan. Conversely, strong particularism (or traditionalism) has it that sets of good cultural practices associated with particular peoples should be endorsed and promoted because they are instrumentally and/or intrinsically valuable to those peoples. And even if individuals don't themselves follow all of these practices, theoretically they could (and in strong forms of traditionalism, they should); indeed they might admire those who do follow them, especially if the practices are in danger of dissolution. Particularists believe that culturally located practices are important to personal identity, and they may object, as Greenfield does, to the appropriation of works of art and architecture and other cultural forms that manifest such practices, or are associated with them, by others with a lesser claim as they see it.

The writings of J.G. von Herder undoubtedly provide a major source for the "cultural nationalism" identified by Merryman with the 1970

[32] Jeremy Waldron, 'Minority Cultures and the Cosmopolitan Alternative', (1992) 25 *University of Michigan Journal of Law Reform* 754. Kwame Anthony Appiah regards cultural purity as an oxymoron; see *Cosmopolitanism: Ethics in a World of Strangers* (New York: W. W. Norton, 2006), 113, and 'Whose Culture Is It?", in Cuno, *Whose Culture?*, 71–86.

UNESCO Convention.[33] Now while it can be argued, as Michael Forster convincingly does, that Herder effectively balanced liberal cosmopolitanism with an empirical understanding of social relationships, he did indeed claim that there was a human need to belong to some community, one key to which was language, "the matrix in which a person's awareness of his cultural heritage is aroused and deepened".[34] Another was customary law. For Herder, ancient Israel was a nomocracy that should continue to inspire respect for the rule of law, which he regarded as the central element of successful republican nationhood.[35]

Hegel also believed in the importance to common culture of the shared language, seeing language and work as the particular social forms in which people pass from a "disconnected mass" to a genuine unity.[36] Noting the Anglo-Saxon world's perception that this aspect of Hegelian (and Herderan) thought is extravagant (and, as Merryman himself suggests, contains the seeds of fascism), Charles Taylor comments that Hegel has simply been misread: his notion of the state is no more than "ethical life" itself:

> What we are as human beings, we are only in a cultural community. Perhaps, once we have fully grown up in a culture, we can leave it and still retain much of it. But this kind of case is exceptional, and in an important sense marginal. Emigrés cannot fully live their culture, and are always forced to take on something of the ways of the new society they have entered. The life of a language and culture is one whose locus is larger than that of the individual. It happens in the community. The individual possesses this culture, and hence his identity, by participating in this larger life.[37]

In Kant's version of cosmopolitanism, individuals would participate in the civic life of a great federation of states that adhered to Christian and classical European ideologies, whereas the defining feature of Herder's

[33] John Henry Merryman, 'The Retention of Cultural Property', (1988) 21 *University of California, Davis Law Review* 491.

[34] Johann Gottfried von Herder, *Philosophical Writings*, trans. and ed. Michael N. Forster (Cambridge: Cambridge University Press, 2002), xxxi–xxxii; see also Waldron, 'Minority Cultures and the Cosmopolitan Alternative', 756–9; and F.M. Barnard, *Self-Direction and Political Legitimacy: Rousseau and Herder* (Oxford: Clarendon Press, 1988), 238.

[35] F.M. Barnard, *Herder on Nationality, Humanity, and History* (Montreal: McGill-Queen's University Press, 2003), 20–3.

[36] See Timothy O'Hagan, 'On Hegel's Critique of Kant's Moral and Political Philosophy', in Stephen Priest, ed., *Hegel's Critique of Kant* (Oxford: Clarendon Press, 1987), 135, 153–4.

[37] Charles Taylor, *Hegel* (Cambridge: Cambridge University Press, 1975), 381.

republican state was respect for just, mutually agreed-upon laws that
emerged within a particular community.[38] Moreover, a people's political
culture had to be in accord with its non-political culture and thus, for Her-
der, cosmopolitanism was an empty formula lacking any comprehensive
system of laws to anchor it.[39] He also promoted a cultural pluralism that
warned against Kant's Eurocentrism:

> Least of all must we think of European culture as a universal standard of human
> values...For "European culture" is a mere abstraction, an empty concept...
> Besides, it can scarcely pose as the most perfect manifestation of man's culture,
> having – who can deny it? – far too many deficiencies, weaknesses, perversions and
> abominations associated with it. Only a real misanthrope could regard European
> culture as the universal condition of our species. The culture of man is not the
> culture of the European; it manifests itself according to time and place in every
> people.[40]

Yet in strongly refuting cosmopolitanism as an ideal form of political
life, he wasn't rejecting the Kantian vision of universal harmony among
autonomous individuals. Quite the opposite in fact, since he believed that
universal values could be shared only through the striving of autonomous
individuals – but autonomy had to begin within some particular political
context, which must be the nation.[41] And indeed Herder's culturally sensi-
tive liberalism has been amplified by a number of contemporary political
philosophers, also attuned to the contribution of shared cultural practices
to the autonomy of individual lives.

 Jürgen Habermas has elegantly analysed one intriguing moment in
the history of particularist thought, an 1846 gathering in Frankfurt of
German jurists, philologists and historians, recorded as the *Proceedings
of the Germanists*. The participants were concerned about a disconnect
between political unity and the larger linguistic community, and histori-
ans among them proposed establishing a 'Union for the Preservation of
German Nationality Abroad' which would embrace, among others, the

[38] Jeremy Waldron regards the "right of nations – what we would call the jurisprudence of
 international law" as the appropriate place for Kant's ideas on a world federation; see
 his 'Cosmopolitan Norms', in Seyla Benhabib et al., *Another Cosmopolitanism: Hospi-
 tality, Sovereignty, and Democratic Iterations* (Oxford: Oxford University Press, 2006),
 89.
[39] But both he and Rousseau were troubled by its failure to emerge as a mature state; see
 Barnard, *Herder on Nationality, Humanity, and History*, 43–4.
[40] Cited in F.M. Barnard, *Herder's Social and Political Thought: From Enlightenment to
 Nationalism* (Oxford: Clarendon Press, 1965), 100.
[41] Ibid., 75–82.

many individuals then emigrating to America.[42] Roman law's evident sophistication and practicality notwithstanding, German customary law was promoted during this meeting as an important expression of the spirit of the people, a theme later taken up by the jurist Otto von Gierke, whose 'realist' theory of collective personality had some influence on British legal thought:

> Our German Fellowship is no fiction, no symbol, no piece of the State's machinery, no collective name for individuals, but a living organism and a real person, with body and members and a will of its own. Itself can will, itself can act; it wills and acts by the men who are its organs as a man wills and acts by brain, mouth and hand. It is not a fictitious person; it is a *Gesammtperson*, and its will is a *Gesammtwille;* it is a group-person, and its will is a group-will.[43]

As Ernest Barker observed in 1934, these Germanist ideas are significantly derived from Herder, whom Gierke cited repeatedly and considered a major influence on the 'School of Historical Law'.[44] Looking with foreboding at Mussolini, Barker was concerned by the danger of imputing real wills to states that then truly become self-willing Leviathans. That having been said, the early particularist writers were more cosmopolitan than Merryman allows. Rousseau, Herder and Hegel shared an agenda in which meaningful collective life must be balanced by individual autonomy.

3. Primitivism and World Culture

Historically, cosmopolitanism and particularism were often entwined. When Napoleon added Italian paintings to the newly established French State collection from his European campaign, Quatremère de Quincy in his *Lettres à Miranda* of 1796 argued for their restitution, because the affective power of art is weakened when removed from its original

[42] Jürgen Habermas, 'What is a People? The Frankfurt "Germanists' Assembly" of 1846 and the Self-Understanding of the Humanities in the Vormärz', in *The Postnational Constellation: Political Essays* (Cambridge, MA: The MIT Press, 2001), 1–25.

[43] F.W. Maitland, introduction to Otto von Gierke, *Political Theories of the Middle Ages* (Cambridge: Cambridge University Press, 1900), xxvi.

[44] "The affinities of Gierke are not with Duguit, the legal philosopher of French syndicalism: they are with Herder, the harbinger of German Romanticism. The figure of the *Volk* remains in the background of his thought; and the majority of the *Volk* is incarnate in a State which remains sovereign, even if it recognises that there are other group-realities besides itself". Ernest Barker, introduction to Otto von Gierke, *Natural Law and the Theory of Society 1500–1800* (Boston: Beacon Press, 1957), li–lii, lxx–lxxi and lxxxii–lxxxiii.

context.[45] However, as noted by John Merryman, Quatremère's sensitivity to local context is balanced with a republican cosmopolitanism:

> The arts and sciences belong to all Europe, and are no longer the exclusive property of one nation... It is as a member of this universal republic of the arts and sciences, and not as an inhabitant of this or that nation, that I shall discuss the concern of all parts in the preservation of the whole.[46]

Alongside this passage, Merryman cites the *Marquis de Somerueles* judgment as an instance of cultural internationalism. This is the earliest-recorded judicial decision on the exemption of art from the spoils of war. In 1813 the British Vice-Admiralty Court in Halifax, Novia Scotia, heard a petition from the Pennsylvania Academy of the Fine Arts ("a scientific establishment at Philadelphia") for the release of 21 Italian paintings and 52 prints captured by a British ship in 1812 from the American merchant vessel *Marquis de Somerueles* and taken to Halifax for judgment as prize. Judge Croke gave the following opinion:

> The same law of nations, which prescribes that all property belonging to the enemy shall be liable to confiscation, has likewise its modifications and relaxations of that rule. The arts and sciences are admitted among all civilized nations, as forming an exception to the severe rights of warfare, and as entitled to favour and protection. They are considered not as the peculium of this or of that nation, but as the property of mankind at large, and as belonging to the common interests of the whole species... In thus favouring an institution of this kind... we shall perhaps at the same time promote most effectually our own best interests.[47]

The judge's opinion was also expedient, since he hoped that by restituting the property he would encourage the development of a public taste in America ("there is a natural connexion between all the arts and sciences, as well material, as intellectual") that could no longer bear "such hideous deformities as the picture of a country... submitting to be the tool of a foreign despot" (i.e., France). Merryman suggests that Quatremère is the immediate source for Croke's cosmopolitan position, not least because of the former's opposition to Napoleon.

[45] Andrew McClellan, *Inventing the Louvre: Art, Politics, and the Origins of the Modern Museum in Eighteenth-Century Paris* (Cambridge: Cambridge University Press, 1994), 201. See also Ana Filipa Vrdoljak, *International Law, Museums and the Return of Cultural Objects* (Cambridge: Cambridge University Press, 2006), 21–9.

[46] John Henry Merryman, 'The Free International Movement of Cultural Property,' in *Thinking About the Elgin Marbles*, 398.

[47] Vice-Admiralty Court of Halifax, Nova Scotia, *Stewart's Vice-Admiralty Reports* 482 (1813), reprinted in John Henry Merryman, 'Note on the Marquis de Somerueles', (1996) 2 *International Journal of Cultural Property* 319–29.

Let me complicate further this cosmopolitan idea of the universal cultural heritage suggested by the two Hague Convention phrases "cultural heritage of all mankind" and "culture of the world", and propose that it has two additional sources, both related to Herder's particularism. The first of these is a series of movements that has come to be known as Primitivism. From the mid-nineteenth century, Western writers, painters and sculptors quickened their interest not only in folk art but also in the non-European 'primitive' and exotic. As industrialisation spread across the Western world, artists and writers looked back to 'purer' times, whether they were actually to be found in the past, or in societies that were deemed to be like the past, such as those of Asia or the Pacific. This is an oft-told story. The 'primitive' was also another means by which one could re-describe the proletarian, pre-industrial and natural in contrast to the bourgeois, industrial and mechanical. Ernst Gombrich argued that J.J. Winckelmann himself, although generally associated with neo-classicism, made a significant contribution to Primitivism in taking from Giambattista Vico the idea that Homeric and other early literatures manifested the virtues of purity and simplicity, and applying it to archaic sculpture and architecture.[48] This taste for the unadorned and 'rude' was seen to avoid the corruptions of later times, and it prefigures descriptions given in the next century of the vitality of *Gemeinschaft* (community) over the decay of *Gesellschaft* (civilisation), distinctions made in 1887 by the sociologist Ferdinand Tönnies.

Primitivism took a variety of forms, including the Gothic revival, the Pre-Raphaelites' turn to a romanticised version of the Middle Ages, and the British arts and crafts movement (which influenced Japan); the fascination exhibited by impressionist and post-impressionist artists with Japanese wood-block prints; the French Nabis painters living amongst indigenous 'primitives' of Brittany, and Paul Gauguin's domicile in Tahiti; the early modernists' valorisation of African and Pacific religious sculpture and masks; the Freudian and quasi-anthropological ideas of the

[48] "The noble simplicity and quiet grandeur *[die edle Einfalt und stille Grösse]* of noble statues is also the true hallmark of Greek writings of the best period – the writings of the school of Socrates"; E.H. Gombrich, *The Preference for the Primitive: Episodes in the History of Western Taste and Art* (London: Phaidon, 2002), 62. Herder's admiration for Winckelmann was tempered only by his feeling that the latter had not acknowledged the role of Egypt in the formation of Greek style: "men or nations invent only exceedingly rarely, where they are not forced to do so, and that they always prefer to fall back on tradition, heritage, imitation, learning" (ibid., 71) (Gombrich translates *Erbteil* as 'heritage' rather than, more conventionally, 'inheritance').

surrealists, and so on. Here is Max Pechstein writing from the Melanesian island of Palau in 1914:

Since I myself grew up among simple people amidst nature, I readily came to terms with the abundance of new impressions. I didn't have to change my attitude that much . . . Out of the deepest feeling of community I could approach the South Sea islanders as a brother . . . [49]

Within this context, much was made of the idea of universal rhythm: "It is through the medium of rhythm that we may enter into a work of art and experience something of the exuberance and glow which fired the artist to creation . . . "[50] This preoccupation has been well described by Dee Reynolds, who notes the importance given in late nineteenth and early twentieth century Western thought to the relationship between poetry, music and early abstract art. Mondrian and Kandinsky were indebted to symbolist poetry, which in turn aspired to the state of music.[51] Profundity was associated with harmony and rhythm, and for Henri Bergson the deep rhythms of life itself.[52] Indeed, the modernist milieu was penetrated by a sense of the spiritual, famously articulated in Clive Bell's *Art* (1913), where he speculated about the emotional affect of an object as an end-in-itself: "We become aware of its essential reality, of the God in everything, of the universal in the particular, of the all-pervading rhythm".[53] Focusing on 'significant form' was, for Bell, the means to experience a deeper reality, but he was also reacting against a widespread preference for morally improving, descriptive narratives.

M.H. Abrams argues that celebrating works as ends-in-themselves, or self-contained worlds, was the product of an 18th century German synthesis – of neo-Platonism (the contemplation of Ideas) and Christian views

[49] Donald E. Gordon, 'German Expressionism', in William Rubin, ed., *"Primitivism" in 20th Century Art: Affinity of the Tribal and the Modern* (New York: Museum of Modern Art, 1984), II: 391.

[50] Osvald Sirén, *Chinese Sculpture from the Fifth to the Fourteenth Centuries* (London: Ernest Benn, 1925), xvii.

[51] Dee Reynolds, *Symbolist Aesthetics and Early Abstract Art: Sites of Imaginary Space* (Cambridge: Cambridge University Press, 1995).

[52] Bergson's ideas "suffered a period of 'absurd' popularity" in England between 1910–20; see Rachel Gotlieb, '"Vitality" in British Art Pottery and Studio Pottery', (1988) 127 *Apollo* 165.

[53] Clive Bell, *Art* (New York: Capricorn Books, 1958), 54. During the mid-nineteenth century, the German experimental psychologist Gustav Fechner designed scientific tests to discern the quantity of pleasure evinced by colours, shapes and lines; see Lynn Gamwell, *Exploring the Invisible: Art, Science, and the Spiritual* (Princeton: Princeton University Press, 2002), 96–7.

about the self-sufficiency of creation – which underpinned the movement known as 'art for art's sake' of which these early 20th century artists and critics were part.[54] Mere imitation was negatively contrasted with 'organic unity', as in the following passage from 1912 where Bell's fellow critic Roger Fry defends Post-Impressionism:

... it is in line with the older and longer and more universal tradition, with the art of all countries and periods that has used form for its expressive, not for its descriptive, qualities. So far from this art being lawless and anarchic, it is revolutionary only in the vehemence of its return to the strict laws of design. If it is not too rash to try to coin a single phrase to explain a very varied movement, I should say that it is marked by the desire for organic unity in a work of art ... [55]

The same year, in the pages of his newly established journal *Rhythm*, Michael Sadleir noted Kandinsky's desire to express the underlying resonance of nature, humanity, *Geist* and art:

From this book [*Concerning the Spiritual in Art*] two main contentions arise. The first is virtually a statement of Pantheism, that there exists a 'something' behind externals common to nature and humanity alike. That is what Wordsworth believed, but while he approached the question subjectively, contenting himself with describing the experiences of his mood communion with the nature around him, the new art is to act as an intermediary for others, to harmonise the inner *Klang* [resonance] of external nature with that of humanity, it being the artist's task to divine and elicit the common essentials underlying both.[56]

Aside from the aesthetic satisfaction that people derive from rhythm within the visual and performing arts, and such qualities ascribed to it

54 M.H. Abrams, 'From Addison to Kant: Modern Aesthetics and the Exemplary Art', in *Doing Things with Texts: Essays in Criticism and Critical Theory* (New York: W. Norton, 1989), 159–87.

55 'The Grafton Gallery: An Apologia' (1912), in Christopher Reed, ed., *A Roger Fry Reader* (Chicago: Chicago University Press, 1996), 113. A theory of organic unity had first been developed in Britain by Samuel Taylor Coleridge, influenced by Edward Young's *Conjectures on Original Composition*, 1759; see M.H. Abrams, *The Mirror and the Lamp: Romantic Theory and the Critical Tradition* (Oxford: Oxford University Press, 1971), 167–77 and 198–202, and James Benziger, who notes the importance for Coleridge of A.W. Schlegel, in 'Organic Unity: Leibniz to Coleridge', (1951) 66 *PMLA* 24–48. Imagination was central to Fry, as it was to Coleridge: "Art, then is, if I am right, the chief organ of the imaginative life"; see Roger Eliot Fry, 'An Essay in Aesthetics' (1909), in Fry's *Vision and Design* (Oxford: Oxford University Press, 1981), 17. Admiring both of Coleridge and Wordsworth, John Dewey underlined the role of imagination in the idea of organic unity: "The idea of a whole, whether of the whole personal being, or of the world, is an imaginative, not a literal, idea", in Dewey's *A Common Faith* (1934), cited by Alan Ryan, *John Dewey and the High Tide of American Liberalism* (New York: Norton, 1995), 271.

56 Cited in Adrian Glew, 'On Kandinsky', *Tate Etc.*, no.7, Summer 2006.

by Bell, Fry, Sadleir and others, it appears that it has a further important physiological function: according to Oliver Sachs, rhythm plays a significant role in "coordinating and invigorating" basic locomotor movement.[57]

The second source of those universalising phrases originates in the same romantic *milieu* as Primitivism. Goethe coined the term *Weltliteratur* to signify writing that expressed *Humanität*, the expression of which was literature's ultimate purpose.[58] For Friedrich Schlegel, romantic poetry was by its very definition a progressive universal poetry that sought to apprehend and express every mode of human experience.[59] Transcending national literatures without destroying their identities, and understood as a concert of works rather than a selective collection, *Weltliteratur* was maintained by the discipline of philology of which Herder was a founder.[60] At the Frankfurt gathering, one philologist identified Goethe's idea with a spirit "which we ourselves call the occidental, a spirit that dominates in America just the same as in Europe".[61] Language and philology were key to both the particularist view of Germans as members of a single language culture (even when they were domiciled in other countries) and the cosmopolitan view that the spirit of poetry was a widely shared, trans-national experience. In 1932 Tönnies made the following point about the relationship of the particular and cosmopolitan, almost half a century after he had first set down his two categories of social life:

I do not know of any condition of culture or society in which elements of *Gemeinschaft* and elements of *Gesellschaft* are not simultaneously present, that is, mixed. Moreover, although *Gemeinschaft*, too, arrives at higher and nobler forms of human relations, it is correct to say that *Gesellschaft* is the essentially variable element which enhances culture but also transforms it into civilization.[62]

[57] Oliver Sachs, *Musicophilia: Tales of Music and the Brain* (New York: Alfred A. Knopf, 2007), 233–42. For an argument about the relevance of neurological insights to the study of art making, see John Onians, *Neuroarthistory: From Aristotle and Pliny to Baxandall and Zeki* (New Haven: Yale University Press, 2007).

[58] Edward Said, *Culture and Imperialism* (London: Chatto & Windus, 1993), 52–3.

[59] Arthur O. Lovejoy, *The Great Chain of Being: A Study of the History of an Idea* (Cambridge, MA: Harvard University Press, 1936), 306.

[60] Erich Auerbach, 'Philology and *Weltliteratur*', trans. and intro. by Edward Said and Marie Said, (1969) 13 *Centennial Review* 1.

[61] Habermas, 'What Is a People?', 14.

[62] From 'My relation to Sociology', quoted in Timothy O'Hagan, *The End of Law?* (Oxford: Blackwell, 1984), 86–7, where the author lists the respective characteristics of *Gemeinschaft* and *Gesellschaft*, extracted from Tönnies' work.

Two decades later, the philologist Erich Auerbach sought to recover that Herderan and Goethean humanism founded on a Babel-like diversity: "The presupposition of *Weltliteratur* is a *felix culpa* [fortunate fall]: mankind's division into many cultures". Profoundly affected by his experience of exile from Germany, Auerbach here attempts to reconcile the universal with the particular:

> The most priceless and indispensable part of a philologist's heritage is still his own nation's culture and language. Only when he is first separated from this heritage, however, and then transcends it does it become truly effective. We must return, in admittedly altered circumstances, to the knowledge that prenational medieval culture already possessed: the knowledge that the spirit [*Geist*] is not national.[63]

This Germanist idea of unity-in-diversity reaches its apogee in the writing of Leo Spitzer, Auerbach's fellow philologist in exile. In his contribution to George Boas's *Studies in Intellectual History* published the year before the Hague Convention, we find Spitzer writing of "the general human mind", "a general human attitude" and our "general human experience" in, as Geoffrey Green puts it, "an effort to integrate his particular humanistic Spirit with the post-war idealistic yearning for world peace that helped create the United Nations".[64] On reflection, it is hardly surprising that humanist versions of the *Geist* should set themselves in opposition to the virulent National Socialist version, and that such thinking should appear in UNESCO's 1946 constitution ("the conservation and protection of the world's inheritance"), or an international convention of the early 1950s. Indeed, Timothy O'Hagan observes that documents such as the French Declaration of the Rights of Man and the Citizen, the United States' Declaration of Independence and the European Convention for the Protection of Human Rights and Fundamental Freedoms were all forged during or in the aftermath of struggles against oppressive political forces or alien occupations.[65] Auerbach's position of unity in diversity – a central concern also to one of Herder's more important translators, F.M. Barnard – reflects the Enlightenment aspect of German particularist thought, whereby individuals find a universal message through their local

[63] Auerbach, 'Philology and *Weltliteratur*', 2, 17.

[64] Contemporary with the publication of Andre Malraux's *Musée Imaginaire de la Sculpture Mondiale* (Paris, 1952–54). See Geoffrey Green, *Literary Criticism & the Structures of History: Erich Auerbach and Leo Spitzer* (Lincoln: University of Nebraska Press, 1982), 118, 145, and Leo Spitzer, 'Language: The Basis of Science, Philosophy and Poetry' in George Boas et al., *Studies in Intellectual History* (Baltimore: Johns Hopkins Press, 1953), 79, 82.

[65] O'Hagan, 'On Hegel's Critique of Kant's Moral and Political Philosophy', 157.

cultural life. Auerbach and Spitzer both eventually immigrated to the United States, promoted as the 'melting pot' *par excellence*, about which one might say that its constitutional and legal instruments form a *Gesellschaft* framework (and Herder would surely have praised the reverence accorded by Americans to the Constitution) while it also embraces many forms of *Gemeinschaft*, or traces thereof. In the twenty-first century, we may not be so concerned about universality as such but still want to make sense of the relationship between individual and community. Before turning back to that in Part III, I want to reflect more on the construction of the idea of heritage, and its inclusions and exclusions.

PART TWO

NARRATIVE AND CUSTOM

3

Constructing British Heritage

This feeling of nationality may have been generated by various causes.
Sometimes it is the effect of identity of race and descent. Community of
language, community of religion, greatly contribute to it. Geographical
limits are one of its causes. But the strongest of all is identity of political
precedents; the possession of national history, and consequent community
of recollections; collective pride and humiliation, pleasure and regret, con-
nected with the same incidents in the past.

J.S. Mill[1]

1. The Badminton Cabinet

In the previous chapter we began with John Merryman's 'two ways of
thinking' and then noted that cosmopolitanism and particularism not only
have overlapped historically but also contained elements of each other.
However, Merryman is perfectly right to recognise the contemporary
force of particularist rhetoric, as we saw in each of the cases outlined in
Chapter 1. This rhetoric has a history, some of the sources for which I
suggest in the present chapter. To understand the construction of national
heritage will help us better understand Merryman's framework as well as
the conflict between established private property rights and the rhetoric
of ownership by a people.

Heritage is rarely identical with history, as David Lowenthal under-
scores in *The Heritage Crusade*.[2] Heritage means different things to

[1] *Considerations on Representative Government*, quoted in Rawls, *The Law of Peoples:
With "The Idea of Public Reason Revisited"* (Cambridge, MA: Harvard University Press,
1999) 23, note 17.
[2] David Lowenthal, *The Heritage Crusade and the Spoils of History* (Cambridge: Cam-
bridge University Press, 1998).

different people, even within the same culture. Whether led by tempera-
ment or agenda, some incline towards myth, whereas others focus on
the historically reliable. Heritage is not an objective fact about the world
but a social construction, to which historical and religious narratives,
customary law and particular individuals have contributed in important
ways. In Britain, for example, there is still a tension in constructions of
the 'heritage' between Protestant asceticism and an originally Catholic
humanism.

To start this off, I shall review the case of the hardstone-inlaid Badmin-
ton Cabinet, described as "the grandest piece of furniture ever ordered by
an Englishman" and "one of the great symbols of Britain triumphant –
like Blenheim Palace or Handel's music" (Fig. 9).[3] As Andrew Graham-
Dixon wrote in *The Independent*, "There is something popish about it,
something redolent of the theatricality and glitter of Catholicism", recall-
ing the comment made by Osbert Sitwell in 1942 that "this great piece
of furniture is a sophisticated work of art, beautiful in its ingenuity and
engineering, as well as in its colour and design, but it will not be liked by
those who only care for old oak".[4] Graham-Dixon continued some three
years later in much the same vein apropos of the Turner prize, stating
that "art's inutility, its frequent mere pleasurefulness, its luxuriousness
trouble the British, who may no longer be the fiercely Protestant people
they once were, but who still hold deeply Protestant attitudes to art, and to
all sorts of other things".[5]

In April 1990, it became public knowledge that the Badminton Cabinet
was to be auctioned in London, its 'possible loss' the latest problem
facing British campaigners for the national heritage.[6] Ordered in Florence
in 1726 by Henry Somerset, third Duke of Beaufort, the monumental,
almost-four-metre-high chest has the general form of a triumphal arch
surmounted by the Beaufort arms. Were it to have returned to its place of
manufacture, lobbyists for the heritage might have voiced less disquiet.
However, the cabinet was sold in July 1990 not to the Uffizi, but to
the American pharmaceuticals heiress Barbara Piasecka Johnson for her
home in Princeton, New Jersey, for the record price of £8.7 million.

During the course of the subsequent, ultimately unsuccessful appeal
launched on behalf of the Fitzwilliam Museum, the cabinet was described

[3] *Fitzwilliam Museum: Badminton Cabinet Appeal Progress Report*, 18 February 1991.
[4] *The Independent*, 25 February 1991.
[5] *The Independent*, 22 November 1994.
[6] Godfrey Barker and Nigel Reynolds, *The Daily Telegraph*, 2 April 1990.

as "the most important piece of furniture in an English private collection", "the most outstanding piece of baroque furniture in Britain" and "the most important Florentine cabinet in existence"; however, unlike *Guernica*, it was also seen to be 'merely' decorative, albeit with fine art elements – hence Lord Grimond's comment that if it was a very remarkable piece of carpentry (thus, implicitly, not within the category of fine arts) which was to be put in a museum, then it might as well go to Italy or America, and the money saved used for things "essential to this country such as the preservation of buildings which once taken down cannot be put up again".[7] This is a lively thought indeed, that buildings should be the principal concern of those seeking to maintain the heritage. Although Italian in manufacture, the cabinet was commissioned by an eighteenth-century English aristocrat and kept within the same Gloucestershire country house where it had excited comment since its arrival. Together with the Duke's other continental acquisitions, it was positioned within a series of rooms at Badminton House that were remodeled for the purpose from a seventeenth-century suite. It was this provenance that pushed it firmly into the heritage arena:

> Turner and Constable did, indeed, make noble contributions to our cultural heritage but major works of art, commissioned from international artists and craftsmen by British patrons, should equally be regarded as part of our national culture and so should those great paintings, acquired in previous centuries, principally in Europe, which have vitally influenced the nation's artistic development.[8]

Beaufort was only nineteen when he visited Florence, but he had possessed title and estates since the age of seven.[9] His social rank and allies enabled him to place his commission with a specialist Medici workshop, the *Opificio delle Pietre Dure*, which manufactured the cabinet for a cost of £500.[10] Monumental in scale (386 × 232 × 94 cm.), it was designed

[7] Respectively: Sarah Jane Checkland, *The Times*, 5 January 1991; Sir Nicholas Goodison, NACF press release, 17 April 1991; Fitzwilliam appeal. *Parliamentary Debates (Hansard): House of Lords Official Report* 528, no. 77 (London: HMSO, 29 April 1991), 478–80.

[8] British Reviewing Committee, *A Review of the Current System of Controls on the Export of Works of Art* (London: HMSO, 1991), 3.

[9] Though not Catholics themselves, members of the Beaufort family had strong Jacobite sympathies; see Osbert Sitwell, 'The Red Folder', *Burlington Magazine* (April 1942) 89.

[10] Allies included Prince James Francis Edward Stuart (known in England as The Old Pretender and in Italy as the King of England) and Cardinal Alessandro Albani, a nephew of Clement XI; see Bruce Lenman, *The Jacobite Risings in Britain 1689–1746* (London: Holmes and Meier, 1980), 189 and 195; and Alvar Gonzalez-Palacios, *Sale Catalogue* (London: Christie's, 1990). See also Tim Knox, 'Badminton House and the Dukes

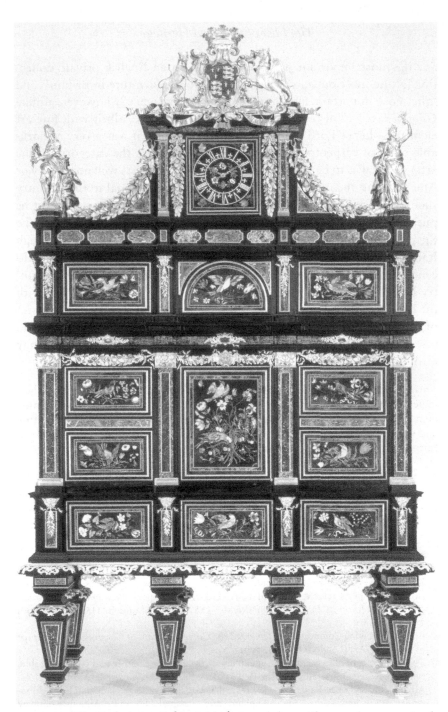

FIGURE 9. *The Badminton Cabinet, Medici workshops, Florence, late 1720s/early 1730s, pietre dure inlay, ebony veneer, ormolu, 386 × 232 × 94 cm. Liechtenstein Museum, Vienna. Photograph courtesy Sammlungen des Fürsten von und zu Liechtenstein, Vaduz-Wien.* Commissioned by the third Duke of Beaufort, the Cabinet was twice sold at auction in London, renewing questions in Britain about the nature of national heritage and the control of cultural material.

in the spirit of Giovan Battista Foggini, director of the *Galleria dei lavori* (the Grand Ducal workshops) who had died the year before Beaufort's arrival in Florence. The piece has no complex interior with concealed drawers to house rare objects, but surface and texture only. Its rarity is all on the outside, with drawer fronts, door and ebony-veneered sides extravagantly inlaid with *pietre dure* birds, flowers and insects.[11] The whole is surmounted at the corners by four ormolu allegorical figures representing the seasons (Flora, Ceres, Bacchus and Saturn) modelled by Foggini's pupil Girolarmo Ticciati, surrounding an inlaid clock and the arms of Beaufort held by a panther and wyvern.[12]

Reflecting the circumstances of its commission – a classicising taste, the capacity to invest significant amounts of surplus capital and the glorification of the private estate – the piece was implicated in a larger social change. For Beaufort, and myriad other eighteenth-century British tourists, the sights and curiosities of classical and contemporary Italy were also to some degree consumable, whether by purchase, or gift or record, embellishing landed estates at home, especially the country house; they were "the most familiar symbol of our national heritage, a symbol which, for the most part has remained in private hands".[13] Installed at Badminton in 1733, the cabinet could not truly be a public statement like the *Studiolo Grande* in the Uffizi Tribuna, although it was perhaps ultimately intended for the baroque palace into which Badminton House might one day evolve, the architectural plans for which the duke himself had drawn up while in Italy.[14]

of Beaufort' and Alvar Gonzalez-Palacios, 'The Badminton Cabinet', *Sale Catalogue* (London: Christie's, 2004), reprinted in Johann Kräftner, ed., *The Badminton Cabinet: Commessi di pietre dure in the Collections of the Prince of Liechtenstein* (Munich: Prestel Verlag and the Liechtenstein Museum, 2007), 59–67 and 69–107.

[11] The bird and flower panels in lapis lazuli, green and red jasper and amethyst quartz suggest the influence of Chinese 'coromandel' lacquer designs imported to Europe mostly in the form of folding screens during the late seventeenth and early eighteenth centuries; see Oliver Impey, *Chinoiserie, The Impact of Oriental Styles on Western Art and Decoration* (New York: Scribner, 1977).

[12] The cabinet arrived at Badminton in 1732. There is a proposal that, because of a 1720 inscription by Baccio Cappelli on the reverse of the central panel, its conception possibly predated the Duke's visit to Florence; see Gonzalez-Palacios, 'The Badminton Cabinet', 88–90.

[13] Gibbon heard that 40,000 tourists were on the continent in 1785, see Damie Stillman, *English Neo-Classical Architecture* (London: Sotheby's, 1988), 1:29. Also Robert Hewison, *The Heritage Industry: Britain in a Climate of Decline* (London: Methuen, 1987), 53. Beaufort's own studies of Italian buildings survive at Badminton.

[14] He would have admired the *Studiolo Grande*, a great cabinet made between 1593–9 for Ferdinand de' Medici which stood within the Uffizi's Tribuna until 1780 (it was broken

The duke's family sympathies lay with the exiled Stuarts, whose four kings had either tolerated or actively embraced Catholicism and had been closer to Rome than the majority of the aristocracy wished. Combined with active endorsement of the divine right, this was a perilous cocktail in seventeenth- and eighteenth-century England.[15] From the accession of George I in 1714 to the time of the visit to Badminton by Queen Charlotte some 70 years later, the family kept prominently on display a portrait of James Stuart, son of James II, who had unsuccessfully challenged George for the throne.[16] The hope of a second Stuart restoration was surely in the Duke of Beaufort's breast when he commissioned the Badminton Cabinet.[17]

Whether Beaufort genuinely believed in the possibility of restoring the Stuart kings, or even more grandly thought of himself as a candidate for the throne in the event of a Hanoverian demise, it was probably satisfying to him that the power of his European connections and his status – ostensibly equal to a Medici grand duke – had been made manifest in so sumptuous a manner. His hopes remained unrealised. He died at the age of thirty-eight in 1745, the same year as the failed rebellion by Bonnie Prince Charlie, "worn out by a complication of disorders", his great palace unbuilt. The Badminton Cabinet survived him in fine condition, the gilded family motto ("I scorn change or fear") and hardstone panels of birds and flowers "emblems of an astonishing – to the modern viewer anyway – princely hubris. Fragile, evanescent Nature, assisted by Art, has conquered Time".[18]

up by 1793). Among the precursors of these baroque Medici *stipo* were seventeenth-century cabinets of curiosity in which strange, odd, unusual and ingenious objects were kept (the seventeenth-century meaning of curious being careful, or scrupulous); see John Dixon-Hunt, *Garden and Grove, The Italian Renaissance Garden in the English Imagination: 1600–1750* (London: Dent, 1986), 73. Both the Badminton Cabinet and the marble-lined room commissioned in Rome (confusingly in the documentation also called a cabinet) appear to have been destined for Badminton rather than a London mansion (which the Duke didn't acquire until 1738); Gonzalez-Palacios, *Sale Catalogue* (1990), 38, and Knox, 'Badminton House and the Dukes of Beaufort', 64–5.

[15] For 150 years the religious destiny of England was never completely a given, from the initial break with Rome by Henry VIII in the early 1530s (over his incapacity to divorce), until the so-called Glorious Revolution of 1688 when William of Orange took the throne from his Stuart uncle James II and committed Britain to a Protestant and parliamentarian future.

[16] Sitwell, 'The Red Folder', 89.

[17] He hosted extravagant festivities in Florence to mark the anniversary of the first Stuart restoration, Knox; 'Badminton House and the Dukes of Beaufort', 61.

[18] Andrew Graham-Dixon, *The Independent*, 25 February 1991.

The association of the Cabinet with Badminton House was a major platform for heritage lobbyists, similar to that of Canova's *Three Graces* with the 'Temple' at Woburn Abbey.[19] Defending the sale, the present Duke of Beaufort argued that the Drawing Room was now accessible only through two small sitting rooms in constant use by the family, and re-location (to the William Kent hall) was not viable: "You must either get rid of the fireplace or of one of the Wootons painted for the room. This is just as impractical".[20] And it was made quite plain by the Beaufort family that to make the object available to the public at Badminton was an intolerable constraint: "He [the duke] believes that allowing the public access would force him to move out".[21]

As the Badminton Cabinet went on show at the Tate on 17th April 1991, Sir Hugh Leggett, secretary of 'Heritage in Danger', remarked of the British system of export controls that

the system is the fairest in the world, but there are not enough public funds available. We are in a puritanical era, reminiscent of when Cromwell dispersed Charles I's art collection. Many of Charles's works are now highlights of the Louvre and the Prado.[22]

Its export had been stopped on 17th September 1990, when the secretary of state for Trade and Industry, acting on the advice of the then minister for the arts, David Mellor, delayed a decision on the licence for two months to enable an offer to be made at or above the recommended price of £8.7 million.[23] By the time the cabinet was displayed at the Tate the appeal stood at £2.6 million, 30% of the necessary sum, of which £2.25 million had come from four sources. Depending on where you stood, the figure represented a major success at fund-raising at a time of recession

[19] "The point of the 'Three Graces' is not so much that it is a masterpiece, but that it is part of a greater whole, the temple built by Wyatville and dedicated to Liberty and to Beauty", Editorial, *The Art Newspaper* (April 1994). This second version of Canova's *The Three Graces* was installed at Woburn Abbey in 1819.

[20] Barker and Reynolds, *The Daily Telegraph*, 2 April 1990.

[21] Ibid.

[22] 'Cromwell Routs the Aesthetes', *The Times*, 18 April 1991.

[23] £8,697,000, comprised the hammer price of £7,800,000, plus 10% buyer's premium, plus value added tax at 15% on the commission. If at the end of this initial period a serious attempt had been made to raise funds for its purchase, a further four-month extension would be granted; by 17th November, the minister was made aware of the Fitzwilliam Museum's intention to match the price, although the joint appeal with the National Art Collections Fund was launched only on 17th February; on 17th March it was again recommended that a decision on the licence be deferred, this time for a further two months. Office of Arts and Libraries Press Notice (OAL 25/91), 22 March 1991.

or a derisory and notional amount towards the purchase. One journalist pleaded the importance of public advocacy on its behalf, stating that "otherwise the Cabinet will leave this country for America, its bizarre grandeur wrenched decisively from any kind of sensible context. And out of context it would easily look like a massive bibelot".[24] *The Independent* newspaper attacked the V&A on 18th March 1991 for its misplaced priorities: "the Duke of Beaufort offered it to the Victoria and Albert Museum in 1989 for a mere £4m. But the Museum's trustees felt too committed to saving Canova's saccharine marble sculpture (price £7.6m.), *The Three Graces*. Had the Duke's offer been handled differently, the cabinet might have been kept from auction".[25] That editorial inspired a brief exchange of letters on the relative merits for the public of the Badminton Cabinet over Paul Gascoigne, the English soccer hero of the 1990 World Cup, who was about to transfer from Tottenham Hotspur to the Italian club Lazio for £8.5 million.[26] Was "the most important decorative work of art threatened with export since the National Art Collections Fund was founded in 1903" more worthy than the *Three Graces*, a more essential part of the national heritage, the demand that it be kept on sovereign territory more urgent?[27] Would other countries indeed "despise us for allowing it to go to America"?[28]

In autumn 2004, Christie's announced that it would offer the Badminton Cabinet at its London salerooms for the second time. It was said to be

[24] Tanya Harrod, *The Spectator*, 2 March 1991. Over the previous fifteen years Mrs. Johnson had assembled a major private collection of European furniture, principally French, but including Italian and English pieces.

[25] The Cabinet was first offered to the V&A in 1989 to settle inheritance tax owed on the estate of the tenth Duke, the price being finally set at £4m. (payable over three years) with the thought that the amount for which the museum was liable would be very substantially reduced by tax deals with the Treasury (from either private treaty or *in lieu* options). However, it transpired that these were unavailable and the museum was itself unable to meet the full price of £4m.; the owners (the Trustees of a Beaufort Family Settlement) and their agent Christie's moved to the open market option. See also 'Funding the Arts', (1984) *Taxation* (11 February) 359–61.

[26] One correspondent of *The Independent* properly questioned the relevance to export stops of the editorial writer's "Wodehousian" description of the buyer as a "Polish-born baby powder heiress"; see *The Independent*, 18, 21 and 26 March 1991.

[27] Sir Brinsley Ford, *Fitzwilliam Museum Appeal Progress Report*. For the Getty appeal over the sculpture, see *R v. Secretary of State for National Heritage and Another, ex parte J. Paul Getty Trust*, Court of Appeal (Civil Division), 27 October 1994, *Lexis Enggen*.

[28] Simon Jervis quoted by Hugh Montgomery-Massingberd, *The Daily Telegraph*, 26 February 1991.

too large for Mrs. Johnson's new home.[29] During the intervening years it had spent time in storage and the question now, aside from guesses about its likely price, was to which country it would go? Bidding at the 9th December auction settled into a competition between an anonymous telephone bidder and Johann Kräftner, director of the Liechtenstein Museum, acting on behalf of Hans-Adam II of Liechtenstein. The prince purchased it at a hammer price of £17 million for the family's newly re-opened eighteenth-century garden palace in Vienna, where it is now shown to the public alongside other fine examples of Italian *pietre dure*.

2. Protestant Roles and Rhetoric

Cultural narratives and roles have a central place in the construction of heritage: we are what we are, because we were what we were. Formed from the interweaving of received practices, verifiable history, myths and religious stories, heritage efficiently takes over already established narratives with their ready-made stocks of roles ranging from the exemplary to the wicked. And when we assign unfavourable, stereotypical roles, they are often insubstantial; in denying to others the richness we perceive in our own cultural practices, we find it hard to recognise them as equals. Conversely, exemplary roles have depth and texture. So it is well to reflect here on the apposite comment of Ralph Inge that a nation is a society that nourishes a common delusion about its ancestry and shares a common hatred for its neighbours.[30] Heritage praises certain political ancestors but marginalises or eliminates others. Thus, in arguments that promote the political symbolism of the Parthenon to the Greek people, the ancestors are Athenian, democratic and philosophical, rather than Spartan, aristocratic and martial.[31] Talking so is not intended to belittle the construction of heritage, but to sound a cautionary note about the task of generating reasonable approaches to heritage objects, where heritage depends often on myth and only quasi-historical narrative.

[29] *The Independent*, 11 December 2004.
[30] Quoted in Avishai Margalit, *The Ethics of Memory* (Cambridge, MA: Harvard University Press, 2002), 76. Noting that metaphors of the family are often abused – such as those used to bind 'organic' nations that posit common descent – Margalit wonders whether the family metaphor will some day be replaced by the metaphor of friendship favoured by David Hume and Adam Smith, 104.
[31] See above, Chapter 1, Section 3, and John Onians, *Classical Art and the Cultures of Greece and Rome* (New Haven: Yale University Press, 1999) 30–50, for the interrelationship in Athens between mathematics and martial skills.

Narratives were also built around legends of noble beginnings, great ancestors and heroic deeds, such as the fiction that Britain was civilised by Trojans from whom King Arthur descended.[32] The most intensive employment of ancient Arthurian apocrypha came during the first years of the Stuart dynasty when for the dominant faction of the English nobility James VI of Scotland seemed the best prospect to succeed Elizabeth, protect the hegemony of Protestantism and unify England and Scotland against Philip II of Spain. His ascension to the English throne as James I in 1603 was accompanied by numerous tracts, pageants and plays designed to impress on people the fulfillment of Merlinic prophesy, with Jonson, Dekker, Fletcher and Shakespeare contributing to a loyalist Trojan-British propaganda in support of the new dynasty.[33]

With respect to 'British heritage', in the name of which demands were made on the Badminton Cabinet and *The Three Graces*, it is difficult to appreciate its construction without understanding the transformation of England, Wales and Scotland into Protestant countries. Both during and after the Reformation, the rhetoric of historical precedent and strong identification with significant moments of the past, both real and imagined, characterised many struggles for political and ideological independence, first in Europe and then in America.

Religion is now used to define us not so much to our private selves, but rather to our peers and our enemies.[34] Whether we reject religious belief or not, religion is a fundamental part of the cultures in which we live and remains a shaper of world events, as contemporary political life

[32] Joseph Strayer points out that medieval French kings also saw their people as the authentic descendants of Trojans settled beyond the Roman Empire; see John Armstrong, *Nations before Nationalism* (Chapel Hill: University of North Carolina Press, 1982), 156.

[33] London itself was now cast as *Troia Nova*, the mayor for years being known as *Praetor* and welcomed by senators. *Macbeth* (ca. 1605–6) was created around a legend known from Holinshed's *Chronicles* that the Arthurian line ran not only through England itself but also through Scotland (via Walter, Lord High Steward and ancestor of the Scottish kings). The witches conjure up eight phantom kings, the last of whom prophesies the longevity of Banquo's line and the eventual re-unification of the empire – as it was now united under James: "And yet the eighth appears, who bears a glass/ Which shows me many more; and some I see/ That two-fold balls and treble sceptres carry" (Act iv). The two-fold balls represent England and Scotland, and the triple sceptres the unity of England, Scotland and Wales. See Roberta Florence Brinkley, *Arthurian Legend in the Seventeenth Century*, Johns Hopkins Monographs in Literary History III (Frank Cass, 1967), especially Chapters 1 and 2; also Simon Schama, *A History of Britain: The Wars of the British 1603–1776* (New York: Hyperion, 2001), 20–3.

[34] Clifford Geertz, *Available Light, Anthropological Reflections on Philosophical Topics* (Princeton: Princeton University Press, 2000), 184.

reminds us only too well. Religious practices are usually entwined with belief in narratives. We may not have invested heavily in the religion to which we ostensibly subscribe, but we are likely to know something about the general beliefs that subscribers to our religion should hold. Since affiliation is likely to be familial, we are probably aware of the numerous expectations associated with the practice of that religion within our family and community and are probably also aware, at least to some extent, of related forms of practice in other communities. In liberal democracies, individuals are generally able to exercise a good deal of choice in what they believe and how they practise it. Such states leave much room for actors to choose for themselves the relevance or force of inherited religious precepts, whereas people under oppression may be forced at least to pay lip service to the stories they inherit or receive.

No doubt a large number of people in the United States, and certainly conservatives, would see the Ten Commandments as simply an unchallengeable 'given' and, moreover, a key part of America's cultural heritage. Others might agree with the second part of that assertion but remain passionate about the separation of church and state. In November 2003, Alabama Supreme Court Chief Justice Roy Moore was dismissed from office for his repeated opposition to the removal of a two-and-a-half ton granite block carved with the Ten Commandments that he installed in the state judicial building.[35] Ruling in June 2005 on two other instances of display of the Commandments, the Supreme Court decided by majority that a monument on the grounds of the Texas Capitol was constitutional, Justice Breyer opining that "the public visiting the capitol grounds is more likely to have considered the religious aspect of the tablet's message as part of what is a broader moral and historical message reflective of a cultural heritage".[36] Components of culture which people see as deeply embedded in their own heritage are often shared with peoples in other countries, but not necessarily in the same ways. This is especially so for those related to religious and political histories. Opposition to tyrants is seen as part of the heritage in a number of nations, but some, such as the United States, emphasise it much more than others.

Proscriptions and edicts such as those listed in the Commandments are typical to the major religions, although how we interpret them

[35] In the summer of 2004, the granite block was sent on a tour as a protest against these decisions.

[36] *Van Orden v. Perry, in his official capacity as Governor of Texas and Chairman, State Preservation Board, et al.*, no. 03–1500, decided 27 June 2005.

fluctuates, especially through shifts in majority opinion (e.g., sixteenth- and seventeenth-century English attacks on the instrumental value of intervention by saints). Ethical guidelines like the Hebraic Command- ments are enforceable by policing only to the extent that they are congru- ent with the laws of a particular country. Proscriptions against taking life are reflected in the laws of all nations in some form, but commandments such as respecting parents, not committing adultery and not coveting the possessions of others have a normative moral force that is much stronger in certain countries than others (the *Roe v. Wade* decision on abortion remains a recurrent flashpoint between liberals and conservatives in the United States).

In the Exodic climax, where Moses twice receives the Command- ments, we have a splendid instance of dramatic narrative both celebrating and reinforcing customary law, underlining how sacred stories legitimate social rules (as they're generally created to do), with later commenta- tors offering an undisguised human perspective on religious, political and legal matters. We draw on such cultural narratives, roles and rules in deciding how to play out our own lives. One such example is Robert Filmer's *Patriarcha*, written before the English Civil War but published only in 1680.[37] In a highly disciplinary reading of the Hebrew bible, Filmer argued that power was derived from God alone and not from the consent of subjects, since God had given the world to Adam and his line by natural inheritance, whence the Stuarts had descended. John Locke made a detailed rebuttal of the *Patriarcha* in the first of the *Two Treatises*, pub- lished almost immediately after the Stuart fall in 1688, ridiculing the idea that the Stuarts were descended from Adam (thus guaranteeing longev- ity to Filmer's polemic).[38] Filmer believed that great families (headed by 'subordinate fathers', the Dukes of Beaufort, for example) should retain their wealth through primogeniture, which had long been justified

[37] Sir Robert Filmer, *Patriarcha and Other Writings*, ed. Johann P. Somerville (Cambridge: Cambridge University Press, 1991).

[38] John Locke, *Two Treatises of Government*, ed. Peter Laslett (Cambridge: Cambridge University Press, 1988), 218–63; also Jeremy Waldron, *The Right to Private Property* (Oxford: Clarendon Press, 1988), 144. Laslett has made the now well-known case that Locke's *Two Treatises* were composed not to justify the Glorious Revolution of 1688, but to rebut the *Patriarcha*. To make a conclusive case, Locke was required in the *First Treatise* to match Filmer by quoting extensively from the Old Testament, as other nat- ural rights theorists had done throughout the century (e.g., John Selden, who frequently made use of both Mosaic and Talmudic law); see Richard Tuck, *Natural Rights The- ories: Their Origin and Development* (Cambridge: Cambridge University Press, 1979), 87.

as fostering civic continuity.[39] The completed Badminton Cabinet was intended to be admired (as it still is) as a great piece of furniture and also as an affirmation of British aristocracy, yet behind this public intention surely lay a private motive to impose on the country a quite different set of political and religious practices from those of Beaufort's parliamentarian and Protestant contemporaries.

In the construction of Protestant heritages, the narrative of redemption from Catholicism evolved differently in England and America.[40] England absorbed the originally Puritan sense of divine mission, using it to justify the expansion of empire in the eighteenth and nineteenth centuries. America on the other hand allied the redemptionist aspect of Calvinism to the War of Independence and the Constitutional Congress, to create a sense of heritage imbued with the spirit of revolution and renewal. We can see this in the enthusiastic endorsement of Gilbert Stuart's Lansdowne Portrait of Washington as a national icon. Ironically, Britain came to represent just the opposite of revolution. Puritan zeal and parliamentary representation had been married during the mid-seventeenth century, but they subsequently divorced, and a Whig version of history that celebrated immemorial custom and the conservative sense of permanence eventually came to dominate.

The Exodus narrative has been repeatedly employed within Protestant countries to shape self-image. For Puritans, a great rhetorical device was to adopt this biblical narrative and identify with the Israelites' flight

[39] Somerville, introduction to Filmer, xv–xxiv. An earlier defence of the originally Norman practice is given by Thomas Starkey within the *Dialogue between Cardinal Pole and Thomas Lupset* (1532–4), where Lupset claims that "if the lands in every great family were distributed equally betwixt the brethren, in a small process of years the head families would decay and little by little vanish away. And so the people should be without rulers and heads . . . [whereby] . . . you shall take away the foundation and ground of all our civility". See Joan Thirsk, 'The European debate on customs of inheritance, 1500–1700', in Jack Goody, Joan Thirsk and E. P. Thompson, eds., *Family and Inheritance: Rural Society in Western Europe, 1200–1800* (Cambridge: Cambridge University Press, 1976), 178–85. One effect in Britain of primogeniture, which did indeed prevent the morcellement of property, was to accelerate the colonization first of Ireland and then of America, promoted among other reasons because the lands would accommodate many younger brothers. Massachusetts eventually adopted partible inheritance, with the elder son given a double share; ibid., 188–9.

[40] David Sugarman and Ronnie Warrington argue that the 'equity of redemption' played a part in the construction of nationhood, the landed gentry sharing a messianic mission to redeem their fellow (landed) men from financial and social hell; see 'Land Law, Citizenship, and the Invention of "Englishness": The Strange World of the Equity of Redemption', in John Brewer and Susan Staves, eds., *Early Modern Conceptions of Property* (London: Routledge, 1995), 111–44.

from tyranny to sanctuary in the Promised Land, wherever that was most suitably found. The new Israel, God's kingdom, was the reformed church.[41] The appeal of such universal stories was surely their ability to accommodate different needs, with people selecting the narratives, roles and masks that served their purposes best. These exodus stories have strong family resemblances to each other: in Holland, England, Scotland and America, the Exodus narrative was so useful because it lent itself to numerous doctrinal interpretations and applications, explaining long-standing resistance to slavery and corruption (the Roman and Norman conquests notwithstanding), vindicating the Reformation, offering protection against the absolutist ambitions of monarchs and underpinning a sense of national purposefulness. It is, as Michael Walzer points out, "a classic narrative, with a beginning, a middle and an end: problem, struggle, resolution – Egypt, the wilderness, the promised land".[42]

Linda Colley cites the remarkable example of a Hampshire-born dissenting minister Isaac Watts who, in compiling his best-selling translation of the Psalms in 1719, replaced every reference to Israel with the words 'Great Britain'. The Peace of Paris in 1763 was celebrated by one clergyman in a sermon entitled *The Triumph of Israelites over Moabites, or Protestants over Papists*. Two important other vehicles for this message were poetry and song, with Handel as supreme exponent of the musical correspondence between Britain and Israel: the oratorios *Esther, Deborah, Athalia, Judas Maccabaeus, Joshua, Susannah, Jephtha* and *Israel in Egypt* all have as their theme the deliverance of Israel from danger.[43] Colley reminds us that images employed by Blake in *Jerusalem* were near to the heart of eighteenth-century Protestant thought.[44]

[41] See Carlos M.N. Eire, *War Against the Idols: The Reformation of Worship from Erasmus to Calvin* (Cambridge: Cambridge University Press, 1986), 259–70.

[42] Michael Walzer, *Exodus and Revolution* (New York: Basic Books, 1985), 10–11. Reviewing Herder's use of the Exodus narrative (as a means further to articulate what he saw as the proper relationship between universal and particular, *Humanität* and *Volk*), F.M. Barnard suggests that "Herder's interpretation of the Mosaic Constitution signals, therefore, an unmistakable shift from the prevailing individualism of the Enlightenment...A person is now seen as being able to find fulfilment only within a land and a people of his own, in which he can stand up and be counted. Indeed, a person can only *be* a person within a cultural and territorial context that is distinctly his own". F.M. Barnard, *Self-Direction and Political Legitimacy: Rousseau and Herder* (Oxford: Clarendon Press, 1988), 259–68.

[43] Linda Colley, *Britons: Forging the Nation 1707–1837* (Yale: Yale University Press, 1992), 30–6.

[44] From *Milton* (1804): "I will not cease from Mental Fight/ Nor shall my Sword sleep in my hand/ Till we have built Jerusalem/ In England's green and pleasant Land".

Whether in stories, plays, poems, sermons or prints, all the players cast within these dramas of opposition and succession are presented behind a mask, something akin to the *persona* worn by actors in the classical theatre. And since masks may be as horrid as they are heroic, heritage stories exclude as much as they include. For the English/British, this divinely ordained role continued to be employed in the service of national propaganda, derogating the French with whom they engaged in nine successive wars between 1689 and 1815. France, of course, had been a constant threat to English autonomy since the Conquest (as had England to France), but until the Reformation it was custom and law that truly separated the countries – now it was also language and religion. In the years leading up to the American Revolution, alongside the articulation of natural rights and neo-Roman republicanism, a third powerful force in America was the revolutionary rhetoric of Puritan redemption. As Walter McDougall emphasises: "The American cause was profoundly religious for Protestants and Deists alike because both identified America's future with a Providential design and both entertained millenarian hopes".[45] Indeed, the Israelitish role was turned against Britain in the 1770s, famously by the Scottish émigré president of Princeton College, John Witherspoon, in his sermon *The Dominion of Providence over the Passions of Men*. As Horace Walpole declared in Parliament: "There is no use crying about it. Cousin America has run off with a Presbyterian parson, and that is the end of it".[46]

3. Common Laws and Constitutionalism

In the construction of English (and British) heritage, other key components are the 'ancient constitution' and the practice of customary law. Against the background of a wider European movement to fortify the sovereign, custom was a powerful weapon – immemorial, sacred and beyond the king's power to alter or annul. All such regional European movements associated long-standing custom and customary law with the freedom of the people, so that, to cite J.G.A. Pocock, "by 1600 or thereabouts there was hardly any constitutional movement without its accompanying historical myth".[47] In these constitutionalist defences against absolutism

[45] Walter A. McDougall, *Freedom Just Around the Corner: A New American History 1585–1828* (New York: Harper Collins, 2004), 237.

[46] Arthur Herman, *How the Scots Invented the Modern World* (New York: Three Rivers Press, 2001), 248. Witherspoon was a signer of the Declaration.

[47] In England, Sir Edward Coke (1552–1634) supported parliament and the common law; in Sicily, Pietro de Gregorio that of baronial privilege and the *parlamento;* François

we see the beginnings of the modern sensibility within cultural heritage debate – that the character of a people and their heritage is deeply rooted in local custom and customary association. Whether through the taking of new roles, the replacement of political ancestors or the reassessment of previously given histories, 'heritage' took on a new urgency.

Under and in opposition to James I (reigned 1603–25), there was a major recovery of indigenous texts, especially legal documents, and a florescence of Saxon glossaries and dictionaries. Chief Justice Sir Edward Coke intended to make the case for the immemorial nature of the common law, and used the Anglo-Saxon lineage only as a convenient marker on his projection of the law back into the far distant past. As Pocock observes:

> Coke's mind, it is clear, was as nearly insular as a human being's could be. He saw the law he idolized as the immemorial custom of England, and he imagined it as being immemorial purely within the island.[48]

In England, as this sensibility descends from Coke to Burke, the focus is on the law, the constitution and social order. The force of the constitutionalist argument is seen in Parliament's protestation of 1621 that its licence to speak freely on matters of state was "the ancient and undoubted birthright and inheritance of the subjects of England".[49] Locke grounds political institutions in the social compact, and in this passage from the *Second Treatise* we find the thought that law-making institutions have the capacity not only to form a social body but also have a life beyond individuals:

> 'Tis in their *Legislative*, that the Members of a Commonwealth are united, and combined together into one coherent living Body. This *is the Soul that gives*

Vranck that of the independent Dutch towns; Erik Sparre in Sweden that of the nobles in their *riksrad;* and in France the Huguenot jurist Francois Hotman that of the antiquity of the assembly of the nation (in the *Francogallia* of 1573). Pocock sees Hotman's *Anti-Tribonian* as "one sign of that reaction towards the customary, the native, the feudal and the barbarous, which was discernible in contemporary thought and may have furnished one of the roots of European romanticism". See J.G.A. Pocock, *The Ancient Constitution and the Feudal Law: A Study of English Historical Thought in the Seventeenth Century* (Cambridge: Cambridge University Press, 1987), 11, 15–17.

[48] Coke was no doubt included by Sir Henry Spelman among those who derived the law from "Brutus, Mulmutius, or the Druids" instead of accepting that English law was largely Germanic in its origins; ibid., at 56, 96–7. See also Colin Kidd, *British Identities before Nationalism: Ethnicity and Nationhood in the Atlantic World, 1600–1800* (Cambridge: Cambridge University Press, 2001), 83–98.

[49] Schama, *A History of Britain: The Wars of the British 1603–1776*, 61.

Form, Life, and Unity to the Commonwealth: From hence the several Members have their mutual Influence, Sympathy, and Connexion: And therefore, when the *Legislative* is broken, or *dissolved*, Dissolution and Death follows.[50]

His contractarian thinking was anchored in Hugo de Groot (Grotius), for whom the republican state was premised on a covenant between its members.[51] From now on, two versions of the national community are handed down, both anchored in seventeenth-century thought. One is Locke's vehicle, the legislature, through which people are united into a 'coherent living body'. This continues to command attention in America, infused as it is with the sense of revolutionary commitment to individual political liberty. The other version is Coke's, where, as Quentin Skinner phrases it, history is seen as the embodiment of what is constitutionally proper, not to be questioned except at grave peril. His view that history is an anchor was transmitted to Edmund Burke, in part through Sir Mathew Hale. Here is Hale's reply to Hobbes:

If any the most refined Braine under heaven would goe about to Enquire... to find out how Landes descend in England... he wou'd lose his Labour... till he acquainted himselfe with the Lawes of England, and the reason is because they are Institutions introduced by the will and Consent of others implicitly by Custome and usage, or Explicitly by written Laws or Acts of Parlement.[52]

One of the 'most potent legacies' of Whig ideology, Coke's originally revolutionary emphasis on immemorial right, was transformed into a tradition of 'skeptical conservatism'.[53] This tradition has been carried on in Britain, recently and notably by the late Lord Denning.[54] As David Lowenthal puts it: "Unfazed by its exposure as a tissue of errors, the British still revel in Whig unreason".[55]

[50] Locke, *Two Treatises of Government*, 407–8.

[51] Charles Taylor, *Sources of the Self: The Making of the Modern Identity* (Cambridge: Cambridge University Press, 1989), at 192–5; and James Tully, *A Discourse on Property: John Locke and His Adversaries* (Cambridge: Cambridge University Press, 1980), 68–9.

[52] 'Reflections on Hobbes' Dialogue' in Alan Cromartie, *Sir Matthew Hale 1609–1676: Law, Religion and Natural Philosophy* (Cambridge: Cambridge University Press, 1995), 102, and also Pocock, *The Ancient Constitution and the Feudal Law*, 172.

[53] Quentin Skinner, *Visions of Politics* (Cambridge: Cambridge University Press, 2002), 3:262–3. The concept of 'Whig history' was Lord Macaulay's.

[54] In *What Next in the Law*, see Timothy O'Hagan, 'Four Images of Community', (1988) 8 *Praxis International* 183.

[55] Lowenthal, *The Heritage Crusade and the Spoils of History*, 130.

4. Edmund Burke on Revolution and Tradition

If, as Peter Laslett observes, Locke's property doctrine gave continuity to a political society, joining generation to generation, Burke's special contribution to the rhetoric of heritage was to understand the body corporate as an enduring and inheritable estate.[56] Addressing the threat of national dissolution from radicalism and dissent in his *Reflections on the Revolution in France* (1790), Burke states that it is the "uniform policy" of the English constitution "to claim and assert our liberties, as an *entailed inheritance* derived to us from our forefathers, and to be transmitted to our posterity; as an estate specially belonging to the people of this kingdom".[57] Referring to the Petition of Right presented to Charles I in 1628, Burke maintains that franchises are claimed not on abstract principles "but as the rights of Englishmen, and as a patrimony derived from their forefathers". The idea of inheritance itself "furnishes a sure principle of conservation and a sure principle of transmission":

[John] Selden, and the other profoundly learned men, who drew this petition of right ... preferred this positive, recorded, *hereditary* title to all which can be dear to the man and the citizen, to that vague speculative right, which exposed their sure inheritance to be scrambled for and torn to pieces by every wild litigious spirit.[58]

Having inherited these freedoms, his fellow countrymen were warned by Burke against acting as if they lived in an ahistorical vacuum:

But one of the first and most leading principles on which the commonwealth and the laws are consecrated, is lest the temporary possessors and life-renters in it, unmindful of what they have received from their ancestors, or of what is due to their posterity, should act as if they were the entire masters; that they should not think it amongst their rights to cut off the entail, or commit waste on the inheritance, by destroying at their pleasure the whole original fabric of their society; hazarding to leave to those who come after them a ruin, instead of a habitation – and teaching these successors as little to respect their contrivances, as they had themselves respected the institutions of their forefathers.[59]

Clearly when we talk about heritage, the word itself denotes an inheritance from the past, as does patrimony (*patrimoine*, from *patrimonium*).

[56] Laslett, in Locke, *Two Treatises of Government*, 106–7.

[57] Edmund Burke, *Reflections on the Revolution in France*, ed. L.G. Mitchell (Oxford: Oxford University Press, 1999), 33.

[58] Ibid., 32.

[59] Ibid, 95. An entail (estate tail) in English law is a right inheritable only by a lineal descendant.

Entailment implies an obligation to pass this inheritance on to descendants. Having no great taste for the contractarianism of Locke's *Second Treatise*, Burke married the Whig programme of immemorial custom to patriachalist thinking on primogeniture. The English social order was evidently more than a business partnership between otherwise disengaged individuals: "It is a partnership in all science; a partnership in all art; a partnership in every virtue, and in all perfection...between those who are living, those who are dead, and those who are to be born".[60] In words that echo Burke's formulation of the entailed estate, during the *Proceedings of the Germanists* the folklorist Wilhelm Grimm also insisted on particular origins: "Our forebears were Germans, even before they were converted to Christianity; it is an *ancient* estate, which forms the point of departure for all of us, a condition that has unified us, one with the other, into a bond as Germans".[61] His observation does not come as a surprise since Burke's *Reflections* had a significant influence on conservative German political thinkers following its translation in 1793 by Friedrich von Gentz.[62]

Burke's career was successfully re-launched by his speeches and writings on the French Revolution, which provided him with the opportunity prominently to restate his long-standing opinion that the 'proper' social order was predicated on inequality.[63] In the report of his speech on the Army Estimates, given in the Commons in February 1790 when Britain was assessing its military preparedness, Burke said the following about the French troops:

It was a desertion to a cause, the real object of which was to level all those institutions, and to break all those connections, natural and civil, that regulate and hold together the community by a chain of subordination; to raise soldiers against their officers; servants against their masters; tradesmen against their customers; artificers against their employers; tenants against their landlords; curates against their bishops; and children against their parents. That this cause of theirs was not an enemy to servitude, but to society.

[60] Preceded by: "The state ought not to be considered as nothing better than a partnership agreement in a trade of pepper and coffee, callico or tobacco"; ibid., 96. In contrast to the law of contract which was briskly dispatched, the estate was considered at length by Burke's contemporary William Blackstone in his *Commentaries on the Laws of England*. Contract acquired its present status only during the nineteenth century.

[61] Jürgen Habermas, 'What is a People? The Frankfurt "Germanists' Assembly" of 1846 and the Self-Understanding of the Humanities in the *Vormärz*', in *The Post-National Constellation: Political Essays* (Cambridge, MA: the MIT Press, 2001), 7.

[62] As evidenced, for example, by the writings of Adam Müller (1779–1829).

[63] Ian Harris, introduction to *Edmund Burke: Pre-Revolutionary Writings*, ed. Ian Harris (Cambridge: Cambridge University Press, 1993), xvi–xxxiv.

He wished the Commons to recall the Glorious Revolution in England of 1688:

With us we got rid of the man [James II], and preserved the constituent parts of the state. There they get rid of the constituent parts of the state, and keep the man... In the stable fundamental parts of our constitution we made no revolution; no, nor any alteration at all. We did not impair the monarchy. Perhaps it might be shewn that we strengthened it very considerably. The nation kept the same ranks, the same orders, the same privileges, the same franchises, the same rules for property, the same subordinations, the same order in the law, in the revenue, and in the magistracy; the same lords, the same commons, the same corporations, the same electors. The church was not impaired. Her estates, her majesty, her splendor, her orders and gradations continued the same.[64]

In the last sentence, Burke is referring to the unprecedented appropriation by the French state of church property only three months earlier, in November 1789. The property of the Crown, émigrés and the royal academies were similarly nationalised, and from 1792 major works were concentrated at the Louvre, re-established as a state rather than royal collection, the Abbé Grégoire claiming that "statues, paintings, and books are charged with the sweat of the people: the property of the people will be returned to them".[65] This was a brisk and effective way to create national cultural patrimony, but at the expense of private property. It is certainly less contentious to talk of national treasures when property is publicly owned, whether by rapid appropriation or gradual acquisition.

Responding to the vandalism recently unleashed on buildings, monuments and artefacts, Grégoire writes in 1794 of "un héritage commun", and so understandably has been credited with originating the idea of cultural heritage.[66] But this view underestimates the impact on Paris of Burke's *Reflections*, the French edition of which had sold sixteen thousand copies by July 1791; "an inheritance" was translated as "un héritage",

[64] Edmund Burke, 'Substance of a Speech of the Right Honourable Edmund Burke, in the Debate on the Army Estimates, in the House of Commons, On Tuesday, the 9th Day of February, 1790. Comprehending a Discussion of the Present Situation of Affairs in France'; ibid., 315–18.

[65] Andrew McClellan, *Inventing the Louvre: Art, Politics and the Origins of the Modern Museum in Eighteenth-Century Paris* (Cambridge: Cambridge University Press, 1994), 92 and 98–9; and also Joseph Sax, 'Heritage Preservation as a Public Duty: The Abbé Grégoire and the Origins of an Idea', (1990) 88 *Michigan Law Review* 1142–69.

[66] Ibid., and Brenda Deen Schildgen, *Heritage or Heresy: Preservation and Destruction of Religious Art and Architecture in Europe* (New York: Palgrave Macmillan, 2008), 121–32. Grégoire coins the term "vandalisme".

"an *entailed inheritance* derived to us from our forefathers" becoming "un héritage qui nous avoit été *substitué* par nos ayeux".[67] Grégoire's appropriation, surely not without irony, of Burke's idea of a collective inheritance/héritage would appear to serve three ends: to legitimate state taking of property on behalf of the people; to dissuade citizens from damaging what is 'properly' theirs; and also, as Anthony Vidler argues, to oppose the centralisation in Paris of monuments and other cultural objects.[68] In doing so, he expands Burke's concept to include cultural practices that have a material form, as would the critic John Ruskin later.

Despite an expansive sense of the social contract, Burke was not a Romantic and the British body politic was not for him an organic one. A line is drawn between the ephemerality of organic growth (and decay) and the longevity and stability of a complex political institution, where the latter might be seen as a 'moral machine'. As noted by Walter Love, Burke uses architectural as much as organic imagery, speaking of buildings, frames and edifices that could be altered, improved, repaired and renovated, as were country houses like his own on an estate at Beaconsfield. These gentry images spoke of permanence, with only gradual change: "I would make the reparation [in political life] as nearly as possible in the style of the building". However, he readily applied the organic image of youth to the evolution of American society, "the most growing branch" of the English nation, as he did the image of parent and child derived from Stuart patriarchalist thinking.[69]

The sense of order that Burke found in late eighteenth-century English society was manifest in the roles that were publicly available – soldiers

[67] *Reflexions sur La Revolution de France* (Paris: Laurent fils, 1790, second edition, Eighteenth Century Collections Online. Gale. University of Pennsylvania Library, 2009), 62; and F.P. Lock, *Edmund Burke, Volume II: 1784–1797* (Oxford: Oxford University Press, 2006), 332.

[68] "Les monumens des arts étant un héritage commun, tous les départements y ont droit", Henri Grégoire, *Instruction publique, Rapport sur la bibliographie*, 11 April 1794, in *Oeuvres de l'Abbé Grégoire*, vol.2 (Nendeln: Kraus-Thomson Organization, 1977), 211, translated by Anthony Vidler as "Artistic monuments being a common inheritance, all departments have a right to them", in 'The Paradoxes of Vandalism: Henri Grégoire and the Thermidorian Discourse on Historical Monuments', in Jeremy D. Popkin and Richard H. Popkin, eds., *The Abbé Gregoire and His World* (Dordrecht: Kluwer, 2000), 142, where he also notes that Grégoire had absorbed Burke's notion of the sublime. French departments are administrative districts.

[69] See Walter D. Love, 'Edmund Burke's Idea of the Body Corporate: A Study in Imagery', (1952) 27 *The Review of Politics* 184–97, and also David Lowenthal, *The Past is a Foreign Country* (Cambridge: Cambridge University Press, 1985), 108–9.

and officers, servants and masters, tradesmen and customers, artificers (craftsmen) and employers, tenants and landlords, curates and bishops – and the social rules and expectations that enabled and constrained what each player might appropriately or inappropriately do. The ownership of land by the aristocracy and gentry and the distribution of political power among them, together with the shared enjoyment of country activities such as hunting (the 'civilian' corollary of military pursuits), and accomplishment in the polite arts, all held Burke's society together. What so distressed him about France was the dismemberment of that consensus, the abandonment of rules, the shredding or exchanging of roles and the threat to the ordering of social classes. At the heart of Burke's sensitivity to what we are now calling cultural heritage were sets of customary political and economic relationships that, in his view, only gradually evolved within Western states through a balancing of powers, of sovereign and council, parliament and judiciary, aristocracy and minor gentry. Life should be transmitted in the way that an entailed estate was transmitted from generation to generation.

The gradual evolution of the common law notwithstanding, customary relationships are vulnerable to change, replaceable by others better suited to present needs; they changed in France and America, in the former case hatefully to Burke, and in the latter quite rationally. Wordsworth came to see tradition at the heart of national life, having revised his initial sympathy for the French Revolution: "There is a spiritual community binding together the living and the dead, the good, the brave, and the wise, of all ages".[70] In fact, tradition as reflected in current practice may not be as long-standing as practitioners believe. David Cannadine demonstrates that although the ritual of twentieth-century British royal weddings and state funerals has contrived to appear immemorial, such occasions were actually done very badly for most of the nineteenth century.[71] And yet the

[70] *Convention of Cintra*, cited in Alfred Cobban, *Edmund Burke and the Revolt against the Eighteenth Century: A Study of the Political and Social Thinking of Burke, Wordsworth, Coleridge and Southey* (London: George Allen &Unwin, 1960), 2nd ed., 147; Simon Schama, *A History of Britain: the Fate of Empire, 1776–2000* (New York: Hyperion, 2002), 98–106.

[71] See David Cannadine, 'The Context, Performance and Meaning of Ritual: The British Monarchy and the "Invention of Tradition", c. 1820–1977', in E.J. Hobsbawm and Terence Ranger, eds., *The Invention of Tradition* (Cambridge: Cambridge University Press, 1983), 101, 130–1, 136–7. For example, in 1817 the undertakers were drunk at the funeral of Princess Charlotte; at George IV's coronation, prize fighters were employed to keep the peace between the "distinguished but belligerent guests"; at George's funeral

eighteenth-century practices valued by Burke differed in one key respect from those of pre-Reformation Britain. Prior to the break with Rome, *contra* Coke's position, English life was an amalgam of language, customs and laws derived from divers sources in continental Europe, among which and vitally so were the many practices of Catholicism, a pan-European ideology. The dismantling of its Catholic past had profound consequences for almost every aspect of life, not least the construction of a national self in subsequent centuries. The ceremonial language of Rome was replaced by the vernacular of the King James Bible. Buildings, works of art, priests and their ritual paraphernalia, sacred objects and ceremonies were pushed to the fringes of a society in which they had not only been central, but defining. Burke's emphasis on the political and legal continuity of the state continued the elision of prior custom, maintaining that Britain's own revolution of 1688–9 had not touched the church.

Forty years after the *Reflections*, but "while the crash of the proudest throne of the Continent is still resounding in our ears", Thomas Babington Macaulay addressed parliament on a proposed act that would now enfranchise the middle classes. He argued that the middle classes would use their votes to overthrow neither the monarchy nor aristocracy, since these were found to be valuable and useful still. Macaulay invoked the idea of a British heritage that was indeed the greatest of all:

Renew the youth of the State. Save property, divided against itself. Save the multitude, endangered by its own ungovernable passions. Save the aristocracy, endangered by its own unpopular power. Save the greatest and fairest and most highly civilised community that ever existed from calamities which may in a few days sweep away all the rich heritage of so many ages of wisdom and glory. The danger is terrible. The time is short.[72]

In 1849 Ruskin forcefully applied Burke's synthesis of Whiggishness and patriarchalism to the preservation of cultural things:

God has lent us the earth for our life; it is a great entail. It belongs as much to those who are to come after us, and those whose names are already written in the book of creation, as to us; and we have no right, by anything that we do

William IV talked constantly and walked out early, *The Times* noting that "We never saw so motley, so rude, so ill-managed a body of persons".

[72] Thomas Babington Macaulay, *Speech on Parliamentary Reform*, delivered 2nd March 1831.

or neglect, to involve them in unnecessary penalties, or deprive them of benefits which it was in our power to bequeath.[73]

... and yet, be it heard or not, I must not leave the truth unstated, that it is again no question of expediency or feeling whether we shall preserve the buildings of past times or not. *We have no right whatever to touch them.* They are not ours. They belong partly to those who built them, and partly to all the generations of mankind who are to follow us. The dead have still their right in them.[74]

Here Ruskin is referring to the destruction and insensitive restoration of the European, particularly British and Italian, built environment. Anticipating much contemporary soul-searching (and litigation) around the conservation of British architecture, he speaks to the idea that we hand on an inalienable inheritance, and that the present generation has no right to interfere with the integrity of monuments that are to inspire and be experienced by generations that follow. I certainly don't wish to diminish the very important contributions made by Ruskin and Grégoire in raising consciousness of the value of fine architecture, respect for which is much more widespread than in their day. Rather I want to draw attention to the cultural narratives through which that respect emerged, and the role that British connoisseurs were to play:

We are still undegenerate in race; a race mingled of the best northern blood ... We have taught a religion of pure mercy, which we must either now betray, or learn to defend by fulfilling ... Within the last few years we have had the laws of natural science opened up to us with a rapidity which has been blinding by its brightness; and means of transit and communication given to us, which have made but one kingdom of the habitable globe. One kingdom; – but who is to be its king? ... Or will you, youths of England, make your country again a royal throne of kings; a sceptred isle, for all the world a source of light, a centre of peace; mistress of Learning and of the Arts.[75]

Jonathan Richardson, writing in 1719 on connoisseurship, is emphatically able to appreciate Italian art without being "enticed and drawn away to idolatry," or "polluted" and transformed into a brute. He is a member

[73] John Ruskin, *The Seven Lamps of Architecture* (Orpington: George Allen, 1890), 2nd ed., 337–8.

[74] Ibid., 357–8.

[75] John Ruskin, from the 1870 Slade Lectures at Oxford, quoted in Edward Said, *Culture and Imperialism* (London: Chatto & Windus, 1993), 123–4. Chris Miele distinguishes progressive and conservative attitudes toward conservation from the eighteenth century onwards, 'Conservation and the Enemies of Progress?' in Chris Miele, ed., *From William Morris: Building Conservation and the Arts and Crafts Cult of Authenticity 1877–1939* (New Haven: Yale University Press, 2005), 1–29.

of the Church of England: "the best national church in the world... a body of free men... all connoisseurs as we are Protestants".[76]

5. Good Roles and Bad Practices

As we have seen above, cultural stories make a significant contribution to the construction of heritage. Jerome Bruner comments about them thus:

> It has been the convention of most schools to treat the art of narrative – song, drama, fiction, theater, whatever – as more 'decoration' than necessity, as something with which to grace leisure, sometimes even as something morally exemplary. Despite that, we frame the accounts of our cultural origins and our most cherished beliefs in story form, and it is not just the 'content' of these stories that grip us, but their narrative artifice.[77]

Narratives make available a stock of roles, often gender-specific, with which particular virtues are associated (I agree with Finnis that virtues – courage, generosity, moderation, gentleness – are not values).[78] Exemplary characters are indeed 'undegenerate': brave, noble, loyal, straightforward, righteous, generous, respectful, graceful, strong, farsighted, learned, wise, and so forth. Oppositional characters are cowardly, base, treacherous, cunning, dishonest, mean, thoughtless, clumsy, weak, myopic, ignorant and foolish. Virtues are also associated with particular periods. The importance of narrative has been highlighted within contemporary political thought by Alasdair MacIntyre, who claims that communal narratives and traditions within which individual lives are composed are central to identity, and that roles and practices provide the arena in which virtues are exhibited. Like other communitarian thinkers he contends that there is a necessary relationship between cultural identification and individual well-being, as indeed do certain liberals, as we shall see in Chapter 6.

MacIntyre's position is that the intentions which lie behind any particular behaviour cannot be understood without referring to the setting in which it is enacted, and such a setting must have a history that contributes to the intelligibility of the action. Since "man is... essentially a story-telling animal," the question that he should therefore ask is "Of

[76] E.H. Gombrich, *The Preference for the Primitive: Episodes in the History of Western Taste and Art* (London: Phaidon, 2002), 48–9.

[77] Jerome Bruner, *The Culture of Education* (Cambridge, MA: Harvard University Press, 1996), 40, quoted in Geertz, *Available Light, Anthropological Reflections on Philosophical Topics*, 193.

[78] John Finnis, *Natural Law and Natural Rights* (Oxford: Clarendon Press, 1980), 90–1.

what story or stories do I find myself a part?"[79] To understand how others respond to us we need to comprehend the social roles into which we have been drafted, and these roles are illuminated by the stories we tell to each other. The only way to make sense of any culture is through its stock of stories. Without access to them our children will be "unscripted, anxious stutterers in their actions as in their words". We should each see our life as a narrative, in which the unity of our character within the narrative over time makes sense of our identity. More than that, we should see it as a narrative quest, in which there is a goal, and the goal is a conception of the good. Hence we should devise political communities that promote the search for virtuous lives. As MacIntyre conceives it, we can only approach this desirable search for virtuous ends as bearers of a particular social identity:

> I am a citizen of this or that city, a member of this or that guild or profession; I belong to this clan, that tribe, this nation. Hence what is good for me has to be the good for one who inhabits these roles. As such, I inherit from the past of my family, my city, my tribe, my nation, a variety of debts, inheritances, rightful expectations and obligations. These constitute the given of my life, my moral starting point. This is in part what gives my life its own moral particularity . . . the story of my life is always embedded in the story of those communities from which I derive my identity. I am born with a past; and to try to cut myself off from that past, in the individualist mode, is to deform my present relationships.[80]

The stories with which MacIntyre requires our familiarity in order to live full, purposeful lives can equally be trans-national or sub-national. Indeed, stories associated with the arts, sciences, political discourse, sport and media are often trans-national, or have trans-national components.[81] In the United States, a country that prides itself on the constitutional separation of church and state – in which political battles are fought over the display of the Ten Commandments in civic buildings – narratives promoted by many citizens may not be imposed on all citizens (although it may be argued that in the interest of neighbourly relations, all citizens should make an effort to learn about the ideological beliefs of their neighbours). So are there core stories that should command the attention of all Americans? Certainly there are a few known to all by dint of being universally taught in schools and memorialised in public holidays: the European settlement and the War of Independence are two principal

[79] Alasdair MacIntyre, *After Virtue* (Notre Dame: University of Notre Dame, 1984), 215.
[80] Ibid., 220–1.
[81] Sports, for example, tend to be trans-national, although there are national, even regional sports, such as Australian Rules Football which is played predominantly in the southeast of that country.

foundation stories, both promoting the idea of a free and independent people. MacIntyre is surely right about the profound influence that stories have in framing our attitudes toward the world. A similar point is made by Thomas Alexander in writing about John Dewey's approach to understanding the world: "Unless one has lived and interacted with others, learned a language and participated in a culture with its stories and traditions, one cannot even begin asking questions".[82] Like MacIntyre, I believe that narratives are central to particular cultures, each of which has thousands of interrelated stories, sacred and secular, all associated with cultural practices, the practitioners of which are seeking intrinsic and instrumental benefits, as all of us do, always. 'Heritage' objects, then, are deeply associated with aggregations of cultural narratives, practices, values and virtues.

MacIntyre regards traditions as having vitality only when they embody conflict about goods, so that Burkean traditions are always "dying or dead" (the "crust of convention", as Dewey put it). A living tradition is "an historically extended, socially embodied argument".[83] Part of the problem, however, with MacIntyre's search for communally endorsed virtues is that narratives and traditions are often exclusionary, as underlined by his focus on the early nineteenth-century English reformer William Cobbett, about whom he writes that

'the something at work in the community' which counteracts the tendency to produce a virtuous and happy community is the all-pervasive influence of *pleonexia* (although that is not Cobbett's word) in the form of the usury (which is Cobbett's word) inflicted on society by an individualistic economy and market in which land, labor and money itself have all been transformed into commodities.[84]

Cobbett promoted a unitary narrative of community well-being, his anti-capitalism put to work on behalf of the rural working class, but he achieved it by taking racism as a partner and laying the source of usury at a familiar door; he opportunistically championed abolitionism only when he saw it becoming popular in his own constituency.[85] He could have talked about usury simply as a bad practice to be eliminated, but his

[82] Cited in David L. Hildebrand, *Beyond Realism and Antirealism: John Dewey and the Neopragmatists* (Nashville: Vanderbilt University Press, 2003), 189.

[83] Dewey is cited in Richard Rorty, *Contingency, Irony, and Solidarity* (Cambridge: Cambridge University Press, 1989), 66; see also MacIntyre, *After Virtue*, 222.

[84] Ibid., 239. *Pleonexia* may be translated as avarice.

[85] The "Jew dogs" had turned London into the "Jew Wen" (tumour); see Schama, *A History of Britain: The Fate of Empire, 1776–2000*, 126–35. Cobbett does, however, come to refer to London in general as "the Wen"; see David Bromwich, *A Choice of Inheritance: Self and Community from Edmund Burke to Robert Frost* (Cambridge, MA: Harvard

agenda had on it more than the creation of an honest and equitable society: it was an honest and equitable society, the story of which excluded certain stereotypical roles. Cobbett wanted his England to be a particular sort of England, an England with a distaste for the cosmopolitan, in which people held virtues in common (lack of envy, love of liberty, perseverance and industry, etc.) and followed common practices (viz., Cobbett's), as distinct from a country in which citizens with diverse interests might make their own choices about the goods that they as individuals wished to pursue. It is not anachronistic to wish that Cobbett might have held more liberal principles – John Stuart Mill was a younger contemporary – but this was also the England of Thomas Carlyle, who had absorbed not only Burke's taste for immemorial custom, but also the contemporary Germanist preference for *Gemeinschaft* over *Gesellschaft*.

A generation after Cobbett and Carlyle, the latter praising the dignity and self-sufficiency of medieval communities, John Ruskin and then William Morris championed the revival of community life in which workers felt engaged and respected, serving goods higher than those which animated an industrial society devoted to contract.[86] It wasn't that leaders of the arts and crafts movement were seeking to elevate *Gemeinschaft* over *Gesellschaft* as such, but rather to attack as aesthetically and morally pointless a manufacturing system that passed off shoddy wares and demeaned those who made them. As Morris put it at a meeting in Manchester in 1891, where he employs the term 'heritage' both in its original meaning (of an inheritance) but also in Burke and Macaulay's sense:

Thus we go round the vicious circle, first employment for the production of useless things; then production of useless things in order that employment may not fall short. Is not this of the very essence of waste? Tell me, I pray you, what is more precious, what is more necessary, to the progress of the world than the skill and force of the workman, the craftsman, which is more truly the heritage handed down to us by countless years of tradition? Yet this precious heritage our society of commercial privilege wastes light-heartedly as if it were a part of the nature of things to make the worst of that which is the best of things, the token and reward of the world's progress, the hope of its future.[87]

University Press, 1989), 88. This is much stronger language than we find in Burke, but the theme is present in *Reflections on the Revolution in France*, 49 and 261–2.

[86] Morris and Edward Burne-Jones were particularly influenced in their youth by Carlyle's *Past and Present* (1843); see Charles Harvey and Jon Press, *William Morris: Design and Enterprise in Victorian Britain* (Manchester: Manchester University Press, 1991), 19.

[87] William Morris, *Socialism Up-to-Date*, 4 October 1891, New Islington Hall, Ancoats, Manchester.

In this regard, Ruskin and Morris shared with Cobbett a public disdain for *selfish* individualism pursued at the expense of others, which raises familiar questions for liberals about the extent to which they should tolerate socially imposed duties. Since only communitarians would have us duty-bound to foster a 'good society' for its own sake, liberals who respond sympathetically to Ruskin and Morris's complaint will need a more socially dependent version of autonomy, wherein autonomous individuals will also wish to promote autonomy for others.

In a parliamentary minute of 1835, Macaulay made the case that for the purpose of educating Indian youth only the English language should be privileged by British government funding, as opposed to Sanskrit or Arabic.[88] Now it is one thing to believe as Macaulay did wrongly that English political and literary culture is objectively superior, but quite another to suggest that only those cultures from which political liberalism emerged can achieve a liberal state, since liberal tenets can be applied by any culture (theoretically at least). Nonetheless, liberals do remain concerned about the exclusionary nature of illiberal societies and the condemnation of the young of certain groups. Does showing respect to tradition commit us to a world in which there is no way to evaluate things other than within their local context, and to an ongoing and dangerous relativism that requires us to endorse practices of which we disapprove? Ernest Gellner thought so, as does Roger Sandall, who sets up Gellner as the voice of civilisation against the unreasoning romanticism of Wittgenstein.[89]

Sandall is angry about 'designer tribalism', an attitude that encourages the status quo with regard to local cultural practices. The argument goes that unreflective support of local cultures, and in particular tribal cultures, has had three negative effects. The first is that tribal peoples are hindered in their progress towards the goods of a liberal democracy, the second is that they tolerate oppressive practices that have value only for dominant (generally male) factions with the local culture, and the third is that the values of Western democracies and their intellectual and scientific

[88] Thomas Babington Macaulay, *Minute of 2 February 1835 on Indian Education*.

[89] Gellner traces the 'relativism' of Wittgenstein's *Philosophical Investigations* to the intellectual climate of early twentieth-century Vienna, and the legacy of Herder's revolt against Kant's foundationalism. Championing the scientific spirit of Enlightenment rationalism he praises Karl Popper, who had lumped Herder together with the pernicious strand of nationalism associated with Fichte. See Ernest Gellner, *Language and Solitude: Wittgenstein, Malinowski and the Habsburg Dilemma* (Cambridge: Cambridge University Press, 1998).

contribution to civilisation are diminished by a generation of politically correct 'do-gooders'. He sees tribal peoples being denied access to civilisation – in Tönnies's sense – by misguided attempts to keep them embedded within community practices that are blind to the benefits of liberal goods, such as those on Rawls's list. Sandall's focus has been on Australian Aborigines and what he sees as the disastrous effect on their quality of life by governmental policies intended to preserve cultural heritage at the expense of integration into mainstream education, with its curricular exposure to the English language and the sciences. He is indignant at what he regards as foolish endorsements of policies that attempt to maintain indigenous cultural heritage at the expense of providing young Aborigines with the opportunity to participate fully in the country's liberal democratic society. Aside from Wittgenstein, his targets include Rousseau, Herder (whose "love of ethnicity was largely an inversion of his hatred of civilization") and Isaiah Berlin.[90] His advocacy of 'negative liberty' notwithstanding, Berlin receives Sandall's disapprobation on account of his sympathy to Herder.[91] The argument somewhat parallels Merryman's critique of 'Byronism'. Here is an opposite position to Sandall's, taken by Richard MacPhail in a paper given at the Bamiyan conference in India:

Cultural diversity – by which I mean religious, social, ethnic, and linguistic diversity – is constantly under pressure for those who value it and those whose primary identity is founded in its particularities, to separate themselves from dominant trends, or be assimilated to an undifferentiated mass of humanity with its common values and commodifying mentality.[92]

However, at the least, we should be mindful that many traditional societies are both authoritarian and patriarchal, limiting the capacity of members to revise their ends; and further, we should be extremely cautious about accepting the idea that all social practices are worthy of protection. Many people in many cultures might agree on the virtue of certain virtues and the vice of certain vices, but it is perfectly common for basic values (e.g., friendship and religion) to be advocated within the context of oppressive practices. Since strong expectations strongly encourage

[90] Sandall contrasts Berlin's supposed 'need to belong' to Karl Popper's own august rejection of ethnic identity and correspondingly firm cosmopolitanism. Roger Sandall, *The Culture Cult: Designer Tribalism and Other Essays* (Boulder: Westview Press, 2001), 90.

[91] The concept of negative liberty asserts the right of individuals to pursue their personal goals protected from the imposition of any other individual or community idea of the 'good', so long as those pursuits do not cause harm to others.

[92] 'Cultural Preservation and the Challenge of Globalisation', in K. Warikoo, ed., *Bamiyan: Challenge to World Heritage* (New Delhi: Bhavana, 2002), 170.

expected behaviours, there exist societies in which it is difficult to revise and reject any cultural practice, which is not to say that social life may not simultaneously be illiberal and moral (and include, for example, the virtue of kindness). Certainly the subsidiary place of women in many cultures is affirmed by just those traditional practices that 'heritage' gathers under its wing. For example, it would be impossible for women to detach themselves from many practices (such as wearing approved clothing) and remain comfortably within those cultures; it is fairly clear, for example, that women under the Taliban regime do not have the opportunity to follow *any* practices other than those prescribed by the ruling regime, for to do so would result in severe punishment. And in reality, progressive, oppositional or even reactionary versions of existing practices evolve through verbal or physical conflict. A familiar and troublesome problem for liberals is how to relate to illiberal societies, or to societies that allow their citizens a degree of autonomy in their social and commercial lives but not democratic participation or peaceful opposition, or to sub-groups within liberal societies that restrict opportunities available to members. We live in a world in which there are many illiberal practices; indeed, as Will Kymlicka notes, all cultures have illiberal strands.[93]

The heritage that reflectively vaunts about its own bad practices as such is unknown; tyrants are prone to promote themselves as virtuous guardians of the people and ethnic cleansing as a necessary step in the advancement of the state. Cultures generally elide bad practices, whether within modern nation-states or tribal cultures, and it is rare even among modern democracies for official rhetoric to dwell on past injustices or worse (such as slavery and massacres). Most of our national pasts have areas with little appeal to historians only of virtue and heroism. The performance of classical music under the Third Reich required no change in musical practice, although it did require a willingness on the part of the performers to ally (musical) practices with oppressive behaviours, tied to a perverse narrative, demonstrating that certain art forms can serve totalitarian states as much as liberal democratic ones. Thankfully, few now wish to champion the rhetoric of the Third Reich.

Unsurprisingly, illiberal ideologies and practices give liberals a problem with MacIntyre's position on the need for common narratives (heritage stories) in order to promote virtuous behaviour. Rhetorical constructions originally served a specific political purpose, such as the Whig myth of

93 Will Kymlicka, 'Dworkin on Freedom and Culture', in Justine Burley, ed., *Dworkin and His Critics* (Oxford: Blackwell, 2004), 126.

immemorial custom, but they may not suit us now. A principal issue at stake for Elizabeth Frazer and Nicola Lacey in their comments on MacIntyre's concept of practice is that many practices are exclusionary, and not just in Western societies.[94] To help with the problem of illiberal practices, Charles Taylor has suggested that the following presumption is valid (which he notes requires something like an act of faith): all human cultures which have animated whole societies over some considerable period of time have something important to say to all humans. Since we should not require all cultures to say important things all the time, this presumption excludes "partial cultural *milieux* within a society, as well as short phases of a major culture".[95] Thus we should not dismiss the many important things Germans have to say to us because of the National Socialist era (the "criminal chapter", as Habermas puts it).[96]

Michael Walzer sees the problem of illiberal practices arising from the deep difference between voluntary association, a characteristic of liberal democracies, and involuntary association such as family membership. Elders in traditional and fundamentalist cultures wish to see their practices reproduced, and familial and community allegiances encourage such reproduction rather than the reflective deliberation promoted by liberals. In addressing cultural rights, he notes that although groups who promote illiberal practices represent the strongest version of involuntariness, involuntary association (beyond the family) is a common cultural phenomenon.[97] One way forward is to encourage individuals to take on the role of citizen alongside their other commitments and thereby participate in the democratic process: "Democracy requires the common life of the public square and the assembly, and certain understandings must be shared among citizens if what goes on in those places is to issue in legitimate laws and policies".[98] Walzer's point is a fine one, namely, that citizens of a liberal democracy should determine the minimal standards of education necessary for citizenship. In addition, the role of citizen within

[94] Elizabeth Frazer and Nicola Lacey, 'MacIntyre, Feminism and the Concept of Practice', in John Horton and Susan Mendus, eds., *After MacIntyre: Critical Perspectives on the Work of Alasdair MacIntyre* (Notre Dame: University of Notre Dame Press, 1994), 265–82.

[95] Charles Taylor, 'The Politics of Recognition', in Amy Gutmann, ed., *Multiculturalism: Examining the Politics of Recognition* (Princeton: Princeton University Press, 1994), 66.

[96] Jürgen Habermas, 'On the Public Use of History', in *The Post-National Constellation*, 27.

[97] Michael Walzer, *Politics and Passion: Toward a More Egalitarian Liberalism* (New Haven: Yale University Press, 2004), 44–65.

[98] Ibid., 61–65.

a pluralistic democracy allows people to recognise as equals those from different cultural backgrounds.

Liberals, however, have to face the prospect of a rejection of their principles (in various versions) by illiberal groups and nations, which tests the desire to reach broad agreement about what cultural heritage means, and how we create policy toward it. As noted above, there are problems simply because of the extent to which heritage depends on narrative – which resists easy containment. For example, narratives that originate in one culture can become embedded in those of another, generating rather different understandings to those they originally had (indeed 'original' versions of cultural stories are themselves elusive, other than those clearly authored by an individual).

Frazer and Lacey suggest that, although people might search for narrative unity, they may in reality have to accept a fragmented and conflicting cultural narrative that doesn't add up to the homogeneity of, say, the ancient Greek world which MacIntyre invokes.[99] Cultures are made up of many components, and they change over time as practices and values are challenged. In the last two decades alone, the Western world has witnessed a growth in non-traditional families, inter-cultural marriages and relationships, and there are now many more people than there would have been even a generation ago who have multiple sets of cultural practices from which to choose. And while it is clear that some scripts about our pasts are unitary, others are fragmentary or internally inconsistent or demonstrably manipulated, as so well captured by Günter Grass in his 1999 collection, *My Century*. Here twentieth-century Germany is 'recalled' through the telling of 100 fictions and quasi-fictions, one per year, that combine in a way that is dark and deeply compelling, and completely subverts the idea of a unitary heritage.

[99] Frazer and Lacey, 'MacIntyre, Feminism and the Concept of Practice', 279.

4

"This Culture of Ours"

Who is not swayed to follow the commands of the great ruler? You might
instruct the ministers responsible for composition to restore the ancient tao
and invite erudite shih, placing them in advisory positions, in order to save
This Culture of Ours.

Fan Zhongyan[1]

1. The Life of Images

That the heritage of a country is an unproblematic given is simply not
borne out in reality. The conflict in Britain between Catholic and Protes-
tant practices, and the elision of the former in the construction of British
heritage, demonstrates clearly that heritage is a complex business. This is
surely so for all cultures. In this chapter I look at a not dissimilar contest
in central and east Asia, and also think about images and relics; these
feature largely in debate about cultural property, as they do in religious
disputes.[2] The Parthenon/Elgin Marbles were themselves originally votive
images, for a religion that no longer has practitioners.

When images play an apparently pivotal part in social life, the gods
themselves are social performers, even if they require human interme-
diaries to interpret for them. An act of devotion recorded in Singapore

[1] Letter to the Song Dynasty Emperor Renzong and Empress Dowager in 1025, in Peter K.
Bol, *"This Culture of Ours": Intellectual Transitions in Tang and Sung China* (Stanford:
Stanford University Press, 1992), 167. Within this chapter I use pinyin romanisation
rather than the Wade Giles system favoured by Bol; *tao* (Way) and *shih* (members of the
elite) would thus be transcribed as *dao* and *shi*.

[2] See David Freedberg, *The Power of Images: Studies in the History and Theory of Response*
(Chicago: University of Chicago Press, 1989), especially Chapter 2.

ca. 1969, although unusual, highlights how plastic the individual under-standing of any such action can be. It involved an image with a dual identity, the reading of which is established by the worshipper. An el-derly lady who frequented a particular 'shop-house' temple and often made minor offerings there one day brought in a tin model of a mounted horseman that she placed on the main altar (where it stayed), asserting it was Guandi, God of War (or Loyalty).[3] As with many other Chinese gods, Guandi's image can be identified only by context and attributes, one of which is the horse Red Hare without which he can be confused with other martial spirits.[4] During future visits, the lady continued to make obeisance to the main temple image but always stroked the horseman. To others, however, it was a wind-up clockwork toy of an American cowboy, complete with pistol, mask and chaps (Fig. 10).[5]

The use of images as vehicle for the *persona* of gods depends neither on naturalistic correspondence nor on iconographic accuracy, as is clear from this example, although the worshipper's obeisance will seem misplaced or indeed comical to other devotees. This tale is a useful one insofar as it reminds us that from the perspective of the faithful, the god, ancestor or spirit as *actor* is profoundly linked to an image, and this is true for many religions. In a culture like China's, in which the dead are still instrumentally active, it becomes hard to say that the image is 'only an image', in the way we would say that the Lansdowne Portrait of George Washington is *only* an image. Likewise images of the saints in Catholic churches for many believers are more than just depictions. The analogy of actors and roles holds well. In traditional Chinese culture and others with a rich pantheon of gods, where sculpted and painted images provided the means by which deities and other spiritual beings manifest themselves, the specific manner in which the deity is shown helps put the role into action for believers. In the above story, the role (Guandi)

[3] The temple was converted from a shop.

[4] Such as the four Buddhist heavenly kings and Weituo, protector of Buddhist texts. Guan Yu was an historical general who became a central character in the *San Guo zhi*, an epic romance set during the collapse of the Eastern Han (25–220 CE), and the following Three Kingdoms. There are acceptable alternatives to conventional depictions, as in the case of the Bodhisattva Dizang, guide of souls, traditionally shown as a young monk but also represented as a spirit magistrate.

[5] I am grateful to Keith Stevens for this story, and for allowing me to reproduce his photograph of the toy that he identified as the Lone Ranger. See also his *Images of the Other Side: Folk Gods of China* (Durham: University of Durham Oriental Museum, 1992), *Chinese Gods: The Unseen World of Spirits and Demons* (London: Collins & Brown, 1997), and *Chinese Mythological Gods* (Oxford: Oxford University Press, 2001).

FIGURE 10. *Clockwork American Cowboy, possibly Hong Kong, 1960s, tin. Courtesy of Keith Stevens.* Placed by a worshipper on the altar of a Singapore 'shop-house' temple, she treated this model as an image of Guandi, God of War (or Loyalty), an important deity in the Chinese popular religious pantheon.

was appropriate to the temple, but the actor (the cowboy) lacked the necessary attributes of costume and bearing to be successful in the role for the community at large, and consequently there was a considerable gap between its private and public meanings. Seen from the different viewpoint of aesthetic judgment, the tin cowboy belongs not to the art form of Chinese sculpture but to the practice of making toys, which can have their own charm and attraction to adults.

Here is a response given in the twelfth century by a Buddhist monk, Jujiu, to the question posed by a Chinese official, Liu Yizhi, on the inherent tension between manufactured image and active spirit, specifically in relation to the Bodhisattva Guanyin, a great Buddhist divinity who by that time had acquired an additional role in China as a miracle-working community god (Fig. 11, illustrated here by a late medieval wooden sculpture lacking its original polychromed surface):

The goddess's manifestations are limitless. Because she has no one place of her own, but is worshipped in the hearts of believers, she thus has a place. I see that monks and lay people go in front of the statue, gather their robes and bow, burn incense and pray on their knees, and tell her of all their illnesses and troubles and ask her for help...I admire the place she is worshipped and make it imposing

FIGURE 11. *Guanyin, China, Song or Jin dynasty, twelfth or thirteenth century CE, wood with traces of pigment, 175 cm. Courtesy of the University of Pennsylvania Museum (54-6-6).* In China, the originally male Buddhist divinity Guanyin (Avalokiteshvara in Sanskrit) was widely seen from the late medieval period as a female, and also incorporated into popular religion, serving as a regional agricultural spirit.

in order to augment their faith... They will know that the bodhisattva does not arise from her image. She is everywhere, in all directions. Every place is her place of worship. And this place of worship is nowhere specific.[6]

[6] Temple inscription of 1157, in Valerie Hansen, *Changing Gods in Medieval China, 1127–1276* (Princeton: Princeton University Press, 1990), 169–70. Guanyin was originally male, except when specifically manifest as female; the *baiyi* (white-robed) and *songzi*

In most cultures, relationships with gods, ancestors and other spirits are understood to affect the well-being both of communities and individuals, but although many people take their own gods to be lively contributors to the community's social and ethical life, it is rare for them to take a similar interest in the gods of others, or in the images and symbols that represent them.

Typical of the cultural forms that the Native American Graves Protection and Repatriation Act seeks to protect are the Zuni War Gods removed from surrounding mountains in the southwest and re-enshrined in museums and private collections. Working together with anthropologists and archaeologists, Zuni leaders persuaded thirty-four institutions of the moral rectitude of their claim, and by 1991 had succeeded in recovering sixty-five figures, almost all those known to be in American museums and private collections.[7] Their success in reclaiming so many images testified not only to the strength of the campaign, but also to a corresponding mood within America to remedy past injustices where politically possible and expedient, and to acknowledge the importance of self-determination for native peoples. The return had a very strong symbolic component. The claims for the War Gods that were sold on or given by third parties to museums and other collections were not advanced on aesthetic grounds but on the basis that these deities were active participants in the lives of the Zuni people. Thus, one can readily appreciate how tensions might build between the Zuni, anxious about the images not being allowed to decay back into the land, and museum curators concerned about just that. For members of the Zuni, the images may be said to possess intrinsic (religious) value and instrumental value (to bring good harvests and to promote political self-determination). Museum curators may be sympathetic to the above, but since members of both groups have different agendas, their values are sometimes incommensurable and competing.

Citing the case of *Pramatha Nath Mullick v. Pradyumna Kumar Mullick*, referred in 1925 from the High Court of Calcutta to the English Privy Council, Lyndel Prott and Patrick O'Keefe observe that 'property'

(child-giving) manifestations were probably supported principally by women. Canonically Guanyin resided on Mt. Potalaka off the South Coast of India; from about the twelfth century, however, Putuo Island, near to the port of Ningbo in the southeast, was locally regarded as Potalaka.

7 Adele Merenstein, 'The Zuni Quest for Repatriation of the War Gods: An Alternative Basis for Claim', (1992) 17 *American Indian Law Review* 591–2.

and 'ownership' are essentially Western concepts that may have little relevance to social practices in non-Western cultures, where the insider attitude is "deeply respectful of heritage objects".[8] *Mullick v. Mullick* brings out three different issues pertaining to the treatment of images of 'other peoples': first, the foreignness of another religion and its 'idols'; second, the religious effectiveness of an image; and third, the special treatment we extend to religious images as distinct from other, more mundane forms of property.[9] This case involved the guardianship of a principal Hindu household image that had passed by succession from the founder to his widow, who in turn had endowed it to their adopted son and to his sons.[10] The Council was of the opinion that the interests of the 'idol' itself and of its female worshippers needed special protection. Lord Shaw, observing that according to Hindu law an image ('idol') is a juristic entity which, though symbolising the Divinity, has status as a separate *persona*, stated that

it has a juridical status, with the power of suing and being sued. Its interests are attended to by the person who has the deity in his charge and who is in law its manager with all the powers which would, in such circumstances, on analogy, be given to the manager of the estate of an infant heir ... There may be, in the nature of things, difficulties in adjusting the legal status of the idol to the circumstances and requirements of its protection and location, and there may, no doubt, also be a variety of other contacts of such *persona* with mundane ideas. But an argument which would reduce a family idol to the position of a mere movable chattel is one to which the Board can give no support.

The thought that images are more than mere movable chattels is of course a crucial one in contemporary cultural property debate. But what, asked P.W. Duff, did the Privy Council mean in talking about the will and interests of the idol?[11] Lord Shaw put down to indigestion any dream in which this *persona* would appear to him and explain what it wanted done – but religious literature is full of dreams in which gods instruct or

[8] (1925) L. R. 52 Ind. App. 245; Lyndel V. Prott and Patrick J. O'Keefe, '"Cultural Heritage" or "Cultural Property"?' (1992) 1 *International Journal of Cultural Property* 310. The Judicial Committee of the Privy Council hears appeals from dominions and dependencies of the Crown.

[9] See also *Salmond on Jurisprudence*, ed. P.J. Fitzgerald (London: Sweet and Maxwell, 1966), 12th ed., 299.

[10] The point at issue was whether the appellant was entitled during his period of custodianship to remove the image to his place of residence from the house of worship built for it by the widow.

[11] P.W. Duff, 'The Personality of an Idol', (1927) 3 *Cambridge Law Journal* 42–8.

otherwise act on the living.[12] The interests and will of the 'idol' are whatever the law takes them to be, argues Duff, and the law will take into account the interests of worshippers and the interests of pious founders. English law will regard the intentions of the image as properly interpretable by the legal person who, by appointment of the founder or by inheritance, has title to the role of guardian, *shebait*. In the eyes of the law, title to the *role* of guardian brings with it a correct understanding of the god's wishes. Duff then considers the rights of the 'idol' which might, as Lord Shaw intimates, by analogy be like those of a very young child or imbecile, whose interests the law will want to protect. He rejects this analogy, as he does that of the trust, preferring to think about the rights of 'idols' as most similar to the rights of corporations. Written in 1927 within the context of a vigorous debate in Germany and England about the nature of collective personality, Duff was concerned not to test the hypothesis that idols are best understood as corporations, but rather to advance the moderately realist thesis that corporations are more than idols.[13]

This talk of idols derives ultimately from Part III of Hobbes's *Leviathan*. The Leviathan, Hobbes's name for the artificial person of the State, is distinguished by him from other categories of purely artificial person, such as "a Church, an Hospital, a Bridge", which being inanimate "cannot be Authors, nor therefore give Authority to their Actors". He singles out the "gods of the heathen" which cannot be authors, "for an Idol is nothing". Nonetheless, as Quentin Skinner paraphrases him, in ancient times such deities were frequently recognised as having the ability not merely to own possessions but to exercise rights. As with the hospital and the bridge, these capacities stemmed from the fact that authorised persons (in this case officiating priests) were assigned a legal right to act in their name.[14] Placed in the context of seeking to determine where the authorising entity for any particular action lay, Hobbes concluded that when the gods of the heathen were represented by priests, their authority

[12] Throughout the Bible, for example. For Chinese examples see Alexander Coburn Soper, *Literary Evidence for Early Buddhist Art in China* (Ascona: Artibus Asiae, 1959).

[13] Duff, 'The Personality of an Idol'. Citing *Salmond on Jurisprudence*, he suggests that though the state can treat a corporation like an idol – empowering both the appointment of *shebaits* whose acts will vest in it rights and liabilities as well as the appointment of a next friend to protect it against the *shebaits* – groups of humans have the capacity to act together in ways that idols do not.

[14] Quentin Skinner, *Visions of Politics* (Cambridge: Cambridge University Press, 2002), 3:194–6.

"proceeded from the State". What, however, if there are no local priests to represent the gods, or the state refuses to do so? And what if the state itself determines that images should simply go, as happened in Reformation and Commonwealth England, and at Bamiyan? The answers are littered throughout history. Are images in temples, churches and museums the "empty bottles" of the Leviathan or the physical *loci* of active spirits? Since we are told that the gods are conscious of respect in countless stories from many cultures, it clearly depends on whom one asks.

A dispute over title to a twelfth-century south Indian bronze image of the Hindu god Shiva, unearthed within the grounds of a temple in Tamil Nadu and subsequently acquired by the Bumper Development Corporation of Canada, served as text for an article by Stephen Weil on the best framework for resolving repatriation claims.[15] Beginning with some of the ramifications of the proceedings, such as whether a god could hold property, sue and be sued, and whether a consecrated image of a god could be property in the conventional sense, Weil goes on to suggest that with its fine cultural and legal nuances the complexity of such a case militates against approaching restitution on a case-by-case basis, and that a strengthened, more predictable and more encompassing international mechanism would be preferable:

Our great Western collections have themselves become cultural artefacts. Arching above once-individual cultures, there is today a collective cultural patrimony that has been formed by the flow, mingle and merge of history. The potential dismantling of that patrimony is too profound a matter to be addressed in a haphazard way... [W]e of the American collecting community would be well advised to consider how such international mechanisms as the UNESCO Convention... might be strengthened, extended, and made more exclusively applicable. What's at stake has become our heritage, too.

2. The Buddha's Finger

In order to underline the complexity of 'heritage', I now want to focus on the clash between Buddhist and indigenous beliefs within medieval China, and the way in which relics and images were implicated in a

[15] Stephen E. Weil, 'Who Owns the Nataraja?' *Rethinking the Museum and Other Meditations* (Washington D.C.: Smithsonian Institution Press, 1990), 157–60. The judgment in favour of the temple itself, delivered in the English High Court in 1988, was upheld by the Court of Appeal in February 1991 and supported by the House of Lords in June; [1991] 4 All E.R. 638. The Appeal Court hearing was not recorded; the Lords rejected an application for leave to appeal on 4 June 1991. See also Jeanette Greenfield, *The Return of Cultural Treasures* (Cambridge: Cambridge University Press, 1998), 177–86.

major cultural shift that valued native narratives, roles and practices over foreign ones: a schism between insider and outsider which, as we saw in the previous chapter, is one of the forces in the construction of heritage.

Martin Scorsese's movie *Gangs of New York* relates a story of conflict in Manhattan during the mid-nineteenth century between 'native Americans', self-defined as belonging to families whose members fought the British in the War of 1812 (1812–14), and the newly immigrated Irish Catholics. The sense of having a stake in the land (wherever the land is) is part of the definition of native, so that more recent imports – whether customs or peoples – will be less native and more foreign. Another, often additional way of defining the self and what one has inherited is to assert the superiority of one's own customary practices and the inferiority of others. This has allowed Han Chinese often to marginalise the minority peoples with whom they have lived as neighbours for centuries. Likewise, it allowed the forerunners of neo-Confucianism to designate Buddhist doctrine as barbaric.[16]

One of the sea-changes in East Asian culture occurred during the medieval period when Buddhism began to lose its attraction to the governing classes in China. Coinciding with the early eleventh-century suppression of Central Asian Buddhism by Islam, Confucianism began to rise again in China as an ideology that could challenge Buddhism for the moral and intellectual high ground. Although Buddhism certainly continued to flourish in the Song dynasty (960–1279), both as a distinct religion and as a component of popular belief, it increasingly lost traction as a vehicle for serious discussion about the role of the individual within social and political life.[17] The neo-Confucian story began to dominate at the upper reaches of Chinese society, promoting as it did literary and civil culture, and devaluing the practices of Buddhism. Expunging culture is often harder than ideologues would like: it was possible to subvert imperial patronage, but Buddhism penetrated all levels of Chinese religious, social and artistic life. In consequence, China developed a complex syncretic religion in which different practices existed side by side. This shift in Chinese ideology threatened an enormously influential and diverse range

[16] Chinese Buddhism was comprised of several different sub-schools of Mahāyāna (Great Vehicle) Buddhism, which was (and is) distinctly different from that practised in southern India; see Chapter 1, note 5.

[17] Peter Gregory challenges the conventional view that Chinese Buddhism declined during the late medieval period; see 'The Vitality of Buddhism in the Sung', in Peter N. Gregory and Daniel A. Getz, Jr., eds., *Buddhism in the Sung* (Honolulu: University of Hawaii Press, 1999), 1–20.

of Buddhist practices. Its beginnings are to be found in the early ninth century – indeed, one might say that the course of Chinese history was altered by a dispute about cultural property.

In 819 CE, the Confucian apologist Han Yu took the emperor Xianzong to task over his support for Buddhism, a religion he saw as both undesirable and alien to the customs and laws of China. As with seventeenth-century English attacks on Catholicism, absolutism and Norman law, Han's landmark memorial covers language, custom, political relationships and religion. Criticising the practice of processing the Buddha's finger-bone from the Famen temple into the Imperial Palace at Chang'an (modern day Xi'an), he writes:

Now Buddha was a man of the barbarians who did not speak the language of China and wore clothes of a different fashion. His sayings did not concern the ways of our ancient kings, nor did his manner of dress conform to their laws. He understood neither the duties that bind sovereign and subject, nor the affections of father and son. If he were still alive today and came to our court by order of his ruler, Your Majesty might condescend to receive him... and he would then be escorted to the borders of the nation, dismissed, and not allowed to delude the masses. How then, when he has long been dead, could his rotten bones, the foul and unlucky remains of his body, be rightly admitted to the palace? Confucius said: "Respect ghosts and spirits, but keep them at a distance!"[18]

Han Yu intensely disliked this performance of foreign ritual at court and was also conscious that human relics cause mischief, not *qua* remains themselves, foul or otherwise, but through their connection with the spirits. In doing so he recognises one of the most potent attractions of both religious and secular stories – the power of magic – seen here in the relic of a great person. Han didn't question the authenticity of the relic, which is probably among the four excavated in 1987 from the foundation of the Famen temple's pagoda (a Chinese architectural form that evolved from Indian reliquaries).[19] At the heart of his complaint was the legitimacy

[18] 'Memorial on the Bone of Buddha', in Wm. Theodore de Bary, ed., *Sources of Chinese Tradition* (New York: Columbia University Press, 1960), 1:373. The bone belonged to the Famen temple in the suburbs of the capital Chang'an and was kept in the palace for three days. These imperial receptions were rare, happening only in 660, 790, 819 and 873, see Kenneth Ch'en, *Buddhism in China: A Historical Survey* (Princeton: Princeton University Press, 1972), 280; also Carson Chang, *Development of Neo-Confucian Thought* (New York: Bookman Assoc, 1957), 1:89–91.

[19] The analysis of a number of other such relics reveals them to have included horse teeth, coral chips and pebbles; see John Kieschnick, *The Impact of Buddhism on Chinese Material Culture* (Princeton: Princeton University Press, 2003), 38.

and fortune of the Chinese state which was subverted by the practice of honouring a relic. He was a rationalist, concerned more about political action and effective government than metaphysics, his cosmology ethical but impersonal. Whether caused by supernatural powers or not, the effect of this memorial was disastrous to Han himself. Construed as a personal attack on the emperor, he was exiled to Guangdong (Canton) province in the far and 'barbarous' south, where he wrote the allegory *Goodbye to Penury*, in which, ironically, spirits are seen as the cause of political and social fortune.[20]

Not least of the attractions of Buddhism as a foreign religion was the alleged power over spirits exercised by individual masters such as Zhu Tanyou, who was summoned to the Eastern Jin court during the late fourth century to avert the influence of an 'evil star'.[21] Yet whereas many members of the Tang elites turned to Buddhism for spiritual comfort or supernatural support, others looked to religious Daoism, a cult rooted in indigenous shamanism, medical practice and star worship that offered the prospect of immortality through self-refinement. Han Yu dismissed it alongside Buddhism, because he saw in it the rejection of immemorial social roles and rules: "Yet the Way [of the Daoists and Buddhists] teaches men to reject the ideas of ruler and subject and of father and son".[22]

Chinese Buddhism was a broad church, with several schools competing for attention and power during the late Tang. As a family of practices they all referred back to the cosmology of Indian and Central Asian Mahāyāna Buddhism, which had entered China at the beginning of the 1st millennium CE, spreading into Korea and Japan (see Map). Some, like Pure Land, focused on rebirth in majestic paradises, others on attaining personal enlightenment. In their beliefs, approaches to living, social networks and what they considered of value, members of the monastic community were profoundly different from Confucian officials. Consequently, in joining the clergy, a Buddhist novice broke away from the binding social relationships of secular life, at least in theory, and in doing so threatened their foundational place in civil society. To the Buddhist laity the benefit of building, renovating or otherwise supporting religious institutions,

[20] David Pollard, trans., *The Chinese Essay* (New York: Columbia University Press, 2000), 35–7.
[21] The Eastern Jin ruled southeast China; see E. Zürcher, *The Buddhist Conquest of China: The Spread and Adaptation of Buddhism in Early Medieval China* (Leiden: E.J. Brill, 1972), 146.
[22] 'What is the True Way *(Yuan Dao)*', in de Bary, *Sources of Chinese Tradition*, note 246, 1:378.

The spread of Mahāyāna Buddhism into East Asia.

as well as commissioning images was predicated on the doctrine of transferable merit, whereby good *karma* created by meritorious deeds could be passed on to others, including the deceased. The exempt status of richly decorated Buddhist temples and monasteries with their abundance of brilliant murals and gilded sculptures made them, however, an obvious target for those unmoved by the faith, as did their role in tax avoidance schemes by the landowning gentry.[23] Associated as they were with individual redemption rather than the common good of the state, or at least the region, Buddhist temples always presented themselves as potential targets for tax reformers. If ideological reasons for the destruction of images were perceived as insufficient, economic ones would back them up. Twenty-five years after the finger-bone memorial, Chinese Buddhism suffered one of its worst-ever purges. Infected by a xenophobia that echoed Han Yu's polemic but also acting out of economic expedience, the Wuzong emperor ordered all metal images to be melted either for the treasury or for agricultural implements.[24]

Confucianism had developed from indigenous beliefs in ancestral, stellar, earthly and other natural spirits, which left Buddhism vulnerable to the charge of foreignness. Late medieval Chinese society was simultaneously confident and fearful – confident of its own procedures for governance, but fearful of alien intrusion and political anarchy. The known world included south and central Asia, but the view held by most Han Chinese was that those who dwelled beyond state borders were barbarian, as were the many non-Han peoples within. Thus a major task for Chinese Buddhist theologians was to reconcile their practices with native ones: for example, in the claim that masses for the dead not only met but exceeded conventional ancestral sacrifices in their discharge of filial obligations (recovering the souls of parents from Buddhist hells – a practice that also provided a livelihood for the clergy). Masses represented

[23] Kieschnick, *The Impact of Buddhism on Chinese Material Culture*, 157–64, 185–99. Buddhist institutions could be added to the assets of secular estates, the entireties of which were then deemed to be tax exempt, see Ch'en, *Buddhism in China*, 271–2.

[24] The 845 purge destroyed some 4,600 temples and 40,000 shrines. See Valerie Hansen, *The Open Empire: A History of China to 1600* (New York: Harper, 2000), 241–2; Edward H. Schafer, *The Golden Peaches of Samarkand: A Study of Tang Exotics* (Berkeley: University of California Press), 268; and L. Carrington Goodrich, *A Short History of the Chinese People* (New York: Harper, 1951), 125–7. Four years before the establishment of the Song, the Later Zhou Emperor Shizong again proscribed the manufacture of copper (hence bronze) images in order to maintain the metal flow; see Mark Elvin, *The Pattern of the Chinese Past* (London: Eyre Methuen, 1973), 153.

a solution to the conflict between native emphasis on the family as the basic social unit and Buddhism's own rejection of kinship ties.[25]

We obtain a glimpse of other strategies used to deal with this challenge through a well-known Buddhist legend, in which the celibate princess Miaoshan sacrifices her eyes and arms to save her iniquitous father from great sickness before manifesting herself as the 'thousand-eyed, thousand-armed' Bodhisattva Guanyin.[26] The story reached a wide public following an account written in 1100 by Jiang Zhiqi, then prefect of Ruzhou in the northern province of Henan and a patron of Buddhism. Jiang also carried the story south, to a Guanyin cult centre in the Southern Song capital Hangzhou, where it was engraved in 1104.[27] The Song was a time of increased mobility among the gentry and emerging merchant classes, and a concomitant increase in pilgrimage and tourist activity. Hence any monastery would have benefited economically from its association with divine revelation and, even better, accompanying relics. And indeed, according to an 1185 inscription at the Xiangshan monastery, to which

[25] See Stephen F. Teiser, *The Ghost Festival in Medieval China* (Princeton: Princeton University Press, 1988).

[26] This tantric manifestation represents the omniscient aspect of Guanyin's all-seeing compassion. A twenty-two m. high bronze version with 40 of the 42 arms replaced in wood, dating from 971, survives at the Longxing temple, Zhengding, Hebei; see Shi Yan, *Zhong'guo meishu quanji: Wudai Song diaosu* (Beijing: Renmin meishu chubanshe, 1988), pl. 33, and Angela Falco Howard, Li Song, Wu Hung, Yang Hong, *Chinese Sculpture* (New Haven: Yale University Press, 2006), 383–6 and pl. 4.24.

[27] The 1104 inscription was engraved at the Upper Tianzhu monastery. A twelfth-century record of the story by the monk Zuxiu concludes with this response to the question "why at Xiangshan?": "Of all sites now within the bounds of China Fragrant Mountain [Xiangshan] is pre-eminent. The mountain lies two hundred *li* to the south of Mount Song. It is the same as the Xiangshan in present-day Ruzhou". Glen Dudbridge, *The Legend of Miaoshan* (Oxford: Oxford University Press, Oxford Oriental Monographs, revised ed., 2004), 141. See also Glen Dudbridge, 'Miao-shan on Stone: Two Early Inscriptions', (1982) 42 *Harvard Journal of Asiatic Studies*: 589–614; Chi-chiang Huang, 'Elite and Clergy in Northern Sung Hang-chou: A Convergence of Interest', in Gregory and Getz, eds., *Buddhism in the Sung*, 326–7; and Chun-fang Yü, 'Guanyin: The Chinese Transformations of Avalokiteshvara', in Marsha Weidner, ed., *Latter Days of the Law: Images of Chinese Buddhism 850–1850* (Honolulu: University of Hawaii Press in association with the Spencer Museum of Art and University of Kansas, 1994), 161–3. *Miaoshan* may have drawn on the still-circulating story that a distinguished abbot Baozhi had revealed himself on his deathbed as the twelve-headed Avalokiteshvara (in 514 CE); see Soper, *Literary Evidence for Early Buddhist Art in China*, 72–3, and Gregory P.A. Levine, *Daitokuji: The Visual Cultures of a Zen Monastery* (Seattle: University of Washington Press, 2005), 297–9, for Zhou Jichang's reinterpretation of Baozhi's transformation, made for a set of twelfth-century paintings that are discussed in Section 4.

the story and associated statue of Guanyin was attached, that was exactly what happened:

> From the time of the Song Yuanfu period (1098–1100) on, the abbots of this monastery successfully built it up on a magnificent scale and with increasing extravagance. The resident monks numbered more than a thousand. Because the Bodhisattva's relics were there in the pagoda and many miracles were wrought, every spring in the second month people from all parts would come, regardless of distance. The worshippers must have numbered tens of thousands, and they made donations according to their means. The monks of the monastery had no need to go begging to meet their annual budget. They had more than enough.[28]

Glen Dudbridge offers three levels at which *Miaoshan* might be under-stood, assisting our understanding of the place of narratives in the complex relationship between alien and native. The first is the sanctioning of Buddhist celibacy as a good life for women. The second is the assertion that Buddhism was relevant to a traditional Chinese life, and the most efficacious means by which the virtue of filial piety could be discharged. The third is the legitimising of Buddhist priests as agents by which souls could be redeemed from the consequences of sin. Each level validated Buddhist practices as instrumentally valuable to a wide stratum of Chinese society. *Miaoshan* underlines the role of ancestors (imperial or personal) in indigenous cultural life, a role that was denied to Buddhist deities like Guanyin unless they were sinicised within legends such as this.

One of the most notable developments in medieval Chinese religion was towards a synthetic pantheon comprised of Buddhist and Daoist divinities and *genii locorum* (spirits of place), the latter created in ever greater numbers to serve the economic complexity of Song society.[29]

[28] Dudbridge, *The Legend of Miaoshan*, 17–18.

[29] In 1008 the Zhenzong emperor (r. 998–1022) revived an old practice of honouring native land and river spirits – with the added provision that titles could now also be given to Daoist divinities. By the Song period, Daoism had already empowered its own perfected beings with the grandeur of Buddhas, so that in 1014 when Zhenzong conferred on the Jade Emperor (Yuhuang) a series of splendid titles ('Most High', 'Creator of Heaven', 'Bearer of the Sceptre', 'Regulator of the Calendar', 'Incarnation of the Dao' and 'Grand Emperor of Heaven'), the deity was already perceived to be equal in power and status to the historical Buddha. From the later eleventh century many more gods and official spirits were recognised, which is to say the government cast more roles for worthy spirits of the dead to fill (e.g., deceased scholars). Confected from a variety of sources, this indigenous heavenly bureaucracy came in time to resemble the practising Chinese civil service, instrumentally important for its (theoretical) capacity to solve legal, agricultural and commercial problems. Many of the gods so honoured were fundamentally versions of earth spirits, concerned with the well-being of the communal environment and particularly with harvests and rain – vital to the prosperity of a settled agrarian society. In

For example, by the early twelfth century we find Guanyin, paragon of compassion, paraded annually in the role of earth spirit for Crow township within the southeastern prefecture of Huzou, the Bodhisattva being known to encourage rain at times of drought and clear the skies when there was a danger of flooding.[30] Earth and water spirits were important because fertile land was important; it was the major resource of an agrarian society.

In the context of a discussion about collective rights, Lyndel Prott notes features of indigenous culture that she perceives to be common across the world: "custodianship of land, respect for the ancestors and the family, a world-view of mankind as an integral part of the natural order to which it owes respect".[31] Certainly the latter two elements were present in medieval China. More questionable is the custodianship of land within a society that was witnessing major developments in industry and agriculture, and the introduction of new economic practices, including government-sanctioned paper currency.[32] The intensive cultivation of agricultural land is not, I sense, quite what Prott means by custodianship. Medieval Chinese farmers can hardly be said to have left land in a natural state, as sometimes but not always happens within hunting and gathering societies, whether nomadic, semi-nomadic or settled. Indeed, one of the distinctions that emerged early in China was between 'barbaric'

a role somewhat similar to that of the Zuni War Gods, they protected the community against disaster and sickness and policed it against bandits and malefic spirits, regulating the spiritual order of the locality just as the living magistrate was charged with the administration of human justice. At the lowest bureaucratic level, the household Stove god was subordinate to the regional City god, who in turn reported back up the disciplinary hierarchy; according to Wolf, whose fieldwork was carried out in northern Taiwan, the soul of a family, its corporate fate, is considered to be somehow localised in the stove. Although bureaucratically 'minor' the Stove god was held in considerable respect, as was the family as the basic social unit. Certainly there were some female gods, like the image of Shengmu at the Jin shrine, Taiyuan (datable to 1087), the Fujianese goddess Mazu (Heavenly Empress) and female manifestations of the Bodhisattva Guanyin, but more generally the pantheon reflected the dominance of patriarchal thinking. See Arthur P. Wolf, 'Gods, Ghosts, and Ancestors', in Emily Martin and Arthur P. Wolf, eds., *Religion and Ritual in Chinese Society* (Stanford: Stanford University Press, 1974), 133–7.

[30] Hansen, *Changing Gods in Medieval China*, 35.

[31] Lyndel Prott, 'Understanding One Another on Cultural Rights', in Halina Niec, ed., *Cultural Rights and Wrongs: A collection of essays in commemoration of the 50th anniversary of the Universal Declaration of Human Rights* (Paris and Leicester: UNESCO and Institute of Art and Law, 1998), 168; see also Patrick O'Keefe, 'Review of Joseph L. Sax, *Playing Darts with a Rembrandt: Public and Private Rights in Cultural Treasures*,' (2000) 9 *International Journal of Cultural Property*, 386.

[32] Printed paper money was introduced in Sichuan in 1023; Hansen, *The Open Empire*, 261–97.

semi-nomadic invaders, such as the Jin and Mongols, and their own 'civ-
ilised' agrarian society. Hansen notes for the Song period that

in an age of rapid economic development, the gods, like the men who worshipped
them, diversified. No longer did they perform just the age-old miracles of bringing
rain, expelling locusts, forestalling drought, and protecting their districts from
rampaging troops. Some began to deal on the national grain market, to advise
their followers on business deals, to manipulate the government's purchasing
quotas, and, on occasion, even to bring their devotees a tenfold increase in profits.
In short, by the thirteenth century, a few gods in the most commercialized areas
exhibited a nice understanding of market dynamics.[33]

During the Song, the Chinese spirit world became a primarily male sur-
veillance network that policed both individual moral behaviour and a
social exchange system sophisticated enough, at least in theory, to facil-
itate the administration of large, densely populated territories, enabling
and constraining the moves of individuals, families and regions. Regional
gods were part of that system, and they were expected by supplicants to
play the game of reciprocal benefit. To quote Hansen again:

What the gods wanted – rather, what they were thought to want – were beautiful
images, new temples, spectacular plays, and adulatory inscriptions. This hunger
for tangible forms of recognition meant that those individuals or groups who had
the money to erect beautiful statues, to build new temples, to sponsor spectacular
plays, and to carve adulatory inscriptions had a distinct advantage over those
who did not.[34]

But indigenous spirits also appear in stories as individuals with their own
agendas: they had official hats, yet they might choose not to wear them;
they had roles, yet they might choose not to play them; they recognised
normative expectations, but decided whether or not to fulfil them.[35] By
securing the cooperation of ancestors and other spirits, not only survival
but also prosperity would ensue.

 Now it may be the case that there are cultures in which ancestors
are only benign. In China, however, if neglected they had the capacity

[33] Hansen, *Changing Gods in Medieval China*, 27–8.

[34] Ibid., 161.

[35] This doesn't apply to Buddhist divinities or the higher echelons of the spirit bureau-
 cracy. For threats to ancestors and gods who didn't perform as expected, see, for the
 Zhou period, James C.Y. Watt, 'Antiquities and the Importance – and Limitations – of
 Archaeological Context', in James Cuno, ed., *Whose Culture? The Promise of Museums
 and the Debate over Antiquities* (Princeton: Princeton University Press, 2009), 99–101;
 for the Song period, see Hansen, *Changing Gods in Medieval China*, 52, 57–8; for the
 Ming period, see C.R. Boxer, ed., *South China in the Sixteenth Century: Being the Nar-
 ratives of Galeote Pereira, Fr. Gaspar da Cruz, O.P., Fr. Martin da Rada, O.E.S.A.
 (1550–1575)* (London: Hakluyt Society, 1953), 214–15.

to harm as much as other spirits, and of course one had to watch out for the spirits of other clans. Within an animistic world, as Arthur Wolf remarks, your ancestors are my ghosts, and my ancestors are your ghosts: "The mandarins became the gods; the senior members of the line and the lineage, the ancestors; while the stranger was preserved in the form of the dangerous and despised ghosts".[36] Wolf does note the relative lack of fear of ancestors in China compared to west African societies, which he attributes to the fact that in traditional China the authority of senior kinsmen was significantly lower than that of government officials. And although gods, ancestors and ghosts are seen in some quarters only as reflections of the socioeconomic order, one can also understand them as active players whose roles relate to those in the mundane world. Thus there are ancestors who act like clan heads, ghosts who act like strangers, and gods who act like civil servants, kings and pan-continental emperors – all of which leaves open the question of whether tablets and images of ancestors and gods are, in fact, more than Hobbes's empty bottles, or projections of earthly power onto fictional entities. Empty bottles or not, I'll continue to think of indigenous Chinese religion as a family of interrelated stories about spirits and men, associated with a variety of social practices that stretch from the peasantry to the court.

Martin Hollis offered the thought that engagement in such practices (ancestor worship for example) has some similarity to playing games, where we follow rules while simultaneously interpreting and developing them. Within every situation we rationally seek to optimise the outcomes for ourselves, yet the roles we inhabit both enable and constrain us.

In learning the rules of a game, one is learning 'how to go on', in Wittgenstein's pithy phrase, how to do what is required, to avoid what is forbidden and to pick one's way through what is permitted in the spirit of the game.[37]

But, as Hollis notes,

Wittgenstein . . . shows no sign of wanting to write social actors out of the human story. He insists that scrutiny of the rules alone will not let us decipher social action. Rule books are always incomplete, because what a rule is depends on how it is interpreted. There is always latitude in interpretation and, in interpreting,

[36] Wolf, 'Gods, Ghosts, and Ancestors', 168, 173–5.
[37] Martin Hollis, *The Philosophy of Social Science: An Introduction* (Cambridge: Cambridge University Press, 1994), 153. As David Bloor remarks, games for Wittgenstein were a "simple, though supremely important, example of institutions"; David Bloor, *Wittgenstein, Rules and Institutions* (London: Routledge, 1997), 37. See also Martin Hollis, *Trust Within Reason* (Cambridge: Cambridge University Press, 1998), 105–25, 152–5 and 161–2.

those who follow a rule also fill it in. They do so only partly, however, since the next new situation will call for further interpretation. Hence, in playing the game, we also help to construct it; and there can be no case for an analysis of rule-following which lets the game absorb the players and reduce them to ciphers... We are thus embedded but not lost in the games of social life.[38]

In the case of China, indigenous religion is predicated on reciprocity between clan members and their spirits: ancestors are expected to collaborate, facilitating health and prosperity in return for appropriate sacrifices. In contrast, exchanges between clan members and ghosts are normatively competitive, with the latter causing damage unless they are bought off or otherwise kept away. And in any society, sanctions are imposed on players choosing to operate outside normative conventions, a fact entertainingly but pointedly addressed in the *Journey to the West* (*Xiyou ji*), a sixteenth-century novel attributed to Wu Cheng'en which draws on earlier narratives and continues to have wide appeal both within and beyond China.[39]

At the beginning of the story, the magical monkey king causes such chaos in Heaven that Guanyin is dispatched to summon the Buddha, establishing for the reader that Buddhist deities are instrumentally more powerful than the indigenous pantheon. Monkey is then imprisoned for an eon under Five Phases Peak and released only to accompany Tripitika on his perilous journey to India (a fictionalisation of the renowned pilgrimage by Xuanzang).[40] In one reading of the novel Monkey is Trickster, satirising social norms while also speaking to the value of mischievous play. In another he is an engaging secular outlaw, selfishly unconcerned with social order, but by assisting Tripitika and submitting to the Buddhist law (not Confucian norms) he is able to discharge karmic debt, achieve enlightenment, and deliver great social benefit to the Chinese community. And in a further reading Monkey is everyman, whose essential goodness emerges only through his embrace of a higher goal, and also, *qua* MacIntyre, a life-enhancing quest. Yet however we read him, he certainly

[38] Ibid., 120–1. Samuel Beckett pointed to the space occupied by interpretation with his response to a director mounting *Waiting for Godot* and unsure about how far to let Estragon's pants fall: "The spirit of the play, to the extent that it has one"; quoted by Paul Taylor, 'Way Out of Line', *The Independent*, 18 March 1994. For a further discussion of how works of art are interpretable, including dramatic narratives, see Joseph Raz, *Between Authority and Interpretation* (Oxford: Oxford University Press, 2009), 241–64.

[39] See Glenn Dudbridge, *The Hsi-yu chi: A Study of Antecedents to the Sixteenth-Century Chinese Novel* (Cambridge: Cambridge University Press, 1970).

[40] I follow John S. Major's translation of *wuxing* as Five Phases, rather than Five Elements.

didn't belong to 'this refined (literary) culture of ours' (*si'wen*, a term that goes back to Confucius), the constitution of which was determined, at different periods, by members of the aristocratic clans, civil bureaucracies and local elite families.[41]

Buddhism was drawn into these debates as an alien element precisely because, initiated by Han Yu, there was growing scholarly faction devoted to writing based on the classics, for which the antique was superior to all other forms, however elegant.[42] Debating *wen* (text-based, civil culture) was certainly an elevated exercise, but an increasingly unavoidable one to those with a stake in governmental policy and procedures. As Albert Welter puts it, "From its outset, the [Song] revival of *wen* signalled a return to native values and a study of the sources that discussed them. Disagreement persisted, however, over what constituted 'native values' and which sources deserved to be singled out for inclusion".[43] Arguing in 1044 for a model of the state in which values were shared by leading officials, and thereby penetrated throughout society, Wang Anshi wrote that "the words and actions of the sages are uniform; of course [our friends and teachers] will resemble each other".[44] To modern eyes, Wang's conservative state is recognisably communitarian. In contrast, the prominent scholar-monk Zan'ning argued that Buddhism constituted an integral part of Chinese *wen* and should be accepted as part of Chinese literary heritage.[45] According to Welter:

Tsan-ning's view that Buddhism be accepted as part of China's cultural heritage was based on a perspective on Chinese tradition as dynamic and evolving. Rather than accept a 'golden age' hypothesis that rooted China's core cultural values exclusively in remote antiquity, Tsan-ning argued that as Chinese culture evolved, so did the values that it identified with.[46]

This accommodation to high culture was made as much by literati sympathetic to the religion as by Buddhist monks themselves. So, Jiang Zhiqi writes of editing out the "occasionally vulgar" language of the *Miaoshan*

[41] Bol, *"This Culture of Ours"*, 3–4.
[42] The literati wrote in a condensed version of the language quite different from vernacular speech.
[43] Albert Welter, 'A Buddhist Response to the Confucian Revival', in Gregory and Getz, eds., *Buddhism in the Sung*, 22.
[44] Bol, *"This Culture of Ours"*, 189.
[45] Zan'ning (919–1001) was an eminent Northern Song dynasty scholar-monk, who served at the Taizong Emperor's court; Welter, 'A Buddhist Response to the Confucian Revival', 37, 39.
[46] Ibid., 46.

story provided to him, a text purportedly originating with the Tang monk Yichang, who "perhaps... lacked literary refinement".⁴⁷ Two centuries later, in 1306, the *Miaoshan* legend was again given legitimacy among China's literati by virtue of its transcription by the noted calligrapher, painter and poet Guan Daosheng (1262–1319), a lay disciple of the Chan (Zen) master Zhongfeng Mingben, as was her husband Zhao Mengfu (1254–1322) who subsequently became President of the Hanlin Academy.⁴⁸

Notwithstanding bridges between the two ideologies – for example, when leading clerics applied their power to helping magistrates with regional political and economic issues – Buddhist practice continued to come under attack from newly energised neo-Confucian scholars, including Ouyang Xiu (1007–72), one of the most influential political theorists, essayists and poets of the Northern Song. A leading advocate of *guwen* (ancient-text *wen*), he berated Buddhism as a foreign import, alien to all that was valuable in Chinese political and moral culture.⁴⁹ Here he employs the language of sickness (common enough in the rhetoric of perceived attacks on the native):

It is clear then that Buddhism took advantage of this time of decay and neglect to come and plague us. This was how the illness was first contracted... The well-field system was the first to be abolished, and there arose the evils of encroachment and idle landlordism. After this the rites of the spring and autumn hunts, marriage and funeral ceremonials, sacrifice and archery contests, and all the ways by which the people had been instructed, one by one fell into disuse. Then the wicked among the people found leisure to turn to other things, and the good were confused and lost, and no longer knew the guidance of rites and righteousness.⁵⁰

⁴⁷ Dudbridge, *The Legend of Miaoshan*, 12.
⁴⁸ Dudbridge suggests that her transcription (and perhaps the accompanying image of Guanyin) was probably executed as an aristocratic devotional exercise, ibid., 42. Zhao Mengfu was the most eminent calligrapher of his day; see also Natasha Heller, 'Between Zhongfeng Mingben and Zhao Mengfu: Chan letters in their manuscript context', in Stephen C. Berkwitz, Juliane Schober and Claudia Brown, eds., *Buddhist Manuscript Cultures: Knowledge, Ritual and Art* (Abingdon: Routledge, 2009), 109–23; and Chün-fang Yü, 'Chung-feng Ming-pen and Ch'an' in Hok-lam Chan and Wm. Theodore de Bary, eds., *Yüan Thought: Chinese Thought and Religion under the Mongols* (New York: Columbia University Press, 1982), 433–4. The Hanlin Academy was China's principal scholarly institution, founded under the Tang.
⁴⁹ See Huang, 'Elite and Clergy in Northern Sung Hang-chou, 325–6. Upon appointment as Director of Examinations in 1057, Ouyang Xiu insisted that *guwen* criteria be made the basis for passing the imperial exams, thereby excluding Buddhist references; Welter, 'A Buddhist Response to the Confucian Revival', 50.
⁵⁰ 'Essay on Fundamentals' (*Ben Lun*), in de Bary, *Sources of Chinese Tradition*, 1:386–390.

What was so distasteful to the likes of Ouyang Xiu was the implicit undermining by Buddhism of Confucian virtues and practices. He is clear that the 'disease' of Buddhism has eroded indigenous customs, including those relating to religious rituals, marriage and funerary ceremony, hunting and archery. "The indigenous ways by which the people had been instructed" were severely threatened in a state corrupted by Buddhism.

In terms of *wen* aesthetics, Guan Daosheng's calligraphic rendering of the *Miaoshan* story is as distant as possible from the tin cowboy Guandi, which is utterly excluded from what Prott calls "Culture" ("the highest intellectual and artistic achievements of a group") but loosely within "culture" ("in the anthropological sense, as shared skills, beliefs and traditions").[51] There is no doubt that elite artists and connoisseurs in many countries have put barriers around themselves – as they did in China – but is it the case that high culture is truly separable from popular culture? The *Miaoshan* legend was brought to the literati world at the beginning of the twelfth century but remained in circulation among the wider populace, in printed books, chanted tales and ballads, in puppet shows and on the stage, which makes the familiar point that elite culture draws on, and frequently develops, elements of popular culture.[52] Many works of art and architecture from across the world that are incontestably classified as high culture draw on shared skills, beliefs and traditions.

3. Expectations and Values

The business of valuing religious images, other works of art and the built environment is something for which there are rarely clear sets of rules. But shared normative expectations provide the background condition against which valuation and innovation occur at different levels of society.[53] For example, from the high Renaissance to the nineteenth century, Western painters were expected both to understand and to employ perspectival formulae, but that expectation receded in the twentieth century. During the same period, the genres of portraiture, still life (often allegories of mortality), urban life and landscape ranked below classical and biblical narratives, and depictions of significant events in the political life of the city-state or nation.

[51] Prott, 'Understanding One Another on Cultural Rights', 164.
[52] Dudbridge, *The Legend of Miaoshan*, 36–7.
[53] The point is nicely made by Skinner with respect to Machiavelli's *Il Principe*, a text that responded to a highly conventionalised genre of political writing; see Skinner's *Visions of Politics*, 1:142–3.

Art forms are themselves ranked within Western conventions, where for half a millennium the 'fine arts' have had a higher status than decorative arts such as ceramics, glass, metalwork and furniture, as they are in many societies, whether codified in writing or not. The present-day elevation of painting and sculpture in the West, although long-standing, is not immemorial. When the Parthenon was built, what we call the (visual) fine arts were classified with crafts such as carpentry and cookery, Plato including painting and sculpture alongside the use of mirrors, magic tricks and the imitation of animal noises. Only through hard-fought battles for social status did they come to rank among the highest arts in the West.[54] In China, until medieval times, painting was valued below music, poetry and calligraphy, and it was not until the late Northern Song dynasty that it acquired its present status, through its association with "our literati culture".[55] Figure painting gave way to landscape as the most valued genre (with sub-genres, such as bamboo painting, that lent themselves especially well to calligraphic treatment), which by the fourteenth century was placed above secular figures, religious subjects, and bird, flower and animal painting.

It has become a convention, in the West at least, to label as 'art forms' practices from which we seek the intrinsic value of aesthetic experience: like Chinese painting, Italian singing, Russian dancing, English poetry, and so forth. Expectations about practices and values in visual art, architecture, writing, acting, music, dance, recitation and ritual develop over a long period of time, differing radically from culture to culture and, within cultures, often across class and gender (e.g., the conservative vein of neo-Confucianism conventionally denied educational opportunities to women even of the gentry class, and it's therefore unsurprising that Chinese literati painting was deemed to be a male preserve, with certain notable exceptions).[56] And within any particular form of art,

[54] See Paul O. Kristeller, 'The Modern System of the Arts: A Study in the History of Aesthetics', (1951) XII *Journal of the History of Ideas* I: 496 and 502, and also M.H. Abrams, 'From Addison to Kant: Modern Aesthetics and the Exemplary Art', *Doing Things with Texts: Essays in Criticism and Critical Theory* (New York: W. Norton, 1989), 159.

[55] Susan Bush, *The Chinese Literati on Painting: Su Shih (1037–1101) to Tung Ch'i Ch'ang (1555–1636)* (Cambridge, MA: Harvard University Press, 1971), 4–13.

[56] See Marsha Weidner, 'Women in the History of Chinese Painting', in Marsha Weidner, Ellen Johnston Laing, Irving Yucheng Lo, Christina Chu, James Robinson, *Views from Jade Terrace: Chinese Women Artists 1300–1912* (Indianapolis: Indianapolis Museum of Art and Rizzoli, 1988), 16. The highly regarded Guan Daosheng (see Section 2) profited not only from the extensive education she received but also her mutually sympathetic marriage to Zhao Mengfu, her teacher both in calligraphy and painting; ibid., catalogue entries 1 and 2, 66–70.

conventions and rules are commonly (but not always) first revised by particular works. Can we imagine cubism developing in the abstract without the initial experiments of Picasso and Braque, particularly *Les Demoiselles d'Avignon*? So practices are comprised of ways of going-on (e.g., "represent a figure from several points of view") and also products (e.g., *Guernica*).[57]

Whereas some of these practices are valued as far back as written records go (poetry and music in China and the classical west), others have emerged more recently (e.g., the novel in Ming China and eighteenth-century Europe, film in the twentieth century), combining existing forms of excellence or recognising new ones. As Joseph Raz points out,

> Many values are mixed values: the value of being a good opera consists in the way visuals, music, words, and action, each with its own form of excellence, combine... [W]e can think of a value as defined by, or constituted by, a standard of excellence of a certain type. Since many values are mixed values, their standards of excellence refer to other values, and their required combination makes the values they define distinctive.[58]

These standards of excellence evolve through oral and printed comments made by authorities who have an interest in evaluation, the benefits from which are engagement with intrinsic values and peer recognition, and perhaps also material reward. Makers, connoisseurs and scholars, critics, collectors and dealers all contribute to the process of evaluating works of art.[59] Fashion certainly plays a part, as does opposition to convention; indeed, the fact that 'conventional' is used pejoratively in Western liberal cultures only highlights a present inclination towards the radical and unexpected. Conventions cover not only how we make and appreciate things but also how they are presented for consumption and subsequently displayed. Our expectations can make it difficult for us to approach forms from other cultures, and in the case of contemporary art often from our own culture. Until the middle of the last century it was a convention that Western paintings were framed in gilded or stained wood, with moulding

[57] There is no necessity that institutions should accompany these practices, yet they often do; during certain dynasties there was an Imperial Painting Academy in China but never an institutional equivalent for literati painting.

[58] Joseph Raz, *The Practice of Value*, ed. R. Jay Wallace (Oxford: Clarendon Press, 2003), 132.

[59] Some are more authoritative, more knowledgeable, more perceptive, more inventive, more sophisticated in evaluating when conventions should be followed and when they should be breached. See also John Henry Merryman, 'A Licit International Trade in Cultural Objects', (1995) 4 *International Journal of Cultural Property* 39.

that drew heavily on architectural ornament.[60] This was hardly surprising since the surrounds for the display of paintings in churches, palaces and substantial private houses included a similar decorative repertoire. Even after the Second World War, when abstract expressionist painting was generally shown without a decorative frame, there was still a relationship with the unadorned architectural styles of international modernism. In China, however, the convention was for paintings to be portable, and valuable scrolls were brought from library storage only for viewing by a privileged group. Thus their relationship to architecture was completely different from that of painting in Europe. For someone used to enjoying elaborately framed Western paintings, a Chinese painting might indeed seem of little consequence.

In the West it is also conventional to think about paintings as things we may not touch except to conserve. However, many great Chinese paintings have one or more inscriptions written on them by contemporary and later connoisseurs. Content aside, the practice adds visual pleasure to the painting when executed by a great calligrapher but may also diminish it when that is not the case, as with the many poems and reflections tiresomely added to major works by the eighteenth-century Qianlong emperor. The practice was expected within the context of Chinese literati (*wenren*) art and, from the Yuan dynasty onwards, painters accepted that the long-term appearance of one's work was unknowable.[61] Thus it isn't universal that one may not add to a work of art, either well or badly, but it is conventional in the West that one does not. Merryman acknowledges that

what is perceived as culturally valuable, and by whom, clearly varies to some extent with time and place. Thus many Americans care about the Liberty Bell, but most foreigners do not. Only a few enthusiasts really care much about the preservation of Art Deco architecture.[62]

And since it is not obvious that all value translates readily across cultures, he wonders how Chinese or Japanese viewers might react to a cubist painting by Braque.

The answer is not obvious, since many Westerners themselves would be repelled, baffled, or merely unimpressed by the same Braque. But how about an educated

[60] For the significance of frames, see E.H. Gombrich, *The Sense of Order: A Study in the Psychology of Decorative Art* (Oxford: Phaidon Press, 1984).

[61] The practice now comes to an end when paintings enter public collections.

[62] John Henry Merryman, 'The Public Interest in Cultural Property', (1989) 77 *California Law Review* 342.

Chinese (somehow insulated up to this point against Western culture), knowledgeable about and interested in art: would he respond to the *quality*, the intrinsic artistic merit, of such a work?

But what about an educated European, knowledgeable about and interested in art; how would he or she respond to the quality of a fine Chinese painting? Thus I want now to look at two late medieval Chinese paintings with subjects drawn from religious narrative. The first was made for a Buddhist temple in the late twelfth century, just over a hundred years after Ouyang Xiu's attacks on the religion; the second, depicting a popular god, was created a hundred years later by the literati painter Gong Kai. Both are now part of the American national collections held by the Smithsonian Institution, in Washington D.C.

4. *Luohans Laundering* and *Zhong Kui Travelling*

The temple picture *Luohans laundering* belonged to a set of a hundred scrolls depicting five hundred *luohans*, inscribed in 1178 by Abbot Yishao for the Hui'an yuan temple in the port-city of Ningbo, near Hangzhou, which had also become a locus of Buddhist activity and a centre of the Tiantai school. (Fig. 12).[63] Many paintings and other items of early Buddhist material culture exported from China to Japan were shipped from Ningbo, as was the Hui'an yuan set, which was sent in the thirteenth century to the Jufukuji in Kamakura, and then, after acquisition by two other temples, deposited during the late sixteenth century at the Daitokuji, a grand Zen temple in Kyoto. In 1894, at a time when the Daitokuji was in serious need of repair, the temple agreed to lend forty-four

[63] Ningbo was a production centre not only for religious art but also for secular decorative paintings, and the principal port through which Buddhist monks passed between China, Japan and Korea during the Song period. Tiantai Buddhism took its name from Mt. Tiantai, one of the five sacred mountains of China, about fifty miles south of Ningbo, where there is a famous natural rock-bridge that is depicted in another scroll from this set, also now in the Freer Gallery, discussed by Wen Fong, 'The Lohans and A Bridge to Heaven', 3, no. l *Freer Gallery of Art Occasional Papers* (Washington D.C: Smithsonian Institution, 1958), where he notes that the Hui'an yuan is the modern Qingshan temple, near Xiangfeng, to the south-east of the city. See also Thomas Lawton, *Chinese Figure Painting* (Washington D.C: Smithsonian Institution, 1973), 947; Wu Tung, *Tales from the Land of Dragons: 1,000 Years of Chinese Painting* (Boston: MFA Publications, 1997), 160–67; Levine, *Daitokuji*, 287–313, and *Sacred Ningbo: Gateway to 1300 Years of Japanese Buddhism* (Nara: Nara National Museum, 2009). See also Koichi Shinohara, 'From Local History to Universal History: The Construction of the Sung T'ian-t'ai Lineage', in Gregory and Getz, eds., *Buddhism in the Sung*, 534–8.

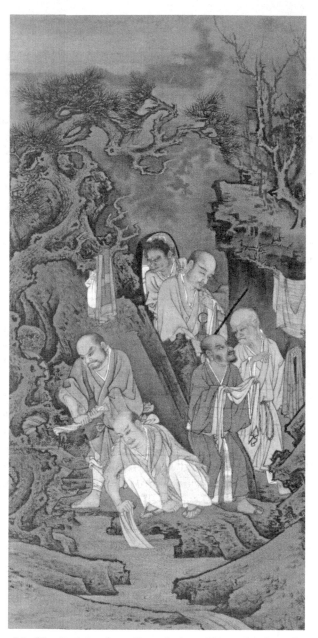

FIGURE 12. *Lin Ting'gui*, Luohans Laundering, *China, Southern Song dynasty, ca. 1178 CE, 111.8 × 53.1 cm. Courtesy of the Freer Gallery of Art, Smithsonian Institution, Washington D.C. Gift of Charles Lang Freer, F1902.224. Luohans Laundering* belongs to a set of a hundred scrolls originally commissioned for a temple in Ningbo, southeast China, and then exported to Japan in the thirteenth century. Forty-four of them were sent to America for exhibition in the late ninteenth century; this one was presented to the exhibition organiser, Ernest Fenollosa.

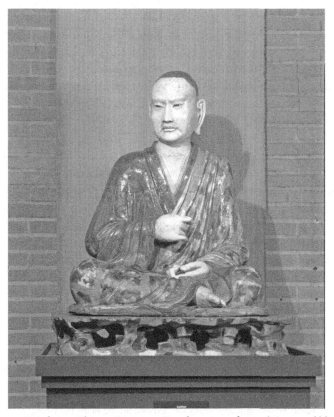

FIGURE 13. *Luohan, China, Liao or Jin dynasty, eleventh or twelfth century CE, glazed earthenware, 120.6 cm. Courtesy of the University of Pennsylvania Museum (C66).* Sculpted and painted images of *luohans*, semi-divine beings who had the appearance of Buddhist monks, were increasingly shown in groups within Chinese temple halls from the tenth century CE onwards, attracting pilgrims and local worshippers.

of the paintings for an exhibition at the Boston Museum of Fine Arts, arranged by Boston's curator of Japanese art Ernest Fenollosa, after which ten were purchased by the B.M.F.A. In 1902, Fenollosa recounted to Charles Freer how at the close of the show the Japanese agent escorting the works had urged him to accept one of the scrolls by way of thanks and, having first demurred, he'd selected *Luohans laundering*, which he was now offering for sale. Freer was pleased to acquire the painting and it is now in the collection of the Smithsonian.[64]

[64] Following the Boston exhibition, those not acquired by the M.F.A. were shown in 1895 at the Pennsylvania Academy of the Fine Arts and then at the Century Association in

Derived from early Indian and Central Asian scriptural sources, *luo-hans* were learned disciples of the historical Buddha. In China they were formalised into groups of sixteen, eighteen and five hundred, whose literary and visual representation clearly borrowed from indigenous stories about mountain-dwelling Daoist immortals. During the late medieval period their often-dramatic images were housed within the halls and grottoes of Chan and Tiantai temples, where they acted as protective deities (in like manner to Guanyin) and clearly became a significant part of the pilgrim and tourist experience. Each of a celebrated north Chinese set of life-sized, glazed earthenware figures has an individualised physiognomy (Fig. 13).[65] Such images made clear both to the laity and political opponents that members of Buddhist clergy should be regarded as powerful individuals, metaphorically manifest in these sets as semi-divine, mountain-dwelling sages clothed in the elaborate robes of earthly abbots. Indeed that sense of the force of Buddhism, as both a religion of redemption and a potent social and political presence, was truly

New York. Freer paid Fenollosa $1,640 for *Luohans Laundering*. Up to the nineteenth century, the scrolls were attributed either to Guan Xiu or Li Longmian, two great medieval artists associated with *luohan* painting. Despite doubt cast on those attributions in 1850 by the Japanese connoisseur Tesujō, on the grounds that the brushwork simply didn't sustain such an attribution, Fenollosa continued to believe that they were executed by Li Longmian and his followers during the twelfth century. Two scrolls were apparently replaced prior to the set's arrival in Japan, and a further six replaced, ca. 1638, with copies by Kano Tokuō. A recent study carried out by the National Research Institute for Cultural Properties and the Nara National Museum has revealed inscriptions on over forty of the Daitokuji scrolls; *Tobunken Monthly Report*, May 2009.

[65] Assuming that they were not commissioned for the mountain caves in Hebei province in which they were discovered, the Yixian earthenware *luohans* would probably have been arranged on platforms against the walls of a temple hall. Two surviving examples from the set, originally probably of sixteen figures, are held at the Metropolitan Museum of Art, and one each at the University of Pennsylvania Museum, the Nelson-Atkins Gallery, the British Museum, the Musée Guimet, the Boston Museum of Fine Arts, the Royal Ontario Museum and the Saison Museum of Modern Art, the latter three having replacement heads. Three are also reported to have been broken when being carried down from the caves in the early twentieth century, and a further one appears to have been destroyed in Berlin during World War II. Based on their technical sophistication, Angela Falco Howard argues for a much earlier date, in the 720s; see Howard, et al., *Chinese Sculpture*, 303–5. Thermoluminescence testing on the University of Pennsylvania figure accords, however, with an eleventh- to twelfth-century date; see Richard Smithies, 'A *Luohan* from Yizhou in the University of Pennsylvania Museum', *Orientations*, vol. 32, no. 2, February 2001, 51–6. For a further discussion of late medieval sculpture in north China, see Derek Gillman, 'General Munthe's Chinese Buddhist Sculpture', in Tadeusz Skorupski, ed., *The Buddhist Forum* 4 (London: University of London, School of Oriental and African Studies, 1996), 93–123.

trans-national, shared by Southern Song Buddhists with co-religionists in the Dali kingdom (in present-day Yunnan), the Jurchen Jin dynasty to the north, Korea, Japan and other surrounding states. Temple paintings were valuable in different ways to different people. They were valuable to the clergy in providing stories about paradises, hells and other conditions into which humans will be reborn; about the compassion of Buddhist divinities; about the instrumental value of the Buddhist clergy through their professional capacity to conduct masses for the dead; and about the acquisition of merit through Buddhist ceremonial practices, donating money to temples, and sponsoring and worshipping images and relics.

The two artists responsible for the Daitokuji set, Lin Ting'gui and Zhou Jichang, show the five hundred figures (five to a painting) engaged in a variety of activities that illustrate both their compassionate natures and magical abilities, and also, as in this scroll by Lin, undertaking the mundane work of real monks. *Luohans Laundering* groups the six figures in pairs: at the center, a *luohan* and bearer (likely a spirit) descend a mountain path behind two *luohans* engaged in conversation, above a further two at the stream bank who attend to the task of washing garments, exposing their muscled, peasant-like arms. The bright mineral-coloured robes strongly stand out again a monochromatic but animated landscape, dominated on the left by a gnarled and wildly twisting pine that embraces the *luohans* as fellow inhabitants of a world beyond the ordinary. Brushed in the figural and landscape styles then current at the Southern Song academy, some eighty miles to the west, Lin's painting masterfully creates an enclosed stage set – one among a hundred – where the principal actors underline their commonality with worshippers and pilgrims, while engaging in just those humble concentration-focusing activities through which illumination can be achieved.[66]

In another painting from the set, this time by Zhou Jichang (Fig. 14), *luohans* demonstrate the peerless nature of Buddhist scriptures, a bundle of which emits rays of illumination over the heads of awed Daoists who, clustered within a mountain grotto, are emotionally, physically and spiritually subordinated. But the force of this image shouldn't lead

[66] Wu Tung suggests that the figures are stylistically closer to Lin and Zhou's near contemporary at court, Liu Songnian, *Tales from the Land of Dragons*, 160; the landscape is in the style of Li Tang, who transitioned from the Northern to the Southern Song academy during the early part of the century.

automatically to the assumption that the artists themselves subscribed to the religion, since like other Ningbo painters they were working on commission, presumably also for Daoist temples (although Lin and Zhou's intelligent handling of this material suggests a considerable degree of sympathy and respect).

Such paintings underlined the roles that gave people legitimacy and acceptance within the Buddhist community. For Ouyang Xiu, however, Buddhists provided poor role models for the Chinese people, from which they would make unintelligent judgments about their lives. Notwithstanding the millennium-long presence of Buddhism in China, he wanted classical roles and their associated virtues to dominate (the righteous and benevolent official, the filial child). If challenged he might have found it hard to dismiss the Buddhist virtues of compassion and generosity, yet would surely have regarded them as insufficient: they didn't adequately support the complex social practices that underwrote spiritual and political power in the Confucian state. Buddhist abbots might have managerial and political talent but were perceived to lack the virtues required to administer a vast empire justly and effectively, and to plan for natural, political or economic crises.

The rejection of Buddhist virtues as non-Chinese was not the rejection of a foreign language *per se*, since Buddhist scriptures denigrated by neo-Confucianists had long been translated into Chinese (or indeed created in Chinese), and many religions maintain their adherents via translation programmes. Although texts may best be studied in the original language, to the lay-follower the vernacular will generally do as well – as much from necessity as choice. Thus Buddhism can be practised in Chinese, Thai, Japanese and English, as Protestant Christianity can be in Chinese, German, Swahili and Arabic. This is not to say that all ideologies are trans-cultural. Many tribal cultures have an ideology that is particular to them even if it does have a 'family relationship' to others nearby. Nonetheless, religious stories survive transition across numerous national boundaries. For example, *jataka* stories of the historical Buddha's life have been retold in the vernacular in India, Sri Lanka, Cambodia, Thailand, Burma, Indonesia, Central Asia, Tibet, Nepal, China, Korea and Japan. The visual images associated with such stories will appear differently, however, according to period and style. Though relating to those of contemporary Japan and Korea, Song Chinese aesthetic values were nonetheless particular to their place. For twelfth-century Chinese connoisseurs, *Luohans laundering* was Ningbo atelier work, as distinct from

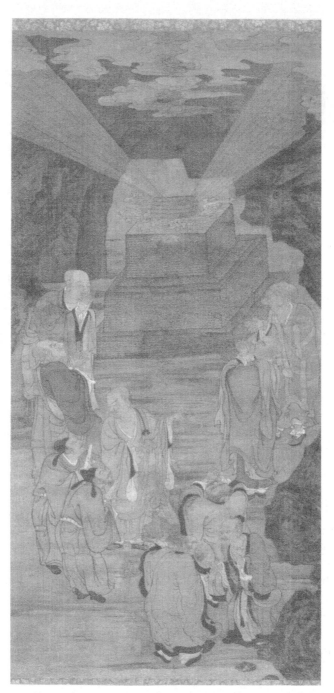

FIGURE 14. *Zhou Jichang*, Luohans demonstrating the power of the Buddhist sutras to Daoists, *China, Southern Song dynasty, ca. 1178 CE, 111.5 × 53.1 cm., Museum of Fine Arts, Boston, Denman Waldo Ross Collection, 06.290. Photograph @ 2010 Museum of Fine Arts, Boston.*

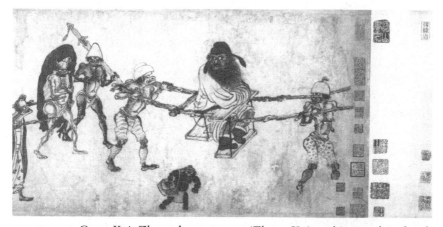

FIGURE 15. *Gong Kai,* Zhongshan quyu tu (Zhong Kui on his travels), *detail, China, Yuan dynasty, late 13th century CE, 32.8 × 169.5 cm. Courtesy of the Freer Gallery of Art, Smithsonian Institution, Washington D.C. Purchase, F1938.4.* Representing a figure from indigenous religion, Gong Kai's literati painting would have appealed to members of the Confucian elite who formulated the idea of 'our culture'.

Chan (Zen) Buddhist painting or Imperial Academy painting or literati painting, and judgment of such work looked to its technical skill, representational accuracy and sense of theatre.[67] For Bernard Berenson, however, the Daitokuji scrolls were simply sublime:

They had composition of figures and groups as perfect and simple as the best we Europeans have ever done...I was prostrate. Fenollosa shivered as he looked. I thought I should die, and even Denman Ross who looked dumpy Anglo-Saxon [*sic*] was jumping up and down. We had to poke and pinch each other's necks and wept. No, decidedly I never had such an art experience.[68]

Dating from the early years of the Mongol Yuan dynasty, and also in the Freer collections, the second painting is by a respected literatus Gong Kai. At one level, as Gao Shiqi wrote in 1700, the hand scroll *Zhongshan quyu tu* (Zhong Kui on his travels) is "bound to cause a good laugh" (Figs. 15, 16). The subject was a spiritual keeper of order (not dissimilar to Guandi, represented above by the cowboy) who appeared to the

[67] And, as in European studios, it is quite possible that studio assistants undertook elements of the paintings, such as the application of the mineral pigments.
[68] Wu, *Tales from the Land of Dragons,* 160.

FIGURE 16. *Gong Kai*, Zhongshan quyu tu, *detail.*

Minghuang Emperor (713–56) within a fever-ridden dream.[69] In gratitude for saving him from a mischievous demon, Minghuang honoured him with the title 'Great Spiritual Demon Chaser of the Whole Empire', and Zhong Kui henceforth travelled the realm cleansing it of malign spirits. In Gong Kai's painting, Zhong and his dour-looking sister are carried and surrounded by rowdy martial ghosts grinning eagerly for battle. Gong's deft and forceful brushwork creates an atmosphere of near anarchy around the wolfish scholar-spirit: a manic metaphysical version of the honourable outlaw, and a vivid but satirical picture of the 'other world' with its fearsome and disruptive ghosts and demons, a number of whom wriggle from the poles onto which they are tied.

What was Gong Kai doing here? His painting was far from being a temple representation of the type represented by the Ningbo scrolls. His landscapes followed the style of the eleventh-century painter and calligrapher Mi Fu, and he himself was fully engaged with the literati programme to calligraphise painting. Although the forms he uses for the spirits probably derive from the Tang painter Wu Daozi, his primary intention is evidently to represent all the figures through the conventions

[69] The story goes that the emperor saw a small demon, 'waste', mischievously gambolling with a stolen imperial jade flute when a huge bearded figure dressed in tattered civil service robes burst in, seized the imp and devoured one of its eyes. The imperial saviour revealed himself as Zhong Kui, a scholar of the previous era who had committed suicide after being defrauded of first place in the highest imperial examinations and thus denied the coveted role of magistrate. See Lawton, *Chinese Figure Painting*, 142–9; the painting was acquired from Tonying & Co., N. Y., in 1938.

of calligraphy.[70] The picture had a further, more covert message. Gong Kai was renowned also for his painting of horses – understood as a symbol of political oppression, since horses in halters were identified with scholar-officials chafing in government service.[71] In a similar vein, Zhong Kui is allegorically driving out the demons from China, not just the ghostly ones but the foreign barbarians: the Jin, who had been ousted by the Mongols from north China a half century before, and the Mongols themselves, who were only now at the beginning of their occupation of the whole of China. Not so much a rallying cry as wishful thinking, the *Zhongshan quyu tu* expressed Gong Kai's longing for the resurrection of an indigenous sense of order and an end to political and social chaos. And then there is a second level of satire identified by Thomas Lawton, where the principals stand for Minghuang and his concubine Yang Guifei, who was seen as partially culpable for Minghuang's infamous flight to Sichuan, which tallies nicely with the over-the-shoulder glare bestowed by Zhong Kui on his somewhat cowed sister.[72]

On the spectrum of Chinese religious imagery, one end is occupied by professionals with only artisan status (in the Ningbo ateliers, for example), and the other by literati artists producing works for their own class. Gong Kai's *Zhongshan quyu tu* or Guan Daosheng's copies of the *Miaoshan* legend have a religious subject or sensibility but only a modest role in the spiritual life of communities.[73] Within the conventions of

[70] See Sherman E. Lee, 'Yan Hui, Zhong Kui, Demons and the New Year', (1993) 53 *Artibus Asiae* 211–227; and Judith T. Zeitlin, 'Luo Ping's Early *Ghost Amusement* Scroll: Literary and Theatrical Perspectives', in Kim Karlsson, Alfreda Murck and Michele Matteini, eds., *Eccentric Visions: The Worlds of Luo Ping (1733–1799)* (Zurich: Museum Rietberg, 2009).

[71] Bush, *The Chinese Literati on Painting*, 105.

[72] Which might suggest a third, tenuous reading where the painting depicts a key event in the reduction of Song dynasty territory, with Zhong Kui representing the last Northern Song emperor, Huizong, carried off in 1127 by the invading Jurchen troops, with the palanquin-bearers now captors.

[73] For a Ningbo painting of the Ten Kings of Hell from the workshop of Jin Dashou, c. 1150–95, see Craig Clunas, *Art in China* (Oxford: Oxford University Press, 1997), pl. 55. Clunas notes the Ningbo workshop practice of stencilling, which made possible both an increase in productivity and standardisation, 114–15. For other forms of Zhejiang professional painting, see also Roderick Whitfield, *Fascination of Nature: Plants and Insects in Chinese Painting and Ceramics of the Yuan Dynasty (1279–1368)* (Seoul: Yekyong Publications, 1993). There was clearly some anxiety among the literati in viewing religious subjects as if they were secular paintings, as we can see from Guo Roxu's comment of ca. 1080: "The theory is sometimes propounded that it is not proper to collect Buddhist or Daoist icons, since it is difficult to unroll and enjoy them from time to time for fear of their being treated irreverently or becoming polluted. My own

contemporary literati painting, Gong's painting was both innovative and brilliantly executed, requiring for full appreciation a knowledge of calligraphic practice in various styles. In an elegant archaic hand, he himself explains:

Some say that painting demons in ink is being merely playful with the brush, but that is certainly not true. This type of painting is like the work of the most divine of the cursive scriptwriters among calligraphers... Yizhen's demons are very skilfully done, but his intention is vulgar. Recently, some intemperate painter depicted the Whiskered One [Zhong Kui] in a field privy being approached by a porcupine, and his dishevelled sister, stick in hand driving it away. Now what kind of a painting is that? My aim in painting the *Zhongshan quyu tu* is to wash away Yizhen's vulgarity, so as not to destroy the pure joy of brush and ink. In calligraphic terms, the painting is something between the regular script and the cursive script.[74]

Rational actors such as Gong Kai interpret those normative, institutionally embodied rules and conventions of visual practice within the options made available to them through their social roles, and subject to their own level of skill and understanding. Artists have to have good reasons (at least to themselves) for choosing whatever it is that they are going to do, whether in making a painting, writing a poem, directing a movie or playing in an orchestra. And although these choices depend on their technical abilities and interpretative and inventive capacities, they are deeply rooted in shared expectations and values. So a fuller appreciation of this painting will draw on knowledge of current political circumstance in Southern Song China, as well as the 'proper' social relationships of gentry (men and women) and their servants, the aesthetic rules and conventions of Chinese calligraphy, Buddhist ghost painting, Song literati painting, literary satire and popular theatre. The painting responds to an array of social and artistic expectations, and we are helped in understanding its freshness and intelligence if we become more familiar with them.

opinion is the reverse. It is a general rule that when scholars and gentlemen meet for the pleasure of seeing and discussing calligraphy or paintings, the place must be quiet and clean, and where there is only appreciation for skill and respect for the images preserved from the past, how could any irreverence of mind exist?... It can thus be known that the opinion that it is improper to collect [icons] is of no importance". Susan Bush and Hsio-yen Shih, *Early Chinese Texts on Painting* (Cambridge, MA: Harvard University Press, 1985), 107.

74 Lawton, *Chinese Figure Painting*, 145. Reduced to poverty under the Yuan, Gong did however exchange work either for cash or goods in kind, the latter being seen as a form of gift-giving that skirted the stigma of professionalism; see James Cahill, *Hills Beyond a River: Chinese Painting of the Yüan Dynasty (1279–1368)* (New York and Tokyo: John Weatherhill, 1976), 17–19.

Bending or breaking conventions was a risky strategy that might bring opprobrium as much as approbation. But when artists successfully carried it off in the eyes of contemporaries and successors, they were applauded for their penetration and understanding. From the colophons and other critical texts on literati painting we receive opinions from a variety of players in the market that evaluated Chinese art, from friends and other contemporaries of the artist, to later owners and connoisseurs. Three centuries after Gong Kai, a sympathetic friend might have been inspired by the way in which the Ming painter Xu Wei 'splashed ink' (linking two of Finnis's values, aesthetic experience and play), but his more conservative contemporaries would have dismissed it as simply careless.[75] Yet there were good reasons for this as we learn from Xu, also an immensely talented calligrapher, poet and playwright, who had anxiously and violently responded to personal crises:

> In my performance the ink is dripping wet,
> The flowers and grasses are confused about the season.
> Do not complain that this painting lacks several strokes,
> For recently the Way of Heaven is full of misdeeds.[76]

Xu pushed his art beyond polite literati boundaries (and, like Gong Kai, was forced by poverty into selling them), but disciplined professional painters like Lin Ting'gui and Zhou Jichang couldn't afford their flowers and grasses to be "confused about the season", since the conventions of commissioned religious painting allowed less poetic licence than a literati approach. Their art was a public one, intersecting with sculpture to create dramatic tableaux of divine beings and eminent disciples, such as are seen within the cave temples at Dunhuang in Chinese Central Asia. In contrast, the intentions of painters such as Gong Kai and Xuwei were fully revealed only to those who could access often abstruse references.

Merryman asked how someone in China, educated in the arts but hitherto insulated against Western culture, might respond to the "*quality, the intrinsic artistic merit*" of a Braque. I think she would probably find

75 Finnis writes of play that "each one of us can see the point of engaging in performances which have no point beyond the performance itself, enjoyed for its own sake. The performance may be solitary or social, intellectual or physical, strenuous or relaxed, highly structured or relatively informal, conventional or *ad hoc* in its pattern". John Finnis, *Natural Law and Natural Rights* (Oxford: Clarendon Press, 1980), 87.
76 Yang Xin, 'The Ming Dynasty (1368–1644)', in Yang Xin, Richard M. Barnhart, Nie Chongzheng, James Cahill, Lang Shaojun, Wu Hung, *Three Thousand Years of Chinese Painting* (New Haven: Yale University Press, 1997), 232.

it hard to make sense of a cubist painting without any reference to long-standing European conventions for representing forms in space, to which Braque and Picasso responded in so many complex ways. Conversely, let me try a speculative answer to my own reversion of Merryman's question: about a Westerner responding to Chinese paintings – in this case Gong Kai's *Zhongshan quyu tu*. First, in a Gombrichian spirit, let me suggest that in assessing different aspects of the painting she will in fact draw on prior evaluations of Western images, and that whatever recognition she has of the painting's calligraphic strength will be conditioned by her knowledge of Western drawing, which is only to say that when we encounter new forms of art we bring along familiar expectations. Second, it depends on her taste in Western art. Even allowing that she should see it 'in the flesh' and not in reproduction, I'm doubtful she will feel on firm enough ground to get much beyond the strangeness of the procession, and if she seeks mathematical perspective, anatomical accuracy and a fully coloured world she will be disappointed (as Merryman suggests many Westerners would still be with the Braque), and will fare better with *Luohans laundering*. She'd perhaps regard the *Zhongshan quyu tu* as belonging to a lesser art form or preliminary to something more 'finished' (like the Lansdowne Portrait). Chinese literati painters after the Song period generally resisted three-dimensional modelling, however, since they believed that illusionistic representation undermined the depiction of essentials, much as European and American modernists thought in the early twentieth century.[77] In another reversal we could put in front of her a mediocre literati painting and, lacking the knowledge and experience to distinguish spirited and original *wenren* work from the formulaic and well-trodden, she could think it quite fine.

If we asked an expert in Chinese painting to explain why, on the evidence of this work, Gong Kai is a superior artist, she might cite the qualities or virtues of imagination, design sense and physical control exercised at the highest levels. Such shorthand, however, glosses the experiential basis of her connoisseurship and judgment, which necessitates examining

[77] Here is Tang Hou (active early fourteenth century): "If one looks at landscapes, ink bamboos, blossoming plums, and orchids, leafless trees and strange rocks, ink flowers and birds, and so on, the playing with brush and ink in which men of high character and superior scholars have given form to inspiration and sketched ideas, one certainly cannot understand them in terms of formal likeness. If one first looks at their true naturalness (*tianzhen*) and then at the conception and when facing them, forgets their means of execution, then one will have grasped their flavor". Bush, *The Chinese Literati on Painting*, 127.

many good and less-than-good examples of this particular art form, and thoroughly understanding its mercurial constraints and enablements: soot-based ink applied to absorbent paper by a long-haired brush that reveals the painter's energy in every stroke. More than that, she will have discussed *wenren* works with her teachers and other experts, and will certainly be familiar with the evaluative literature.

Now while it is certainly possible to appreciate art only for its formal qualities, I imagine most 'educated' spectators would, if asked, want to engage with more than just the aesthetic. But, in so wishing, our educated Westerner who is unfamiliar with Chinese conventions would almost certainly miss the intellectual and social intentions of *Zhong Kui travelling*, failing not only to understand its use of the genre to create an allegory of order and disorder, but also the deliberate distancing from conventional (professional) religious art. She will misread the work as 'just' an illustration instead of as a vehicle for guarded political comment which depicts a maligned (and 'physically' transformed) fellow scholar guarding the indigenous Chinese moral order against a barbarian invasion that has transformed society into a version of hell. Similarly, we can read *Macbeth* for the intrinsic brilliance of its poetry and drama yet remain innocent of its political meaning.

Going beyond Merryman's question, would we not want to attempt more than just an aesthetic appreciation of Gong Kai's *Zhong Kui travelling* or Picasso's *Guernica*, and engage also with the artists' intentions, recognising their explicit or tacit narratives of invasion and social chaos, and their desire to speak to the instrumental values of autonomy and national self-determination? As Picasso himself questioned Simone Téry in 1945: "What do you think an artist is?... How could it be possible to feel no interest in other people, and... to detach yourself from the very life which they bring to you abundantly? No, painting is not done to decorate apartments. It is an instrument of war".[78] This aspect of Picasso is addressed by David Hockney, here writing about a painting from 1951 relating to the Korean War:

I think that this picture has a power in it that "Guernica" does not, in that the latter was made by Picasso because he knew the city. Picasso was reacting as a Spaniard to an atrocity in a Spanish town. He could not help but react. But in "Massacre in Korea" he is addressing a more distant, more abstract cruelty; he's reacting as a human being and as a painter. He is pointing out to people that

[78] Russell Martin, *Picasso's War: The Destruction of Guernica, and the Masterpiece that Changed the World* (New York: Dutton, 2002), 175.

painting should be involved in things other than the proportion and relationship of right angles to one another, even in the subject matter.[79]

Medieval China was a socially complex state with many factions and classes holding different and often incommensurable values. *Luohans laundering* would have had little value to purist neo-Confucians. In contrast, at least from Ouyang Xiu's viewpoint, the *Zhongshan quyu tu* would unproblematically be part of Confucian heritage. Yet Buddhism has remained a part of Chinese culture for almost two millennia, now persecuted, now promoted, now benefiting from imperial patronage, now excluded from court, championed more strongly in some areas than in others. In Japan, where Buddhism generally maintained a much higher social and political status, *Luohans laundering* continued to have value.

Nonetheless, as in China, Japan wasn't immune from attacks by the native on the foreign. At the beginning of the Shinto-focused Meiji Restoration in the late 1860s there were ferocious attacks on Buddhist temples and images (as there were in China in 845), which in turn led to the passing of the 1871 Decree for the Protection of Antiquities. Almost a quarter century later, months before the Daitokuji paintings went on display in Boston, the former governor of Kyoto, Kitagaki Kunimichi, noted in his diary his opposition to the chief abbot's proposal to sell some of the paintings without formal approval or even supervision by the prefectural office. It is therefore unsurprising that the scrolls remaining at the Daitokuji were listed in 1908 as Japanese national treasures.[80]

[79] David Hockney, *Picasso* (Madras: Hanuman Books, 1990), 60–1.

[80] See Levine, *Daitokuji*, 305–9, where he notes that Japan had set up a quasi-governmental system in the late nineteenth century for selling art overseas, with which, through intermediaries, the Daitokuji monks might have had dealings, and also that, during 1907 in Tokyo, Freer purchased his second painting from the set for $1,500, Zhou Jichang's *Rock Bridge at Tiantai*. In 1897, Morimoto Kōchō, Director of the Imperial Museums in Kyoto and Nara, wrote of the sale to Boston: "recently the paintings were sold to a foreign country, the foreigners acquired 12 scrolls...I regret the loss". Wu, *Tales from the Land of Dragons*, 160.

REGULATION AND RIGHTS

5

Regulation and Private Rights

I do not think we have the right to feel we own the works of art we have, any more than the spouse we have. Therefore we should not kill them off just because we do not like them. Still, it is arguable that a portrait of oneself, or of someone near and dear, is a special case.

David Sylvester[1]

1. Export Estoppels

Thus far we have looked at different claims about heritage and the means by which it is constructed and disputed. I now want to move on to the regulation of valuable objects and buildings. In the early twenty-first century almost every country has a formal attitude to the regulation of cultural things, ranging from tight state control to decentralised, regionally administered laws. I focus here on three common law countries, Britain, Australia and America, because their strong private rights regimes pose interesting challenges to general claims on property made in the name of heritage.[2]

My case for considering common law regulation of art and architecture in the same breath, as it were, is that arguments made for controlling (or not controlling) movable cultural properties and historical buildings often have the same grounds and employ similar forms of rhetoric, generally derived from the 'Whig version of history' noted in Chapter 3. Since the

[1] Joseph Sax, *Playing Darts with a Rembrandt: Private and Public Rights in Cultural Treasures* (Ann Arbor: The University of Michigan Press, 1999), 39.

[2] Although the component countries of the United Kingdom share many statutory laws, Scotland has a different domestic legal system from England and Wales.

Ancient Monuments Act of 1882, Britain has incorporated into legislation Ruskin's architectural version of Burke's conservative sense of the entailed estate. This history has been strong enough in Britain to balance private rights to property with a respect for the built environment, exteriors and interiors. In contrast, America has a different, revolutionary sense of self. That having been said, Americans newly concerned about heritage have been surprisingly quick to adopt British-style rhetoric.

In Britain, the perceived problem of losing national treasures went back to the early years of the twentieth century, when a flood of pictures exited landed estates to offset the effects of the agricultural depression and the introduction of death duties in 1894.[3] The Waverley Committee was appointed in 1952 to rationalise a British export system that was widely regarded by the art establishment as unfair and uncertain, the history of which has been mapped out by Clare Maurice and Richard Turnor, and Vivian Wang.[4] It concluded that control should be applied to a smaller

[3] European grain and meat prices fell dramatically from the 1880s onwards, caused by new plantings in America and the development of rail routes and refrigerated ships; Meryle Secrest, *Duveen: A Life in Art* (New York: Knopf, 2004), 43–4; see also Robert Hewison, *The Heritage Industry: Britain in a Climate of Decline* (London: Methuen, 1987), 54. Under the Finance Act of 1894, taxable property was widely defined to include even that held in a family settlement in which the deceased might have had only a life interest. Estate duties were replaced/renamed first in 1975 under a new Finance Act (as Capital Transfer Tax), and then again in 1984 (as Inheritance Tax); the tax falls on property leaving the estate of the donor, whether on death or within the period seven years before death. See generally Julia Simmonds, *Art and Taxation* (Leicester: Institute of Art and Law, 2001).

[4] In 1911 the Trustees of the National Gallery set up a committee chaired by Lord Curzon to enquire into the national retention of important pictures, to learn that in the previous few years over five hundred had been exported, including fifty (attributed) Rembrandts, twenty-one Rubens, five Velasquezs, eleven Holbeins, four Corregios, seven Vermeers and twenty-nine Gainsboroughs. Reporting in December 1913, the committee argued against restriction or prohibition of export, or for the introduction of export duties, but it did make a number of recommendations to help national collections acquire works of art so threatened. The First World War added to the flood, as the carnage in the trenches left landed families with double or treble death duties (from heirs to the same estate), the obvious capital source for the payment of which was the inherited picture collection. An export tax proposal was put forward again in 1922, and a list drawn up of the 'paramount' pictures in the country, to be reviewed from time to time. Any of these works would be eligible for purchase by the nation with a sum voted by Parliament on the recommendation of the Treasury (the Wilton Diptych was acquired in this way in 1929). The situation then changed in 1939 with the introduction of the Import, Export and Customs Powers (Defence) Act designed to control exports not as a restrictive measure *per se*, but to ensure that exported goods earned their proper quota of foreign exchange. In the following year works of art were included under its powers, and by 1944 it was realised that this was an instrument that could, indeed did, *de facto* protect 'national treasures'. The system stayed in operation after the war ended but was a cause for grievance by vendors who

number of higher quality items, that controls had to be imposed at an earlier stage and that clear policy statements were needed. The general view was that some artefacts ought to remain in the country, but not that the gap be closed between 'ought' and 'shall'. Beneath set limits on the age of an object, its financial value and the period of time it had been in the United Kingdom, no object should be referred back for a licence. When export is stopped, usually for two to three months, the money to be found from a public institution must be a fair market price, arrived at by taking account of past offers, offers for similar or comparable objects, market trends and other relevant factors.[5] If a matching offer is made there will be a further deferral period, often equal in time, during which the funding has to be achieved.[6] The criteria recommended by the Waverley Committee for judging the appropriateness of stopping a work from leaving the country were as follows:

> Is the object so *closely associated with our history and national life* that its departure would be a misfortune?
>
> Is the object of *outstanding aesthetic importance?*
>
> Is the object of *outstanding significance for the study* of some particular branch of art, learning or history? (emphasis added)

felt, rightly, that directors of the national galleries and museums had the field tilted in their favour, since objects were refused licences with no corresponding offer from an institution. Hence it was out of perceived injustice that the Waverley Committee came into being. See Clare Maurice and Richard Turnor, 'The Export Licensing Rules in the United Kingdom and the Waverley Criteria', (1992) 1 *International Journal of Cultural Property* 273. See also Vivian F. Wang, 'Whose Responsibility? The Waverley System, Past and Present', (2008) 15 *International Journal of Cultural Property* 227–69; and *The Export of Works of Art Etc., Report of a Committee Appointed by the Chancellor of the Exchequer London* (London: HMSO, 1952).

5 During *The Three Graces* estoppel period in 1990, following an offer by Jacob Rothschild to acquire it for the nation and display it at Waddeston Manor (the former Rothschild estate now held by the National Trust), the minister for Trade and Industry, Nicholas Ridley, changed the Waverley rule that only public institutions could make an offer. In the event, the sculpture was acquired jointly by the National Gallery of Scotland and the Victoria and Albert Museum with funds from a variety of sources, including John Paul Getty II. The revised guidelines published in 1997 are that a private offer can be accepted if accompanied by a signed undertaking "with a public institution" to guarantee reasonable public access, provide satisfactory conservation conditions and not sell the object for a specified period. See Sara E. Bush, 'The Protection of British Heritage: Woburn Abbey and *The Three Graces*', (1996) 5 *International Journal of Cultural Property* 269–90; Richard Crewdson, 'Waverley Adrift', (1997) 6 *International Journal of Cultural Property* 353–4; and Edward Manisty, 'UK Export Licensing for Cultural Goods', (2007) XII *Art Antiquity and Law* 317–35.

6 Maurice and Turnor, 'The Export Licensing Rules in the United Kingdom and the Waverley Criteria'.

I shall gloss the first as the 'value of heritage'. Thinking back to John Finnis's list of basic goods (Chapter 1), the retention of an object associated with 'our history and national life' will be instrumentally valuable insofar as it helps us realise such intrinsic values as knowledge, play, friendship and religion. The Confucian concept of 'our refined (literary) culture' did similar work to 'heritage', albeit in a more elitist way, amalgamating Finnis's separated values of aesthetic experience, knowledge, practical reason and religion.

The second and third Waverley criteria focus on just the value of aesthetic experience and the value of knowledge (mapping directly onto Finnis's list). These criteria were always intended to be pragmatic guidelines rather than exclusive categories, and were conceived not to impose restrictive practices on free trade but to bring to the attention of institutions those artefacts likely to go overseas, and if necessary to provide special assistance with the purchase of objects considered outstanding. If, for example, the Lansdowne Portrait had been properly returned before the expiration of the six-month temporary licence and subsequently offered for sale in the United Kingdom, there seems little doubt that it would have been stopped by the Waverley criteria. Had a matching offer been made by a home institution, the painting would have remained in Britain, irrespective of any American interest in it.[7]

The original thought was that adequate purchase grants to national museums would be backed up by contributions from the public via charities such as the National Art Collections Fund (now the Art Fund). But as the Reviewing Committee and numerous others have underlined, the system works only if the government makes funds available to catch not only the important and cheap, but the important and very expensive. Theory and practice subsequently parted company as purchase grants made available to the national institutions failed to keep apace of the unpredicted and massive rise in art prices during the 1980s. And indeed such grants were actually frozen, so that when the Badminton Cabinet came before the Committee in 1990, purchase grants were the same as in 1985.[8] Despite the existence of the National Heritage Memorial Fund the system became a near parody of itself until the creation of the National

[7] There has been no obligation for vendors to accept offers from home institutions, but proposals have been put forward to avoid this; see *Quinquennial Review of the Reviewing Committee on the Export of Works of Art* (London: HMSO, 2003), 24, and Sir Nicholas Goodison, *Goodison Review: Securing the Best for Our Museums: Private Giving and Government Support* (London: HMSO, 2004), 37–8.

[8] £8.5 m. per annum across the national institutions.

Lottery. During a debate on public funding for the arts, three days before the end of the estoppel period for the Badminton Cabinet, Baroness Birk drew attention to the fact that the Victoria and Albert Museum's purchase grant presently stood at £1.145 million, lower than ten years before:

> While museums strive to maintain their collections, great works are leaving Britain with depressing ease. Although many are retained they are usually the less expensive works. If the Minister says that we have managed to keep more than 51 per cent of the works he must translate that into their value. It is only one-tenth of the value of those that got away.[9]

The 1990–91 annual report of the Reviewing Committee described the appearance of a major heritage object before it as "one of those quaint old British rituals, like Morris dancing on the green, a harmless custom, the original purpose of which is almost forgotten". Only since the mid-90s did the system begin to make some sense again through a considerable injection from the Heritage Lottery Fund, although, as Wang notes, the initial optimism with which the lottery was greeted has since been dampened by the relative sparsity of its grants for Waverley objects.[10]

Following its first auction, the Badminton Cabinet duly passed before the Reviewing Committee. Given the adversarial nature of the process, it was unsurprising that the representative for the applicant contended that the piece did not fulfil satisfactorily any of the Waverley criteria: it was not connected with British history or national life, it had been little commented on and rarely mentioned in either popular or learned publications, its aesthetic importance had also been called into question, its significance to the study of a particular branch of learning was extremely narrow, and although conceivably of interest to Florentines, their *pietra dure* manufacture could hardly be said to be of outstanding significance to this country.[11] Those arguments notwithstanding, the Committee decided that it met the second and third Waverley criteria (values of aesthetic experience and knowledge), and a licence was deferred for two months

9 "Many people in the art world and outside it are anxious about the Badminton Cabinet... It was made for the then Duke of Beaufort in the Medici workshops. It bears the Plantagenet coat of arms and is part of our heritage". *Parliamentary Debates (Hansard): House of Lords Official Report* 528, no. 87 (London: HMSO, 15 May 1991), 1616–17.

10 Canova's *Ideal Head* was acquired for the Ashmolean Museum with lottery money. Waverley was most effective when directly supported by the Treasury, from which it became formally detached in 1965, Wang, 'Whose Responsibility? The Waverley System, Past and Present', 248–51.

11 *Export of Works of Art 1990–91, Thirty-seventh Report of the Reviewing Committee appointed by the Chancellor of the Exchequer in December 1952* (London: HMSO), 11–12.

with the option of a further four-month deferral if a serious offer was made.

As far as British controls are concerned, origin is not crucial, allowing works produced elsewhere to qualify as nationally important. Indeed, the Reviewing Committee has wanted to see retained key works that are "generally accepted by informed opinion as being essential parts of our cultural, artistic or historic heritage... We must argue... strongly against the insular prejudice that all heritage objects must carry a 'made in Britain' stamp".[12] During the years 1991 to 1993, applications came before the Committee for twenty-five licences for European drawings from Holkham House in Norfolk, following their sale by the then Viscount Coke (now the seventh Earl of Leicester).[13] The expert adviser argued that a single, informed taste lay behind the assemblage, and that the first earl had commissioned William Kent to design Holkham specifically for the purpose of housing his Grand Tour paintings and drawings, the latter still in their original mounts, many with contemporary annotations and numberings. When the sale was announced in July 1990, a consortium of museums met to plan how they might forestall dispersal and preserve what was regarded as the surviving *locus classicus* of Grand Tour taste, but negotiations to acquire them *en bloc* were unsuccessful and the Christie's auction realised £3.2 million.[14] At the event, ten of the drawings found homes in British museums.[15]

After the Badminton Cabinet and Holkham sales, the British arts minister requested the Reviewing Committee to look again at the existing system of export controls. They concluded that, so long as adequate funding was available, Waverley was still the most effective means of preventing the export of important national treasures (or "heritage objects", an "ugly but convenient phrase"). Failing that, it would be feasible for the government to introduce a list of items that would be prohibited from leaving the country without compensation to owners (as has happened

[12] *A Review of the Current System of Controls on the Export of Works of Art* (London: HMSO, 1991), 3.

[13] Including works by Guercino, Bernini, de Ribera, Reni, Poussin, Rosa, Cossiers, Snyders and Castiglione, and also sixteenth century works by Bandinelli, Veronese, Salviati and Vanni.

[14] The consortium comprised the British Museum, the National Galleries of Scotland, the Ashmolean and the Fitzwilliam.

[15] At the Ashmolean, Fitzwilliam, National Galleries of Scotland, Walker Art Gallery, V&A and the Barber Institute and Birmingham Museum (in collaboration). *Export of Works of Art 1991–92, Thirty-eighth Report* (London: HMSO), 3–4, 26–39, and *Export of Works of Art 1992–93, Thirty-ninth Report* (London: HMSO), 16–17.

in Australia without a list).[16] The Reviewing Committee suggested that excluding books, manuscripts and archives, such a British list might number some 2,000 works.[17] Compensating owners was seen to pose many difficulties: of calculating market values (in the UK and internationally), of agreeing on dates when reductions in value occur, of the timing of payments and of adjusting for hypothetical market behaviour. Listing would prevent the loss of great works whilst at the same time allowing museum directors to concentrate on their own priorities rather than fire fighting on behalf of the nation, and only a few people would be affected since it would act as a wealth tax on those who held, as the Committee put it, "a certain type of asset, to which the nation lays a claim, but for which the nation is not willing to pay the open market value". The Committee noted the practice of starring items of especial importance (such as *The Three Graces* and eighteen of the Holkham drawings) in order to signal the need for every effort to be made to produce a compensating offer, and it regretted its not starring the Badminton Cabinet.[18] It also suggested to the secretary of state the addition of a fourth criterion that would cover objects from key integral collections ("the combined contents of which are greater as a unit than the individual parts and which in aggregate are supremely listable"), a concern that reappeared in modified form in the Committee's quinquennial review a decade later.[19]

[16] See the Protection of Movable Cultural Heritage Act 1986, and the National Cultural Heritage Control List set up under Section 8 of the 1986 Act.

[17] *A Review of the Current System of Controls on the Export of Works of Art*, 6.

[18] Begun during the 1987–88 year.

[19] Sales included the collection of a Methodist missionary George Brown, who assembled a large number of works from the Pacific around 1880, which was acquired in 1954 by King's College, Newcastle, later the University of Newcastle (having first been purchased by the Bowes Museum, Co. Durham). The National Museum of Ethnology in Osaka purchased the Brown Collection in 1986 from Newcastle, which divided the overall valuation of the Collection by the number of items so that values for individual pieces fell below the export threshold limit. The Reviewing Committee subsequently put stops on licenses for the more valuable items (such as painted carvings from New Ireland), some of which were acquired by British institutions at fair market value; see Steven Hooper, *The Robert and Lisa Sainsbury Collection* (New Haven: Yale University Press and UEA, 1997), II, 305 *et seq*. The Reviewing Committee's report for 1991 discussed the difference between publicly and privately held collections, and set out examples of interest, including collections formed by significant collectors or institutions; collections important for the study of an aspect of history or taste [such as the first Earl of Leicester's "single, informed taste"]; collections "where the furniture, pictures or other fittings were put together at one time as part of an integral whole which is an outstanding example of its kind and are still preserved in their original setting, e.g. the Chippendale furniture at Nostell Priory or the Adam furniture and fittings at Osterley". The intention wasn't "to catch the entire accumulation of a country house built up over the centuries, although

Between the devil of a continued freeze on funding and the deep blue sea of losing key, 'starrable' heritage objects, the Committee supported listing without compensating owners for loss of value.[20] Strategically this offered the conservative government an unattractive alternative because, as observed by the Museums and Galleries Commission (now the Museums, Libraries and Archives Council), listing ran counter to the country's traditions. On the rights of an owner, the Commission observed that

This is a philosophical and legal area of fundamental importance, central to the historical and social fabric of our society. There are no black and white positions where heritage items are concerned, since the public at large has a legitimate concern about the disposal of such items whether publicly or privately owned.[21]

The official response came six months later, when the secretary of state for National Heritage rejected the idea:

The disadvantages of listing far outweigh the advantages. Listing would represent a diminution in the rights of owners to dispose of their property as they saw fit. And prohibition upon the export of outstanding heritage items would distort the market value, both for outstanding items and others. Therefore, I have firmly decided against the committee's recommendation, made most reluctantly, to list works of art. The protection of the heritage is one of my prime concerns. There are, however, ways of achieving that aim other than listing, such as the scheme for acceptances in lieu of tax.[22]

When the Commission spoke of listing being against the country's traditions, they meant a tradition of natural rights thinking that acquired its modern cast through the work of seventeenth-century legal theorists, including Grotius, Samuel Pufendorf, John Selden and John Locke.[23]

part of the contents of such a house might qualify"; Reviewing Committee on the Export of Works of Art, *A Review of the Current Controls* (London: HMSO, 1991), 15, and 51–4. See also Bush, 'The Protection of British Heritage: Woburn Abbey and *The Three Graces*', 283. It was proposed in 2003 that the rubric to the third Waverley criterion be amended to note that an object "might be considered of outstanding significance either on its own account or on account of its connection with a person, place, event, archive, *collection or assemblage*"; *Quinquennial Review of the Reviewing Committee*, 32–3.

[20] *A Review of the Current System of Controls on the Export of Works of Art*, 11.

[21] Ibid., 52.

[22] *Parliamentary Debates (Hansard): House of Commons Official Report* 208, no. 22 (London: HMSO, June 5 1992), 646. Also Goodison, *Goodison Review*, 11.

[23] The discoveries of the sixteenth and seventeenth centuries gave an unprecedented scope to warships and privateers to commandeer property, and there consequently became an urgent need for the newly powerful northern maritime powers to settle not only

Central to Locke's highly influential defence of natural rights to property was the notion of historical entitlement. Property rights are established contingently and historically through individual action, and should be defended against the impositions of civil society.[24] On the one hand, society has a responsibility to protect private holdings for which pedigree can be established and, on the other, to rectify historical injustice, but it has no licence to assert further jurisdiction over privately held resources. For the libertarian philosopher Robert Nozick, there should be no restrictions on the movement of cultural things, either within or beyond state boundaries, because self-determination is secured by self-ownership, which in turn is secured by the right to act without permissions.[25] Such attraction

legal rights to conquered territories but also the extent of territorial waters. Grotius was retained by the directors of the Amsterdam branch of the Dutch East India Company to justify the capture and appropriation in late 1602 of the *San Jago*, a Portuguese carrack transporting porcelain and other Chinese goods belonging to the Tuscan merchant Francesco Carletti. Carletti sued for years to obtain compensation (as a neutral in the Spanish/Netherlandish war) and the case provided primary source material for Grotius. The cargo is usually confused with that of the *Catharina* captured the following year, also carrying Chinese porcelain reported to weigh around 60,000 kilos. Henri IV acquired a dinner service of "the very best quality" from the auction in Amsterdam, as did James I. See C.J.A. Jörg, *Porcelain and the Dutch China Trade* (The Hague: Kluwer, 1982), 16–17, and T. Volker, *Porcelain and the Dutch East India Company* (Leiden: Brill, 1971), 22. In the *Mare Liberum* of 1609 (the only chapter published of *De Iure Praedae*, the rest staying in manuscript until 1868, following its rediscovery in 1864), Grotius argued that there was a misunderstanding about the nature of 'common property' (in this case the sea) which, far from being exclusive to some, was fundamentally vacant. There was a natural right to common property, *dominium* by similitude or analogy, which was acquired by occupation. See Richard Tuck, *Natural Rights Theories: Their Origin and Development* (Cambridge: Cambridge University Press, 1979), 17–31 and 59–61. Selden's *Mare Clausum* was written in 1618 (but published only in 1635) to refute the *Mare Liberum* and establish rights over all the waters around Britain. Joseph Raz draws attention to the reassessment of Locke that sees him occupied more by law and duties than rights; *Ethics in the Public Domain: Essays in the Morality of Law and Politics*, revised ed. (Oxford: Clarendon Press, 1994), 29.

24 Cicero's writing continued to be an important source for humanists determined to establish new political and legal norms across Europe, especially the *De Officiis*, where economic 'taking' is discussed as a legalised form of theft. Grotius employed Cicero's simile of the theatre to argue that once vacant seats are occupied, the occupant has exclusive rights to their use. See also Hadley Arkes, 'That "Nature Herself Has Placed In Our Ears a Power of Judging": Some Reflections on the "Naturalism" of Cicero', in Robert P. George, ed., *Natural Law Theory: Contemporary Essays* (Oxford: Clarendon Press, 1992), 245–77.

25 But, asks Will Kymlicka, if self-ownership is essentially instrumental, why may not other ways of achieving self-determination be pursued? Will Kymlicka, *Contemporary Political Philosophy: An Introduction* (Oxford: Clarendon Press, 1990), 123.

as Nozick's argument has is that it strongly respects the Kantian intuition about treating people as ends rather than as means. But his defence of an individual's right to act without constraint remains open to the charge that it conceptualises the individual in too asocial a way.

Britain's solution with respect to export controls, then, has been to compromise between 'protecting the heritage' and safeguarding natural property rights by means of temporary estoppels, at the risk of losing the odd Constable or Turner. No increase in funding was promised but it was presumably more comfortable for the minister that the National Lottery was on the horizon, a proportion of the proceeds from which was already notionally targeted for the arts. The simplest resolution would be for the state to guarantee the owners of Medici cabinets a fair market price in return for not selling the family silver to distant cousins. A less straightforward answer is to list with compensation, yet that was rejected in the UK by the Reviewing Committee not only on grounds of impracticality, but because if the state has the means to compensate then it has the means to buy on the market. Moreover, even if they could find the funds rapidly enough to compete at auction, or at least within a 'reasonable' period of time, states have priorities other than Constables and may prefer to subsidise hospitals instead. When the Badminton Cabinet came to auction for the second time, British institutions evidently stayed away because of their minimal purchase grants, the director of the V&A saying that "since public funding is unlikely to be available, this will only happen if an individual makes it happen".[26] This time there was no chance of an estoppel since the Waverley rules do not apply to objects already given an unconditional licence.

'Heritage' in Britain is seen to include clearly more than just the native, hence Constable and Turner though desirable are not the only desiderata. Noting that Constable's 1824 diploma picture for the Royal Academy was clearly regarded as part of the British heritage in 1991 when a licence was temporarily withheld, we might wonder whether Melbourne's very similar painting, *Study of a Boat Passing a Lock*, acquired in 1951, is now similarly understood to be part of the Australian heritage? An interestingly different situation from the above-mentioned British examples arose in Australia in 1996 when a painting was imported from Britain solely for public auction.

Following the record-breaking sale of Eugene von Guerard's *A View of Geelong* at Christie's Melbourne, there was an outcry in the Australian

[26] Mark Jones, *Western Daily Press*, 10 September 2004.

media and art world about the likely return of the picture overseas, which influential figures in the state of Victoria saw as a tragedy. But the strongest comment came from Dr. Joseph Brown, the Melbournian art collector and dealer who was reported to have said that to allow this colonial icon to leave the country would be "an act of treason" and, moreover, that pictures of this age and quality should stay in Australia.[27] The painting did in fact leave, it being made clear by the auctioneer that had an export licence not been guaranteed in advance, the von Guerard would never have been shipped from England, where it had been housed by the Dalgety family since its creation in the 1850s. *A View of Geelong* returned to Victoria for the Geelong Art Gallery's centenary celebrations, on loan from the new owner Sir Andrew (now Lord) Lloyd Webber, from whom the city of Geelong subsequently purchased the painting in 2006.

Another Australian case involved John Glover, unquestionably one of the country's most important colonial artists. Born in Leicester, England, in 1767, Glover emigrated only in his early sixties to Tasmania, where he worked until his death in 1849.[28] The refusal of an export licence for his painting *The Bath of Diana* (Fig. 17) became a test case for export restrictions in Australia, which, although it has yet to create a list of specified national treasures (unlike Japan), makes it clear through the Protection of Movable Cultural Heritage Act 1986 that liberty to circulate items of property may be constrained if their loss "would significantly diminish the cultural heritage of Australia". David Waterhouse acquired the painting in the mid-1980s in Australia, and then offered it at Sotheby's in Melbourne in 1989 when it sold to a Los Angeles dealer for Au$1.76 million, the record price at that time for an Australian painting. However, following the refusal of a licence and Waterhouse's subsequent unsuccessful application for review, heard in November 1993 in the Federal

[27] *The Age* and *The Sydney Morning Herald*, 7 May 1996. Dr. Brown donated over 150 works from his collection to the National Gallery of Victoria in May 2004.

[28] Glover began painting in London in his late thirties, moving in the circles of West, Turner, and Constable. Writing in *The Age*, Rachel Buchanan noted the classification by the Tate of Sidney Nolan as a British artist, and also the sale by London dealer Agnews of works from the Nolan estate, including paintings from his celebrated series depicting the outlaw Ned Kelly, quoting Janine Burke (biographer of Nolan's erstwhile colleague Albert Tucker): "They should not be for sale [the early works painted in Melbourne]...It's a pity Australia can't come to some form of arrangement, that the Government could give these works back to us. These works are part of our national treasures, we should be able to view them here". As the article noted, Nolan left his native Australia at the age of 33 and lived for over forty years in Britain until his death in 1992. 'The Hijacking of Ned Kelly, How Did Sidney Nolan and His Works Become British Property?' *The Age*, 12 December 1998.

Court in Sydney, the painting was finally sold to the Australian National Gallery for almost a million dollars less.[29]

Australia has continued to refine its controls for the export of culturally valuable things, which are more comprehensive than the Waverley criteria and especially sensitive to Aboriginal material.[30] The statutory right to prohibit export is rarely employed, but it represents a quite different approach to Britain's, as does Japan's, where registered 'national treasures' and 'important tangible cultural properties' may not be exported.[31] The constraint placed on Australian owners of works has been underlined by Alison Inglis, who notes that, although the original legislation intended to avoid disadvantaging private owners by establishing a National Cultural Heritage Fund, in practice the Fund had no money and vendors were therefore forced to sell on the Australian

[29] Any such item must fall within the Act's Control List of categories, established in response to Article 5 of the 1970 UNESCO Convention. Article 5.b requires "establishing and keeping up to date, on the basis of a national inventory of protected property, a list of important public and private cultural property whose export would constitute an appreciable impoverishment of the national cultural heritage". See Gregory J. Tolhurst, 'An Outline of Movable Cultural Heritage Protection in Australia', (1997) II *Art Antiquity and Law* 139, and *Waterhouse v. Minister for the Arts and Territories* (1993) 43 Federal Court Records 175.

[30] The criteria for assessing the cultural significance to Australia include "the contribution of the object in the understanding of Australian prehistory, history and culture; the contribution of the object to Australian cultural development; the association of the object with a notable person, business, enterprise or event; the importance of the object in technological development in Australian history or prehistory; the existence, relevance and quantity of similar objects held in Australia or represented in Australian public collections; ... [and] any other relevant circumstances". The 1999 amendments describe an Australia-related object as one made "in or outside Australia by an Australian; or in Australia by a foreign person who, at some time, worked or resided in Australia; or outside Australia by a foreign person, if the object incorporates Australian motifs or subject matter, or is otherwise relevant to Australia". *Amendments of Protection of Movable Cultural Heritage Regulations commencing on 1 May 1999*, 19. See Barbara Adamovich, 'The Protection of Movable Cultural Heritage and the Waverley System: A Study of the Australian and United Kingdom Export Controls Relating to Cultural Property', (1998) 3 *Media and Arts Law Review* 4–17, and Hugh H. Jamieson, 'The Protection of Australia's Movable Cultural Heritage', (1995) 4 *International Journal of Cultural Property* 221–2.

[31] The first control in Japan was the Decree for the Protection of Antiquities of 1871 (see above Chapter 4, Section 4), followed by the 1897 Law for the Protection of Old Shrines and Temples, the 1929 National Treasures Preservation Law, the 1933 Law Concerning the Preservation of Important Objects of Art and the 1950 Law for the Protection of Cultural Properties. See Michihiro Watanabe, 'Background on Cultural Properties and Programs in Japan', in Joyce Zemans and Archie Kleingartner, eds., *Comparing Cultural Policy: A Study of Japan and the United States* (London: AltaMira Press, 1999), 75–6.

FIGURE 17. *John Glover (1767–1849)*, The Bath of Diana, Van Diemen's Land, *1837, oil on canvas, 96.5 × 134.5 cm. Courtesy of the National Gallery of Australia, Canberra. Purchased with the assistance of the National Gallery of Australia Foundation, 1993.* Following its sale to an American dealer, *The Bath of Diana* was denied an export licence. It was eventually acquired by the National Gallery of Australia for less than the public auction price.

market.[32] Although this would be fine for categories that are of interest principally to Australian collectors and institutions, others, such as Old Master paintings, would necessarily suffer from the restriction of competition. One journalist observed that the Australian Antique Dealers Association supported the legislation if the fund was truly available, but that opposing heritage legislation "is like denouncing motherhood".[33] It smacks of treason.

Let us return to the Chinese examples and hypothesise the relevance of the *Luohans laundering* and the Gong Kai scroll to America, conceiving their value to the national heritage in terms of Waverley values ('heritage', aesthetic experience and knowledge). Having been in the country for over half a century, both paintings would probably be flagged for their association with America; they would be adjudged aesthetically important

[32] Alison Inglis, 'An Earthly Paradise in Adelaide', *Art Monthly Australia* (June 1994), 17.
[33] Terry Ingram, 'British Players Invoke Patriotism to Keep Treasures', *Financial Review*, 11 July 1996.

and as having significance for the study of early Chinese figure painting. They are readily seen to possess aesthetic value and knowledge value for Americans.

The harder call is the 'value of heritage', as it is for many examples of contested objects serving other, intrinsic values. As we have seen, a characteristic feature of this value is the linkage of community life to social actors, real or imaginary. Hence, the construction of British heritage involved biblical characters, Saxons and champions of customary law. For the Parthenon/Elgin Marbles, associational value may involve the goddess Athena, Phidias, Pericles and the Socratic school of philosophers; for the Lansdowne Portrait, Washington, Stuart and the Marquess of Lansdowne; for the *Zhongshan quyu tu*, Zhong Kui, the emperor Minghuang, Gong Kai and writers of the colophons; and for *Luohans laundering*, mythical *luohans* (of Chinese and Indian appearance), Lin Ting'gui, the Daitokuji, Fenollosa and Freer. The *Luohans* scroll was acquired at a time when sophisticated American collectors were becoming aware of the enormous richness of Asian cultural traditions, and thus it has an association with the early history of American connoisseurship, and in particular with Charles Freer. Does *Luohans laundering* 'belong' to Japan, where it was held for over six centuries? Into what heritage does it fit best: Chinese, Japanese, American or Buddhist? Likewise did the Bamiyan Buddhas belong to the Afghani people, to Buddhists, or to all mankind?[34] Are these exceptions, distinct from clear instances of regional heritage (such as those for which Greenfield argues in her book)? I think rather that their complex associations are not untypical of valuable objects and buildings.

How best to weight the value of 'our heritage' remains a persistent feature of cultural heritage debate. The range of values possessed for people by the Parthenon/Elgin Marbles, for example, is not exhausted by their value for Greek citizens only. For many people across the world, they will be valued for the aesthetic experience and knowledge they provide.[35] We may choose to visit ancient Greek sculpture or Song paintings in countries other than Greece and China. Not all people will. But for those who do, the aesthetic and knowledge value of those objects may be as great as

[34] J.P. Sigmond makes a similar point about the *Mona Lisa* and horses of San Marco, in 'Some Thoughts on the Importance of Cultural Heritage and the Protection of Cultural Goods', (2005) X *Art Antiquity and Law* 68.

[35] The opportunities and ways of life of ancient Greece, although being valued both by present-day Greek and other citizens, may not now be options for any of us; Raz, *Ethics in the Public Domain*, 179–80.

they would be for people in Greece or China. Hence it is fair to question whether the intrinsic values that examples of Greek and Chinese art possess for individual residents and visitors in England may be trumped by a general 'value of heritage' that such works have for citizens of Greece and China.

2. Regulation and Taking

Governmental constraints on what may be done to cultural things are imposed not only at the national level but also at the regional level (cantonal, state, provincial, county, city, etc.). They cover archaeological excavations and discoveries, the maintenance of historic sites, and the regulation of the built environment. The rhetoric that is applied to cultural heritage at large applies no less to architectural heritage.

In the English-speaking world, initial concern for such matters is associated primarily with John Ruskin and William Morris, the latter founding the Society for the Protection of Ancient Buildings in 1877, the first of many such voluntary associations.[36] Five years later the Ancient Monuments Act was passed in Parliament, with the first Schedule protecting 29 monuments in England and Wales, and 21 in Scotland. By the time its successor Act was passed in 1979, 12,000 monuments had been scheduled, and 260,000 assorted buildings listed in the United Kingdom.[37] The listing of buildings is relevant here because such conflicts as exist between 'heritage' and private rights are common to the Lansdowne Portrait, the Badminton Cabinet and historic buildings. In *Amalgamated Investment and Property Co. v. Walker (John) and Sons* heard in the Court of Appeal, Lord Justice Buckley recognised the British conflict between public interest in the built environment and rights to private property:

It seems to me that the risk of property being listed as property of architectural or historic interest is a risk which inheres in all ownership of buildings. In many cases it may be an extremely remote risk. In many cases it may be a marginal risk.

[36] Including the Society for the Protection of Ancient Buildings (1877), the National Trust (1895), the Ancient Monuments Society (1921), the Council for the Care of Churches (1922), etc.; see Hewison, *The Heritage Industry*, 26. For an account of the different approaches taken by Ruskin and Morris to the use of art in social reform, see Frances Borzello, *Civilising Caliban: The Misuse of Art 1875–1980* (London and New York: Routledge, 1987).

[37] Roger W. Suddards, *Listed Buildings: The Law and Practice* (London: Sweet and Maxwell, 1982), 1–2.

In some cases it may be a substantial risk. But it is a risk, I think which attaches to all buildings and it is a risk that every owner and every purchaser of property must recognise that he is subject to.[38]

Unlike in the United States, listing regulations in Britain constrain change not only to exteriors and public interiors but also to "any part of a building, as so defined".[39] The definition of a building is broad, as indicated by some exclusions: a bird cage, a dog-kennel, a hen-coop, a canal and a bank of earth.[40] The British Reviewing Committee (for the export of works of art) has made it clear that designation of architecture is now reasonably self-evident:

It is, for instance, widely accepted that the owner of a listed house, set in a park in an area of outstanding natural beauty, cannot demolish the portico, sell the statues off the pediment, remove the chimney pieces designed by Kent and carved by Rysbrack, and divide up the Capability Brown park for building plots.[41]

The question then is, how does one draw a line between architectural fabric and movable chattels? At the time of *The Three Graces* sale, it was asked whether the Canova sculpture was an inalienable interior fixture (hence part of Woburn's structure) or a saleable fitting.[42] In 1990, the then secretary of state for the Environment Chris Patten created this criterion to assist in making the distinction:

It may in certain circumstances be relevant to consider . . . the weight which should be given to the possibility for such an object to be moved to, and displayed in another position, or taken away to where it could be viewed and appreciated by a wider public, or whether it could be, or had ever been, treated as an item separate from the building itself, for example, for tax purposes.[43]

His successor, Michael Heseltine, concluded that where a piece of sculpture was designed to ornament or enrich a building it was subject to regulation, but where the building was designed to house a sculpture, the

[38] Ibid., 13; [1976] 3 All England Reports 509.

[39] The prevailing thought in the U.S. is that exteriors and public interiors are a matter of public interest, whereas private interiors remain private. Moreover, the enthusiasm for such regulation varies from city to city, Boston and New York having fairly elaborate preservation laws, whereas cities such as Chicago, "with a devotion to unfettered private enterprise", have much less ambitious codes; Paul Spencer Byard, *The Architecture of Additions: Design and Regulation* (New York: Norton, 1998), 81.

[40] Suddards, *Listed Buildings*, 15.

[41] *A Review of the Current System of Controls on the Export of Works of Art*, 47.

[42] Bush, 'The Protection of British Heritage: Woburn Abbey and *The Three Graces*', 274–5.

[43] Ibid.

piece could be regarded as a chattel.[44] Beyond that particular interpretation, the larger concern is over governmental justification of regulation without compensation, as opposed to 'taking'. In common law countries, taking by eminent domain for the public use – that is taking with fair market compensation – is largely uncontroversial and a crucial legal feature of both local and national development policies.[45] Taking without compensation remains deeply controversial. Within the strong private rights regime of the United States there is considerable sensitivity to this distinction between regulation and taking that refers back to the fear of Constitutional violation, with some preservation laws staying on the regulatory side by virtue of imposing brief periods of delay to building work, not dissimilar to the Waverley estoppels in Britain. The distinction between an aspect of policing and a taking that should be compensated "has historically been regarded in constitutional jurisprudence as a matter of degree".[46] Margaret Jane Radin observes that

> it seems that courts have not been able to do better than to tell us that when government regulation 'goes too far' they will deem it a taking, whereas otherwise they will deem it within the state's normal 'police power'. This is no more than to repeat the question, because 'going too far' is a synonym for 'taking'.[47]

A key precedent for historic designation in the United States is *Penn Central Transportation Co. v. City of New York*, where the Supreme Court decided in 1978 that application of New York's landmark preservation law did not violate the Fifth and Fourteenth Amendments and take Penn Central's property without just compensation by disallowing the construction of an office tower above Grand Central Terminal on 42nd and Park Avenue. It upheld the decision of the New York Court of Appeals, which rejected the claim that there could be no taking since the law had not transferred control of the property to the city, but only restricted the

[44] Bush makes the point that, although Jeffrey Wyatt's 'Temple of the Graces' was added to Woburn to house *The Three Graces*, the sculpture could also be said to have been acquired to adorn the existing Sculpture Gallery (designed by Henry Holland); ibid., 276.

[45] Margaret Jane Radin, *Reinterpreting Property* (Chicago: University of Chicago Press, 1993), 136.

[46] Byard, *The Architecture of Additions*, 81. Tony Honore notes that property rights have had a social aspect even in the most individualistic ages ("of Rome and the United States"); A.M. Honore, 'Ownership', in A. Guest, ed., *Oxford Essays in Jurisprudence*, first series (Oxford: Clarendon Press, Oxford, 1961), 107–47.

[47] Radin, *Reinterpreting Property*, 146–7.

appellants' exploitation of it. Justice Brennan introduced his opinion with the question of whether

a city may, as part of a comprehensive program to preserve historic landmarks and historic districts, place restrictions on the development of individual historic landmarks... without effecting a 'taking' requiring the payment of 'just compensation'... [There] is a widely shared belief that structures with special historic, cultural, or architectural significance enhance the quality of life for all. Not only do these buildings and their workmanship represent the lessons of the past and embody precious features of our heritage, they serve as examples of quality for today.[48]

The purpose of historic conservation was to enhance, or perhaps develop for the first time, the quality of life for people. It was a public programme promoting the common good, and there was no 'set formula' for determining when 'justice and fairness' require that economic injuries be compensated.[49] As Radin explains, the Court applied a 'multi-factor balancing test' where one of the factors was the promotion of "health, safety, morals, or general welfare".[50] The majority opinion was clear: "Legislation designed to promote the general welfare commonly burdens some more than others". Justice Rehnquist dissented, seeing the imposition of preservation costs of landmarks on the owners of individual properties as a constitutional violation: had the costs of preserving the Terminal as is (i.e., the purported economic loss to Penn Central) been spread across the entire city of New York, "the burden per person would be in cents per year". For libertarians, however, even taxation is a *prima facie* taking, as are all welfare contributions.[51] In 1993, the Pennsylvania Supreme Court ruled against a 1987 designation by the Philadelphia Historical Commission of both the exterior and interior of an art deco theatre (the SamEric, formerly the Boyd). Although the local code was deemed consistent with the state Environmental Rights Amendment, the Preservation Ordinance was deemed "unfair, unjust and amounts to an unconstitutional taking without just compensation in violation of Article I, Section 10 of the Pennsylvania Constitution".[52]

[48] 438 U.S. 104 (1978).

[49] Ibid., and Radin, *Reinterpreting Property*, 131–2.

[50] Ibid., 124–5. Under the city's zoning laws, the owner was allowed to transfer development (air) rights from the historically designated Terminal to contiguous sites, of which they owned a number.

[51] Ibid., 122.

[52] Supreme Court of Pennsylvania, *United Artists' Theater Circuit, Inc. v. City of Philadelphia, Philadelphia Historical Commission*, entered 10th July 1991, reargued 23rd

3. *The Dream Garden*

Thoughts about the common good were evident in the case of a vast glass mosaic installed in late 1915 at the Philadelphia site for which it had been commissioned: the main lobby of the Curtis Publishing Building, paces away from Independence Hall.[53] *The Dream Garden* was created through a collaboration between Louis Comfort Tiffany's New York studio and the American illustrator and painter Maxfield Parrish, already well known for serving up contemporary paradises that featured idealised youths in idyllic Italianate landscapes. To a country deeply engaged in a great capitalist project to modernise its cities, with all the associated social issues including massive immigration, huge urban poverty, and the disruption of prior customs and conventions of almost every class and ethnic group, escapist dreams were a palliative and this artist was the master of them.[54] Despite Parrish's misgivings about working with Tiffany, the colour range, iridescence and sheer number of the studio's *favrile tesserae* give an astonishing luminosity and scale to his pre-Raphaelitish fantasy (Fig. 18).

With the passing of the Curtis empire, the building was eventually acquired by Philadelphia property developer John W. Merriam, who

October 1991, decided 9th November 1993. The designation had been upheld in 1989 by the Commonwealth Court *(Sameric Corp. v. City of Philadelphia)*. In 2002, an attempt was made to have the exterior listed, but this was rejected by the Philadelphia Historical Commission on the grounds that the façade alone didn't warrant designation. In 2009, Philadelphia City Council considered amending the section of its code covering historic buildings to include public interiors (following the practice of New York, Boston, Chicago, San Francisco and Los Angeles), by which time the Boyd's interior had been sympathetically restored; see also Sass Silver, 'Not Brick by Brick: Development of Interior Landmark Designation Policies in Washington, DC', (May 2004) *Georgetown Law Historic Preservation Papers Series*, paper 15.

53 The mosaic is approximately fifty feet long and fifteen feet high. Up to the Wall Street crash, Philadelphia was America's publishing centre and Curtis publications included some of its most successful magazines, such as the *Saturday Evening Post* and the *Ladies Home Journal*. Edward Bok, editor of the *Ladies Home Journal* and Cyrus Curtis's protégé, conceived the idea for a grand mural across the rear wall of the front lobby directly facing the entrance doors. The commission seemed ill-fated because of the death of other artists to whom it was offered; Parrish took it on reluctantly because of his other commitments, including the murals for the ladies dining room in the Curtis Building. See Kim Sajet, 'From Grove to Garden: The Making of *The Dream Garden* Mosaic', in *Pennsylvania Academy of the Fine Arts: 200 Years of Excellence* (Philadelphia: Pennsylvania Academy of the Fine Arts, 2005), 42–51.

54 Trained at the Pennsylvania Academy, Parrish was a precocious draughtsman and illustrator, and his calendars hung on the walls of countless American homes. He related the subject to his own passion for gardening and insisted on installing a reflecting pool and balustrades in front of *The Dream Garden*; ibid., 49.

sold it on in 1984. Merriam retained title to *The Dream Garden*, telling
the Curtis Center's new owner that he intended in time to pass title to
the National Park Service, which controlled the adjacent Independence
Hall.[55] He made a will naming four local educational institutions as bene-
ficiaries of his estate: the University of Pennsylvania (which was given a
double share), Bryn Mawr College, the University of the Arts and the
Pennsylvania Academy of the Fine Arts, but he failed to revise or reaffirm
it following his second marriage to Elizabeth (Betty) Merriam in 1992.
Consequently, when he died in 1994, Mrs. Merriam contended that he
should be deemed to have died intestate. The fate of the mosaic was now
subsumed by a complex negotiation to determine a fair and appropriate
division of assets, out of which it was agreed by the parties that the widow
should receive 41%, and, to reflect the intentions of the original will, that
the remaining 59% should be divided among the previously named char-
itable beneficiaries. The estate was estimated to have a value in the region
of 100 million dollars, much of which was represented by real property.
The Dream Garden, however, remained in the background until the last
weeks of July 1998, when the *Philadelphia Inquirer* announced that it
had just discovered the proposed sale of the mosaic to an anonymous
buyer who intended to remove it not only from the Curtis Building, but
also from Philadelphia.

The correspondence in the newspapers that followed on from the
Inquirer's announcement, and the public campaign to collect signatures
for a petition to keep *The Dream Garden*, amply undermines any per-
ception of a more phlegmatic approach towards heritage in the United
States. At the vanguard of the outraged was the president of the Phil-
adelphia chapter of the American Institute of Architects, John Fox Hayes,
who called the removal of the mosaic "a clear example of the 'pil-
laging of Philadelphia'... Next it will be Benjamin West and the Liberty
Bell... There is a real need to keep these things right here".[56] In a letter
to the *Inquirer*, artist Bruce Pollack wrote that "the mural is as much
a part of our cultural history as the Michelangelo frescoes in the Sistine
Chapel are to Rome... This is a theft from us all".[57] The implication was
that not only *should* the mosaic be in Philadelphia, but also that it would
be most valued there.

Was *The Dream Garden* perceived in Philadelphia to be valuable
because it was designed by Maxfield Parrish, or because it was a Tiffany

[55] The Center was acquired by the Kevin F. Donohoe Company.
[56] *Philadelphia Inquirer*, 24 July 1998.
[57] *Philadelphia Inquirer*, 26 July 1998.

FIGURE 18. *Maxfield Parrish and Louis Comfort Tiffany*, The Dream Garden, *1914, favrile glass mosaic, 4.57 × 14.93 m. Courtesy of the Pennsylvania Academy of the Fine Arts, Philadelphia. Partial bequest of John W. Merriam; partial purchase with funds provided by a grant from the Pew Charitable Trusts; partial gift of Bryn Mawr College, the University of the Arts, and the Trustees of the University of Pennsylvania.* Installed in 1915 at the Curtis Center, a major publishing headquarters in Philadelphia, *The Dream Garden* became a focus of attention in 1998 when it became available for sale. Regional outcry about its possible departure led to an 'historic object' designation made by the city.

mosaic, or because the subject was an Elysian scene, or because it was regarded as an excellent work of art, or because it was an integral part of the building's aesthetic? Clearly there were proponents of keeping the mosaic *in situ* (as actually happened) who, if asked these questions, would have said that *The Dream Garden* was valuable on account of all of the above. But that would be too brisk. What if the mosaic had another subject (for example, the Mad Hatter's tea-party from *Alice in Wonderland*), or had been designed by a complete unknown, or was a painted mural, or had been commissioned for the top floor of the building and subsequently moved downstairs? Would it have been as contentious? And are the factors of artist, medium, subject, context and aesthetic quality of equal value? What if the fifty-foot production was deemed to be a mediocre work of art? Would we be excited about it? I think less so. The excellence of a work of art or architecture is crucial to our valuations. Ideas about excellence are socially constructed and conventional and, as suggested in the previous chapter, very much subject to change and review. Indeed many works of art and architecture have been allowed to decay or have subsequently been destroyed because they were no longer considered of value. Yet tastes change, and what is poorly thought of in one generation might come back in the next.

A professor of history at Ohio State University, Steven Conn, wrote that

European countries have much more stringent laws governing the sale and dispersal of cultural patrimony. I suspect that if the mural had been installed in London or Paris, it would not have to endure being ripped out of the wall. But in this country, selling to the highest bidder is still essentially how we define ourselves culturally.[58]

If Americans truly defined themselves in that way, there would be a robust public trade in body-parts, which there isn't because of the sensibility that respects the autonomy of the individual, although they do define themselves in terms of a strong private rights regime. Conn's statement about export restrictions was broadly correct, even if he didn't explain the crucial differences between statist approaches in France and Italy, for example, and the generally individualistic traditions of Britain. It certainly hinted at the stronger listing codes prevalent in Britain, where interiors are as protected as façades.[59] The Ruskinian assumption that these are a 'part of the nation's heritage' has entered British statutory law, which protects almost all structures built before the reign of Victoria, the entireties of which may not be touched except with appropriate permissions.[60]

Following *The Dream Garden* announcement, the chair of the Philadelphia Historical Commission, and other key players engaged in discussion with Mayor Edward Rendell about a move that would place the sale in check, if not checkmate.[61] The mayor called a press conference to announce that the city would do all it could to keep the mosaic in place, after which the Commission certified *The Dream Garden* as an 'historic object' under the city's Historic Preservation Ordinance. Upon learning of this unprecedented move, supporters were elated, whereas Mrs. Merriam, the executor of the Merriam Estate, was infuriated and instituted legal proceedings to have the certification declared invalid. Caught in the awkward position of indirectly being party to the deal, the four charitable beneficiaries attempted to distance themselves from

[58] *Philadelphia Inquirer*, 28 July 1998.
[59] Penelope Cooling, Vincent Shacklock, Douglas Scarrett, *Legislation for the Built Environment: A Concise Guide* (London: Donhead, 1993), 60.
[60] Reviews are increasingly rigorous as one moves up through the ranking from grade II, II* and I. On Ruskin see also Chapter 3, Section 4.
[61] The Chair of the Commission was Wayne Spilove; others involved were Diane Dalto, director of the city's Office of Arts and Culture, Michael Sklaroff, commission member and Mark Zecca, of the city Solicitor's Office.

the proceedings. The buyer was reported to have been Steven Wynn, owner of the Las Vegas *Bellagio* casino, who, according to the *Inquirer*, withdrew from the sale after being apprised of the controversy. Philadelphia *Inquirer* writer Stephan Salisbury wrote a post-mortem piece on the historic certification:

The near loss of the Parrish-Tiffany mural and the loss of the [Ellsworth] Kelly have led preservationists and cultural officials to question whether the public interest is being served by regulatory safeguards governing public art. They also are starting to reconsider the nettlesome question of whether there is a potential public interest in all public art – even if it is not publicly owned.[62]

The last sentence encapsulates very nicely the tension between private rights and public interest. And of course, the teasing phrase in the above sentence is 'public art', which reflects an American hesitance to go too far into the realm of private property. In contrast, there was nothing public about the Badminton Cabinet at Badminton, or the Holkham drawings at Holkham, yet in England they were said to represent "a certain type of asset, to which the nation lays a claim". Certainly counsel for Mrs. Merriam saw the conflict between private property rights and public interest in no uncertain terms: "the City is intent on depriving the estate of its property without any compensation in derogation of the law, in violation of the Constitution of the United States and in contempt for fundamental notions of private property underlying our nation", which echoes in stronger language the conclusion reached by the British secretary of state, cited above: "Listing would represent a diminution in the rights of owners to dispose of their property as they saw fit".[63]

The Dream Garden continued to be fiercely contested between the estate and the city for over three years after the sale was announced, towards the end of which Betty Merriam herself died.[64] The matter was

[62] *Philadelphia Inquirer*, 9 August 1998.
[63] Written to the Administrator, Board of License and Inspection Review, 16 April 2001.
[64] The principal sticking point was the failure of any party to come up with a cash offer to buy out Mrs. Merriam's interest in an amount sufficient to meet the value that counsel for Mrs. Merriam placed on her 41% interest in the mosaic (a figure related to the amount believed to have been offered at the time of the aborted sale). The charities had indicated that they were willing to forego any compensation for their aggregate interests in order to keep the mosaic in a suitable public venue in Philadelphia. Following Mrs. Merriam's death (at which time the author was president of the Pennsylvania Academy), the charitable beneficiaries attempted to dissuade the Merriam Estate from engaging in what was becoming increasingly expensive litigation over the historic certification.

finally settled when one of the major charitable foundations in the coun-
try, the Philadelphia-based Pew Charitable Trusts, generously made a
substantial grant to the Pennsylvania Academy of the Fine Arts that
allowed the charitable beneficiaries (of which the Academy was one) to
purchase Mrs. Merriam's 41% interest in the mosaic. The University of
Pennsylvania, Bryn Mawr College and the University of the Arts then gave
up their own respective interests in *The Dream Garden* and passed title
as a whole to the Pennsylvania Academy, which accepted the fiduciary
obligation to maintain it *in situ*. The capacity of the private philanthropic
sector to intervene in cultural disputes should not be underestimated, but
nor should it be seen as typical across nations: its strength in America is
a function of the particular tax regime. Although Britain also has chari-
table foundations with the capacity to provide economic assistance, their
activities are generally on a modest scale compared to the United States.
Recently, Sir Nicholas Goodison has recommended strengthening the tax
incentives for British owners of significant cultural objects, in order to
encourage more private giving to institutions, not only as a reaction to
the threat of export but also to enrich collections.[65]

The Philadelphia Historical Commission grounded its mandate to pro-
tect and preserve *The Dream Garden* "in the interests of the health,

[65] Goodison, *Goodison Review*, 10–11, and Chapter 5. The owner of an object of heritage
interest which has been in Britain for more than fifty years has available a range of
choices either for raising capital or for the legitimate exemption from tax (payable either
directly, or by heirs). He or she could transfer it to another individual, in which case
the object would be potentially exempted from Inheritance Tax (IHT). It could be kept
in situ but accessible to the public and visiting scholars, in which case the transfer of
the object would be conditionally exempt from IHT as long as that situation prevailed.
The owner could hope to have it accepted in lieu of tax, in which case IHT liability
would be annulled (but not Capital Gains or Income Tax liabilities). He or she could
give it to the nation, in which case the overall tax liability on the estate would be reduced
in value. It could be sold by private treaty to a local authority, university or national
museum, whereby IHT or CGT liable on the sale is subtracted from a mutually agreed
market price, and the resultant figure increased by a douceur (or 'gratuity-bribe') of
25% of the liability, in which case there would be a profit but the open market value
wouldn't be tested (a rational gamble). The owner could sell it on the open market, in
which case there would be a profit but the cash in hand is subject to CGT. Generally,
Inheritance Tax encourages the transfer of ownership, even if the object remains *in situ*,
whereas Capital Gains Tax encourages retention. Conditions to be met are that objects
transferred must fall within the categories specified by the Treasury, and Ministers have
to be satisfied that they are 'pre-eminent' for their national, scientific, historic or artistic
interest. Inheritance Tax Act 1984, Pt VIII, Sections 230, 3–4. See also Vivian F. Wang,
'Deductions and Donations: Tax Policy as a Manifestation of Attitudes About Art in
the United States, United Kingdom and Canada', (2009) XIV *Art Antiquity and Law*
79–100; and Simmonds, *Art and Taxation*.

prosperity and welfare of the people of Philadelphia". I suggest, for two reasons, that we interpret welfare here as the individual welfare of some number of Philadelphians, rather than see it in utilitarian terms as an aggregate. The first reason derives from a liberal focus on individual well-being. The second recognises simply that human welfare is difficult to quantify: we probably can't know whether failure to list one more building or historic object in Philadelphia will significantly reduce the welfare of Pennsylvanians, or what impact that failure would have on future generations. Even if we assign monetary value based on the generation of tourist revenues, specific utilities are near impossible to calculate.[66] Tibor Machan offers a contrasting, libertarian view, namely, that a central problem for the American body politic resides in the conflict between the rhetoric of the Constitution – which protects a Lockean doctrine of natural rights – and utilitarian considerations for the 'general welfare' and 'community goals' that have dominated public policy, for example, in the areas of labor policy and national health and safety.[67] Yet Charles Taylor reminds us of Locke's Puritan-derived concern that we should give ourselves "energetically and intelligently" to useful tasks, not only for our own benefit but also for the common good (albeit cast in material terms, as the "common stock of mankind").[68] And unlike local governments, which are not so obliged, all charitable organisations are indeed mandated to maintain or increase non-economic good.[69] So, although it is the case that institutions qualifying for tax benefits could forego them, and thereby maintain independence from the state, I doubt that any but the wealthiest would. Charitable corporations wish to be seen as contributing to some manner of public, not private, good.

[66] It is possible to calculate more accurately the economic benefits of some material cultural things, temporary exhibitions for example, but this is more easily done for the performing than the visual arts.

[67] Tibor Machan, *Private Rights & Public Illusions* (Oakland: The Independent Institute, 1995), especially Chapter 11.

[68] John Locke, *Two Treatises of Government*, ed. Peter Laslett (Cambridge: Cambridge University Press, 1988), 294; also Charles Taylor, *Sources of the Self: The Making of the Modern Identity* (Cambridge: Cambridge University Press, 1989), 238–9.

[69] Either through direct tax exemption, or receipt of money from bodies that are themselves tax-exempt, or receipt of money or goods that can be set against tax owed to the state by individuals. In common law countries, the good management of charities is accountable to national revenue services, Attorney Generals, and, in England and Wales, the Charity Commissioners. See Peter Cannon-Brookes, ed., 'University and Foundation Collections and the Law: Proceedings of a Seminar Held at the Courtauld Institute of Art, London, June 23 1994', (1994) 13 *Museum Management and Curatorship* 341–3 and 356–61.

4. Integrity and Respect

Suppose *The Dream Garden* was regarded by informed opinion as a mediocre work of art. Might we be willing to enhance the Curtis Building lobby with a better work? Bearing in mind the revisability of aesthetic opinion, people now think carefully about moving something that might be regarded as fine by their successors.[70]

Experts often argue that the original configuration of an historic building or site has integrity similar to that of a work of art. Yet our ideas about what constitutes a complete architectural complex (or complete painting, poem or symphony) have developed over centuries, and across classes, regions and cultures. Should we think that buildings, sculptural tableaux and collections are like persons, the integrity of whom should not be endangered?[71] The case for universal human rights is based on Kant's premise that people should be treated as ends rather than means, although they can simultaneously serve as the means to someone else's ends.[72] Though we might say that buildings and their contents have integrity, it is surely not the same as the integrity of persons.

With respect to British and American codes that determine what owners or tenants may or may not do to buildings, we should remember that the common law is a practical tool and that lawyers generally want to achieve a solution to problems at hand. Hence we should not look too hard, for example, at the English Town and Country Planning Act in its several revisions to find a rigorously developed aesthetic theory. There were of course such theories, such as that offered by four contemporaries of Burke, the architects Humphry Repton and John Nash, and Whig squires Uvedale Price and Richard Payne Knight, whose ideas about

[70] English judges have weighted the intentions of architects over original owners, notably in the case of an Eric Gill sculpture within an art deco hotel; see A.H. Hudson, 'Historic Buildings, Listing and Fixtures', (1997) II *Art Antiquity and Law* 182–3, for *Lancaster City Council v. Whittingham*.

[71] The Unidroit Convention (Article 5) recommends preserving the integrity of a complex object; see John Henry Merryman, 'The Unidroit Convention: Three Significant Departures from the *Urtext*', (1996) 5 *International Journal of Cultural Property* 15.

[72] In the *Groundwork of the Metaphysic of Morals* (1785) Kant asserts that individual persons have dignity (*Würde*), an unconditioned and incomparable worth, different to that of entities with a price on the market; see Stephen R. Munzer, 'An Uneasy Case against Property Rights in Body Parts', (1994) 11 *Social Philosophy and Policy* 266. For a summary of arguments about works of art themselves having rights, see Ronald Moore, 'Moral Rights of Art: Historical and Conceptual Overview', in Michael Kelly, ed., *Encyclopedia of Aesthetics* (Oxford: Oxford University Press, 1998), 3: 288–92.

picturesque landscapes eventually became part of a general British sensibility towards 'the heritage'. As Rosemary Hill puts it:

The Picturesque developed in their hands into the aesthetic branch of Romanticism. It was a theory of art that put the personal and the particular above the powerful and the public. It dealt in the semitones of experience, its moods were meditative, 'it neither tenses nor relaxes', Price wrote... The Picturesque fed on the power of memory and association, the interchange of subjective and objective experience.[73]

An intriguing, recently published document within the literature on historical designation illuminates the subjective way by which we perceive integrity and wholeness in the built environment. Issued in confidence in 1944, the 'Instructions to Investigators' assisted those preparing the first statutory lists of British buildings of special interest.[74] Its language is discursive rather than imperative, the officials of the Ministry of Town and Country Planning assuming a set of shared expectations with respect to the built and natural environment:

A third type of building which... may qualify for listing on aesthetic grounds is the outstanding composition of fragmentary beauties welded together by time and good fortune.

Further,

by the good fortune of architectural good manners or a prevalent unity of feeling and approach at the time and place of building, a row of separately planned and built houses blend together into a group which in its wholeness gives a greater value to many of its members than they would have if they stood alone.[75]

It is not original intention that is being recommended for conservation here, but aesthetic wholeness resulting from felicitous circumstance – "time and good fortune". Integrity is a fugitive term, the diverse uses of which represent different moves in the (serious) games of cultural life. So let me return to the Waverley criteria with this question about integrity in mind. The first criterion addresses Burkean thinking about continuity and customary relationships, described in Chapter 3, as well

[73] Rosemary Hill, *God's Architect: Pugin and the Building of Romantic Britain* (New Haven: Yale University Press, 2009), 16.

[74] John Delafons, *Politics and Preservation: A Policy History of the Built Heritage 1882–1996* (London: E & FN Spon, 1997), 194–200.

[75] These phrases also have as a background Renaissance and neo-classical ideas about harmonic relationships in art, architecture and music. See also E.H. Gombrich, *The Sense of Order: A Study in the Psychology of Decorative Art* (Oxford: Phaidon Press, 1984), 285–305.

as fronting Finnis's basic values of knowledge, aesthetic experience, play, friendship and religion. This first criterion obviously pertains to works that are affixed to a site (hence the relevance of the thinking behind it to the Greek argument for the Parthenon/Elgin Marbles). But it also applies to movable objects, secular and sacred, including those commissioned and/or associated with particular places for a significant period, such as *Luohans laundering* at the Daitokuji, the Badminton Cabinet and Thomas Coke's Grand Tour drawings at Holkham.

Holkham is also a good place to start with the second criterion, which addresses aesthetic value and the integrity attributed to buildings and interiors. Conceived for Coke by Lord Burlington, the austere house is sited within picturesque grounds also designed by Kent, but now referencing Italy through the eyes of Poussin and Claude, a juxtaposition of the Palladian and Arcadian that became increasingly common in Britain. The idea of a house and interior integrated by stylistic unity was taken to a new level by the next generation of neo-classicists, exemplified by the Adam brothers whose buildings (Lansdowne House for example) were an ideal stage for the British gentry to demonstrate classical learning, virtues and decorum. An early commission by the brothers for the fifth Earl of Dumfries became the focus of yet another heritage campaign in 2006–7 when, wishing to concentrate on his other properties, the Marquess of Bute put the house on the market and its contents up for sale at Christie's. Dumfries House was generally in fine condition despite being used to billet troops during World War II, and what especially exercised the Art Fund and other charities was the looming separation from its Adam rooms of two exceptional groups of contemporary furniture by Thomas Chippendale and the Edinburgh cabinetmaker Alexander Peters respectively. Strong responses both from the Art Fund and the Prince of Wales to the proposed Dumfries sale reflected sensibilities captured by all the Waverley criteria: they wished to maintain historical associations (Waverly 1); to keep in Britain significant works of art and design (Waverley 2); and to stimulate the study of intentions and taste (Waverley 3). And indeed the sales were successfully averted when the Prince put together the necessary funds, some £40 million, intending to build model housing within the extensive grounds.

During the nineteenth century a strong reaction against neo-classicism offered the urban and soon-to-be suburban middle classes a rather different decorative style, promoted notably by Augustus Pugin (whose father was linked to the above theorists of the picturesque) and Ruskin and Morris, for whom medieval Christian honesty and craftsmanship were greatly superior to the 'pagan'. As Charles Eastlake commented: "It is a

curious and interesting epidemic this 'moyen age' mania in our island at the present time ... It is pointing our windows, and inlaying our cabinets, and gothicizing the plates we eat from, the chairs on which we sit, the papers on our walls. It influences the bindings of our books, the colour of our carpets, the shape of our beer-jugs, picture frames, candlesticks – what not?"[76] Aesthetic and moral qualities were strongly linked by the Gothic revivalists, perhaps explaining some of the discomfort still felt when architectural schemes are threatened or modified. Yet architecture accommodates not only the wear and tear of human life over generations but also changes of taste, style and circumstance, so that a European building might become, quoting from Burke, "part Gothick, part Grecian, and part Chinese".[77]

Triggered by several sales (see Section 1), the suggestion was made that an additional criterion be established to defend against the dispersal of "key integral collections". A working party was therefore set up in late 1986 to consider the status of collections. It recommended, unsuccessfully, that publicly owned collections should be subject *in toto* to a new Waverley criterion that would allow estoppel on the grounds that they represented a larger whole than the constituent parts (but it wouldn't, of course, prevent dispersal within the country). I think a stronger case can be made for rare or unique sets of non-identical objects, like the set of a hundred paintings from the Daitokuji that includes *Luohans laundering* (Fig. 12) and *Luohans demonstrating the power of the Buddhist sutras to Daoists* (Fig. 14). Either as Buddhists or non-Buddhists, we can engage with these for their value to us as historians of art and culture, or for their religious value, seeing the *Luohans* as appropriately depicted actors within Buddhist narratives, or for their aesthetic value, whether as individual works or, where possible, as part of the set. Here is Gregory Levine on the idea of a reunion exhibition:

Still, given the high value attached to cultural heritage and historical reconstruction by art history, the Japanese government, and Daitokuji itself, it is possible that some or all of the paintings may one day be temporarily reunited with their compatriots. This might transpire in a "homecoming exhibition" (*satogaeri-ten*) held, perhaps, at the Kyoto National Museum or possibly at Daitokuji itself. It

[76] Charles Lock Eastlake, *London Society*, August 1862, cited by Clive Wainwright, 'Morris in Context', in Linda Parry, ed., *William Morris 1834–1896* (London: Philip Wilson Publishers in association with the Victoria and Albert Museum, 1996), 358.

[77] Walter D. Love, 'Edmund Burke's Idea of the Body Corporate: A Study in Imagery', (1952) 27 *The Review of Politics* 189. A 1927 photograph of the north drawing room at Dumfries reproduced in the Christie's sale catalogue reveals four levels of miscellaneous objects in the alcove, ceramic plates hanging on the walls, and late Victorian or Edwardian furniture.

might also occur in conjunction with an exhibition of works sent from Daitokuji to a museum in the West. In any case, one can imagine that a reunion exhibition in this day and age might commence with Buddhist rites of purification and consecration performed by senior monks from Daitokuji that would bring to the exhibition venue a moment of ritual revivification.[78]

And one could imagine that such an exhibition might then travel from Japan to a museum in China, or subject to appropriate climate control perhaps to Hangzhou's Lingyin si, an important temple in the Southern Song capital when Lin Ting'gui and Zhou Jichang painted their 500 *luohans*, which, following the depredations of the Cultural Revolution, is again a centre for Chinese Buddhist practice.

In objecting to the separation of the Parthenon/Elgin frieze, William St. Clair draws attention to recent scholarship that provisionally identifies several different master sculptors, arguing that "genuine research can only be fully effective if all the surviving slabs can be seen together so that close comparisons can be made".[79] This is a familiar argument from the basic value of knowledge. Special exhibitions are often devised to test a thesis or, as here, to allow scholars, conservators and other scientists to pursue a specific research exercise. A further such suggestion is made above for the Daitokuji paintings, from the basic values of religion and aesthetic experience. These agendas are highly worthwhile but don't require permanent adjacency.[80]

Paul Bator talked about how separating the individual parts of a set, or series of works constituting an integrated whole, may be the aesthetic equivalent of physical dismemberment.[81] But, as Bator continues, it depends:

The importance of maintaining the integrity of a complex of works or a set (where no problem of physical destruction or mutilation is involved) is a matter

[78] Gregory P.A. Levine, *Daitokuji: The Visual Cultures of a Zen Monastery* (Seattle: University of Washington Press, 2006), 313.

[79] William St. Clair, 'Imperial Appropriations of the Parthenon', in John Henry Merryman, ed., *Imperialism, Art and Restitution* (Cambridge: Cambridge University Press, 2006), 87–8; the research discussed is Sarantis Symeonoglou's.

[80] St. Clair believes that signatories to the *Declaration on the Importance and Value of Universal Museums* are trying to create an autonomous aesthetic realm; however, only a relatively few institutions seem deliberately to pursue an 'art-for-art's-sake' approach to display; ibid., 94–5; see also above, Chapter 2, Section 3, and Chapter 4, Section 4.

[81] Paul Bator, *The International Trade in Art* (Chicago: University of Chicago Press, 1983), 22–3. On the 'legality' of the destruction of the Buddhas, one might argue that the Taliban had governmental rights to act, as did Henry VIII in destroying Catholic buildings and works. I wouldn't so argue, for the reasons following.

of degree. Some things are much more beautiful or interesting if seen as part of a given complex, some only a little. Consensus about the "how much" may be difficult to find; consensus about whether this factor should be determinative in a given case even harder. In sum, the value of maintaining the integrity of artistic complexes, sets and collections is clearly relevant, but no principle tells us what weight is to be assigned to it and whether that weight is sufficient to be decisive in any specific case.

Physically destroying works, however, clearly and qualitatively differs from removing them from one site to another.[82] So, concerned about the fate of *The Dream Garden*, Philadelphian attorney Stanhope S. Browne mused that

> on the one hand, it is something that the public absolutely has an interest in. And on the other hand, it is private property . . . If I own the Mona Lisa and I take an ax to it, have I committed a crime by destroying something I own?[83]

A good question, well addressed by Joseph Sax in *Playing Darts with a Rembrandt*, where he records a range of opinions about the right to destroy works of art, offered after it was discovered that Lady Churchill had burned Graham Sutherland's harshly descriptive portrait of her husband.[84] For some, this was a legitimate act by a private owner, the understandable response to an image that continued to upset Sir Winston. For others, no one had any such right. In a number of countries, and certain states within the U.S., copyright and associated laws protect creators and their estates against interference with original work. Some writers have persisted in seeing these rights as Roman in origin, but the idea of an individualistic moral right protecting creators' reputations and non-pecuniary rights arose in fact from the economic concerns of authors during the late eighteenth and nineteenth centuries.[85]

So, aside from economic reasons, why should we not destroy works of art that we own? Joseph Raz's principal reason why I should not destroy my van Gogh or Picasso, other than that I could sell it for a large sum of money and that many would derive great pleasure from looking at it,

[82] It was reported that at least three of the *luohans* were destroyed in the act of carrying them down from the caves at Yixian.

[83] *Philadelphia Inquirer*, 9 August 1998.

[84] *Playing Darts with a Rembrandt*, at 35–47. Stephen Guest suggests that because of the intrinsic value (or nature) of art, it is not obvious that the artist has a right to destroy a work, 'The Value of Art', (2002) VII *Art Antiquity and Law* 6.

[85] See David Saunders, *Authorship and Copyright* (London: Routledge, 1992), 75 *et seq.* and 111.

is that by doing so I am "blind to one of the values which give life a meaning".[86] We should not destroy works of art for reasons of respect:

> Not everyone has much time for Picasso's paintings, and there is nothing wrong in not caring for them (so long as it does not involve false beliefs about them or their value). But no one should destroy them, or treat them in ways inconsistent with the fact that they are aesthetically valuable. No one need care for dancing. But no one should spoil (possibly other people's) dances.[87]

There is a universal reason for respecting what is of value, whether it is instrumental or intrinsic: it is the right reaction to what is of value, whether you personally care for it or not.[88] Things of value should be respected wherever they are: whether in private hands or publicly held, whether out of sight or on public display, whether within the country in which they were made, or abroad. Institutions included, we have a duty of respect towards valuable objects and practices, as we have towards people in general:

> Respect for Michelangelo's work consists primarily in acknowledging his achievement in what we say, and think, and in caring about the preservation of the work. This fact reflects another: one need not be an art connoisseur to respect Michelangelo's work, nor need one be among those who spend time examining it and admiring it. Not everyone need be an art connoisseur, or a devotee of Michelangelo's work. But everyone ought to respect his work.[89]

This also holds for religious images, objects and sites perceived by believers to be animated by gods and spirits, such as those associated both with Buddhist and popular cults in China. Can we say that these images, objects and sites are ends in themselves, in the way that people are ends? Without settling that, most of us nevertheless remain deeply and properly concerned about dismemberment and destruction. So though I personally cannot say whether religious images are truly animated by gods and spirits

[86] Joseph Raz, *The Morality of Freedom* (Oxford: Clarendon Press, 1986), 212–13.

[87] Joseph Raz, *Value, Respect, and Attachment* (Cambridge: Cambridge University Press, 2001), 163–4; see in general 158–75.

[88] Ibid., 164. Ulrike Heuer argues that Raz makes the reasons for preserving, not destroying, and acknowledging value dependent on reasons for engaging with value ('Raz on Values and Reasons', in R. Jay Wallace, Philip Pettit, Samuel Scheffler and Michael Smith, eds., *Reason and Value: Themes from the Moral Philosophy of Joseph Raz* [Oxford: Clarendon Press, 2004], 127–52). Given the abundance of reasons to do things that count as engaging with value, she sees us allowing our tastes and inclinations to determine what reasons to follow.

[89] Raz, *Value, Respect, and Attachment*, 161; see also Joseph Raz, *The Practice of Value*, ed. R. Jay Wallace (Oxford: Clarendon Press, 2003), 143.

(and therefore that we should accord them a like respect to human persons), or whether they are Hobbesian empty vessels, we can surely argue that we should respect them because they are of value to the people who made them, and/or to the people who value them still. In an age where the politics of identity has acquired such prominence, people are particularly sensitive to symbolic expressions of respect.[90] Respect extends to all valuable forms of life. Although we may not value them ourselves, we ought to respect things that are valued by others. I might attempt to persuade my friends of the value of a particular Song dynasty sculpture of Guanyin, but if their tastes are confined to bird watching, chess, dancing, baseball and Californian painters, my enthusiasm will have little effect. They should all respect it, however, because of the value it possesses for others. Indeed, when any work of art is displayed within another cultural context, respect should be shown for those valuable practices through which it came into being.

[90] Raz, *Value, Respect and Attachment*, 171.

6

Liberalism and Valuable Practices

The tensions... – between the cosmopolitan and communitarian account of human life and activities – are not merely disagreements at the level of comfortably competing lifestyles. They are not to be thought of as liberal bedfellows who have already settled the basic terms and conceptions of their association. They are tensions at a deep philosophical level.

Jeremy Waldron[1]

1. Reason and Treason

The rhetoric of 'our heritage' usually suggests that cultural objects are best appreciated 'at home', and thus the Parthenon/Elgin Marbles will be more highly valued in Greece, where they were made, than Britain. To balance that, *Guernica* was painted within the context of avant-garde art in France, whereas the Badminton Cabinet was made in a Florentine court workshop. The Lansdowne Portrait is embedded in 'our American heritage', yet in 'our British heritage' as well. It also contributes to general knowledge about the appearance and manner of George Washington, about the painter Gilbert Stuart, about the visual construction of a new republic and about Anglo-American trade relations after the revolution.

Before seeking a way out of this apparent conflict between particularism and cosmopolitanism, let us recall the positions on cultural heritage commonly put forward in the worlds of art, anthropology and archaeology. This is the debate on which Merryman focuses. They generally

[1] Jeremy Waldron, 'Minority Cultures and the Cosmopolitan Alternative', (1992) 25 *University of Michigan Journal of Law Reform* 761.

represent, on the one hand, those who foreground some collective good (whether on behalf of a region, an ethnic group or a nation) and, on the other, individuals who strongly defend free trade and private rights. That was so when heritage lobbies clashed with the Duke of Beaufort over the Badminton Cabinet, or with Viscount Coke over the drawings from Holkham, or with the executors of the Merriam estate over *The Dream Garden*, or with the SamEric Corporation over the Boyd Theater.

When cultural heritage seeks to trump private rights by limiting the sale of works of art to the local market only, value is more likely to be reduced than not. The Duke of Beaufort's defence of the sale of the Badminton Cabinet was predicated on a rights regime that, at its most rigorous, allows little encroachment or restriction. Such a position may simply dismiss the notion of a common asset and/or non-economic value: "at the end of the day, it's really just a cupboard of which I was never very fond".[2] After the second sale, the Duke's comment on this latest episode in the cabinet's history was "I don't give a damn where it went, but I wish I'd made that much money when I sold it fifteen years ago".[3] The sale of drawings from Holkham, proceeds from which were to finance an estate modernisation programme that included the installation of bathrooms in 300 tied-cottages, was defended as follows by the then Viscount Coke (descendant of Sir Edward): "I took a lot of flak from the heritage lobby, selling the country's silver, you know. How come they'd suddenly become the country's property? It was my ancestor who bought them... In any case, which was more important, a few paintings – which were light sensitive and so could never be displayed – or the comfort and well-being of the people who work for you? It seemed to me there was no choice. I would certainly not contemplate selling any of the houses".[4]

So, let us now follow a hypothetical debate between 'Reason' and 'Treason', where Merryman's free-trading cosmopolitans will be 'treasonable' (recalling Joseph Brown's comment that to allow such a painting as *A View of Geelong* to leave Australia would be "an act of treason"), and particularists will be 'reasonable'. Reason will argue against the notion that cultural goods should serve all mankind and that there should be unrestricted trade in them. The stake is such valuable works of art as the Badminton Cabinet, *The Bath of Diana* and the Lansdowne Portrait, and

[2] Duke of Beaufort, quoted in *The Sunday Times*, 17 March 1991.
[3] *The Art Newspaper.com*, 12 December 2004.
[4] 'How Eddie Became an Aristocrat', *The Independent*, 27 August 1993.

works that have been, or could be, detached from their original setting, like the Parthenon/Elgin Marbles and *The Dream Garden*, but also things deemed to be culturally important to certain peoples but of lesser economic value. They argue principally about moral claims to cultural material held by other parties, and state controls on private owners. Reason seeks to control the export of treasures, to restitute them as appropriate and to regulate buildings, whilst Treason will have none of it. These are strong positions but not the only ones, as we shall see in the following section.

Treason argues that rights which cordon liberty trump interference by the state, and in contrast Reason insists that Badminton Cabinets are more than mere cupboards, that Anglo-Saxon charters are more than business records, and, importantly, that personality may be profoundly tied to cultural things.[5] Reason defends cultural heritage as a form of public good, to which Treason is publicly indifferent. Reason makes it clear to Treason that paintings, sculptures, ritual objects, buildings and the myriad other manifestations of material culture are expressive in a way that is uniquely different to other forms of art, such as literary works and movies that exist through reproduction. There is only one *Bath of Diana* by John Glover, and it can only ever be in one place at any one time. Also, there are individual works so distinctively expressive of a particular culture that they should be regarded as a national resource. Treason counters that although many cultural forms are particular to a region, the values they enshrine are often trans-national. Reason's reply to Treason is that the customary practices and ethical life of a people are to be greatly valued, points strongly made by Burke and Hegel, and notes that while there may well be a cultural heritage of all mankind, it can't tell the whole story. Treason responds that Burke is speaking only to foundational institutions like the constitution and the customary law, and that individuals still have primacy. Promoting the value of heritage, Reason argues that things of value are best (or most) valued where they were originally made, or with the people most associated with their manufacture, and where relevant at the sites for which they were commissioned. For example, *The Dream Garden* should stay at the Curtis Center rather than in, say, a casino in Las Vegas; not because it possesses the greatest aesthetic value or the highest value for study there (which is not to say

[5] In 1991, the Reviewing Committee recommended estoppel of the Charter of Godwine, 1013–20 CE. The expert adviser argued that Anglo-Saxon charters as a group were central to understanding the language, history and culture of Britain.

that it doesn't), but because the complex value of 'our heritage' is greatest at its original location.

Even allowing a degree of individual autonomy, Reason sees much material culture as an emanation of community itself. Also, aesthetic appreciation has a moral, even spiritual, dimension and to tamper with virtue is to risk slipping into vice. But Treason points out that engaging with value doesn't necessarily imply virtue, since individuals may deny similar such engagement to others and indeed oppress them generally.[6]

Treason also wishes to know from Reason the grounds on which privately owned cultural resources can be seen as public goods and subjected to collective rights or governmental interference. Conceding a public interest in properties held by charitable corporations, how are cultural things bound up with group identity or personality in any substantive way, especially when the people in question may be extremely diverse, and how can Reason justify the case that there are group rights to such cultural things as the Parthenon/Elgin Marbles or the Badminton Cabinet?

Reason answers that the Greek people have a moral right because restitution is necessary to their well-being, a good so strong that it trumps private rights. Reason argues that 'interference' in private lives is long-established in Western societies to maintain or protect public goods. If access to a particular holding is so valuable to cultural continuity (the Liberty Bell locked in perpetuity in a Philadelphian bank vault), then Reason should attempt to force the object into the public domain by all available legal means. But Treason finds the listing of art and architecture in the name of general welfare an unbearable and unjustifiable imposition. Thus the state didn't originally commission and pay for the Badminton Cabinet, and it didn't acquire and pay for the Holkham drawings, so what is the justification for restricting present owners from putting their chattels onto a free market in the hope of achieving the highest price? Indeed, points out Treason, owners of British historic houses have understandable loyalties to the continuity of their estates (as the 1991 *Review of Export Controls* put it: "Their heritage objects are often seen as a first reserve to pay capital taxes or to establish a maintenance trust or to repair the roof or to fund capital projects necessary for maintaining the viability of the estate"), irritating Reason by citing Ruskin's Burkean warning about the preservation of buildings: "it is again no question of expediency or feeling

[6] John Carey cites George Steiner on classical music performed under the Third Reich, *What Good Are the Arts?* (Oxford: Oxford University Press, 2006), 144.

whether we shall preserve the buildings of past times or not. *We have no right whatever to touch them.* They are not ours. They belong partly to those who built them, and partly to all the generations of mankind who are to follow us. The dead have still their right in them".[7]

Treason is also ready to head off any attempt at a utilitarian case for restitution, since the idea of general welfare as an aggregate of international preferences stretches credibility.[8] And equal preferences are likely to create unexpected consequences: the preferences of citizens in Japan and Burma for Central-Asian Buddhist sculptures might greatly outweigh those of citizens in Afghanistan and Pakistan.

Both Reason and Treason agree that it is right and proper to examine all the evidence pertaining to title in any individual case. The larger problem for Reason resides less with disputes on which national laws are readily equipped to adjudicate, but, as Greenfield observes, with properties (including land) acquired under colonial rule or through unequal treaties or as booty, the distribution of which manifests centuries of imbalances of power. How does one remedy a myriad acquisitive acts by ruling groups across the world, towards both other societies and their own members, which would be disallowed in the twenty-first century? Merryman reminds us that in international law the legal effects of a transaction depend on the law in force at the time.[9] So, although the 1954 Hague Convention and the 1970 UNESCO Convention both seek to penalise a range of now-unacceptable and illicit acts, success for Reason depends on courts being willing to shake off bias against retroactive legislation, and also to abate statutes of limitations.[10] All of this leaves us questioning not

[7] *A Review of the Current System of Controls on the Export of Works of Art* (London: HMSO, 1991), 48; for Ruskin see above, Chapter 3, Section 4.

[8] The many citizens of Greece who derive a (measurable) benefit from the sculptures would have to outnumber all those in Britain who might derive an equal benefit (foreign tourists aside, who could equally visit Athens). Thus heritage becomes a numbers game, in which objects should reside wherever utilities are maximised. The Greek government might argue that the entire Greek population deriving a benefit from seeing all the marbles in the vicinity of the Acropolis must be greater than all Britons who would derive a similar benefit in London. But then this argument assumes that all Greeks derive that benefit by virtue of the fact that they have an interest in being Greek, or, as Kymlicka puts it, from their cultural membership; hence that version of the utility argument allies cultural membership with preferences.

[9] John Henry Merryman, 'Thinking about the Elgin Marbles', (1985) 83 *Michigan Law Review*, 1881–923, at 1900, and Chapter 1, note 43.

[10] Ibid., where Merryman also notes the rules of prescription (statutes of limitations); conversely, there are rules of negative prescription by which rights are lost through the lapse of time. See also Jeanette Greenfield, *The Return of Cultural Treasures* (Cambridge: Cambridge University Press, 1998), 216–17, and 219. For tolling statutes, note the

only whether Reason has over-weighted the good of 'our heritage' over other, intrinsic goods, but also whether such goods are commensurable.

Reason and Treason have played out some of the conflicts over heritage between free traders and particularists. Yet, as I said in Chapter 2, their concerns also map on to a contemporary debate between communitarians, liberals and libertarians (and I use *libertarian* here in the sense that Will Kymlicka uses it, as the right-wing of procedural liberalism, with the left-wing being represented by liberal egalitarianism).[11] So now I think it is useful to open Merryman's 'two ways' to related ideas in contemporary political thought.

2. Another Way of Thinking

How profoundly English Catholic, Chinese Muslim, American Buddhist do we need to be to lead a full life? Can we be complete individuals without an overarching English-ness, Chinese-ness, American-ness, Catholicism, Buddhism or Islam that gives meaning to our lives? Communitarians such as MacIntyre, who have promoted an understanding of the 'good life' as one embedded within community, do so in part to rebut liberal efforts to protect individual freedoms against any particular conception of the good. They doubt that liberalism or libertarianism can successfully argue for both the primacy of autonomy and the worth of particular cultural practices. As Kymlicka puts it, "they seek to promote a 'politics of the common good'... even if this limits the ability of individual members to revise their ends".[12] Conversely, while liberals see the importance of establishing particular political communities (in order to create the conditions for individual well-being), they seriously worry whether communitarians, in advocating particular practices and values, can protect equal rights for all citizens. Moreover, autonomy is diminished not only when individuals can't meaningfully revise their ends, but also when they have limited access to the sorts of information that would allow them to consider alternative ends.

In practical terms, their differences often come down to what they are willing to support from the public purse. Liberals wish to support society's basic infrastructure needs, including defence, policing, the courts, customs, transport, energy, agriculture and trade, as well as programmes

judgment in *Erisoty v. Rizik*, 1995 WL 91406 (E.D. Pa.). The UK announced its intention to accede to the 1970 Convention in March 2001.

[11] Will Kymlicka, *Politics in the Vernacular: Nationalism, Multiculturalism, and Citizenship* (Oxford: Oxford University Press, 2001), 328–9.

[12] Will Kymlicka, *Multicultural Citizenship* (Oxford: Oxford University Press, 1995), 92.

benefiting individual flourishing, such as those that affect education, health, welfare, sport, culture and the environment.[13] In theory, libertarians will generally support only infrastructure and basic educational needs, whereas communitarians split into two camps, each wanting tax revenues to serve 'a politics of the common good' (including religious programmes).[14] However, again in theory, whereas 'left' communitarians share with liberals the idea that governments should help create opportunities for individual flourishing, 'right' communitarians will incline just to infrastructure and basic education. In practice of course individuals find their own place on the spectrum of political options.

During the past two decades, as political theorists have attempted to understand better the relationship between individual and community, or universalism and particularism, a number of liberals have moved towards a conception of the individual as dependent upon social practices, but also able to revise or reject them. As Hollis maintained, liberals can "subscribe to a communitarian idea about persons but trump it by insisting that communities must accept liberal ideas about universal demands of the right and the good. These demands are left deliberately incomplete".[15] Kymlicka argues that a recent shift in political thought is missed if the nationalist/cosmopolitan debate is framed as between an "illiberal preference for ascriptive group identity over individual choice" and autonomous individuality. To have contemporary relevance the debate should be entered on one side by liberal cosmopolitans and on the other by liberals who focus on the crucial contribution that social practices make to the lives of autonomous individuals for whom the practices are meaningful. The latter represents another way of thinking about cultural property.[16]

[13] For example, Timothy O'Hagan comments that "Most liberals, apart from the most brutish libertarians, will allow that there is such a thing as a natural environment and that its survival constitutes a common good, rather than a particular *conception* of the good"; 'The Idea of Cultural Patrimony', in Richard Bellamy and Martin Hollis, eds., *Pluralism and Liberal Neutrality* (London: Frank Cass, 1999), 152.

[14] The strongest, Nozickian, version of libertarianism would have "no public education, no public health care, transportation, roads, or parks", Will Kymlicka, *Contemporary Political Philosophy: An Introduction* (Oxford: Clarendon Press, 1990), 97.

[15] Martin Hollis, *Trust Within Reason* (Cambridge: Cambridge University Press, 1998), 162. See also Alan Patten and Will Kymlicka, 'Language Rights and Political Theory: Context, Issues, and Approaches', in Will Kymlicka and Alan Patten, *Language Rights and Political Theory* (Oxford: Oxford University Press, 2003), 11, and Will Kymlicka, 'Liberal Theories of Multiculturalism', in Lukas H. Meyer, Stanley L. Paulson and Thomas W. Pogge, eds., *Rights, Culture, and the Law: Themes from the Legal and Political Philosophy of Joseph Raz* (Oxford: Oxford University Press, 2003), 233–4.

[16] He includes liberal nationalism and liberal multiculturalism as forms of liberal culturalism; see Kymlicka, *Politics in the Vernacular*, 42, 204, 220. Not all liberals who agree

Kymlicka's own 'liberal culturalist' approach has been described by David Laitin and Rob Reich as attempting to capture the nationalist perspective but contain it within liberal principles:

Will Kymlicka is the foremost exponent of liberal culturalism. As a liberal, Kymlicka demands that a state guarantee the basic civil and political rights of all its citizens and he defends the value of personal autonomy. As a culturalist, Kymlicka thinks that individuals exercise freedom only through their moorings to a societal culture, and that this fact should lead liberals to take a moral interest in cultures.[17]

In formulating his understanding of what liberal culturalism implies for public policy, Kymlicka draws on Ronald Dworkin's analysis set down in a paper from 1984 on why liberal states should support the arts.[18] Dworkin suggested that since 'orthodox' liberals will be neutral towards differing ideals of the good life, and therefore resist preferential subsidies, they will not expect the state to subsidise Titians rather than football on television, or vice versa. Left to itself the market will not fully fund expensive forms of cultural life (e.g., museums, public libraries and gardens, theatres, and halls for concerts, opera and dance), either through direct or indirect subsidy. To ensure that we have these, the state must step in. But why should it, since the sum of extrinsic benefits – such as pride and the economic impact on a city's economy – is not high enough to justify substantial spending?[19] The arts for Dworkin are broadly dissimilar to public goods from which no one can be excluded, such as clean air and defence spending which have to be available to all, non-exclusive and not be divisible into private goods.[20] In this Dworkin differs from Lyndel Prott, who observes that some people would see cultural heritage law as a part of environmental law, with heritage preservation pertaining to such collective goods as clean air and clean water (to which we might

on the strong relationship between autonomy and established social forms wish to be gathered under the liberal culturalist flag. David Laitin and Rob Reich, for example, regard their own approach as liberal democratic; 'A Liberal Democratic Approach to Language Justice', in Kymlicka and Patten, *Language Rights and Political Theory*.

[17] Laitin and Reich, 'A Liberal Democratic Approach to Language Justice', 89.

[18] Ronald Dworkin, 'Can a Liberal State Support Art?' first presented at the Metropolitan Museum of Art in April 1984 and published in *A Matter of Principle* (Oxford: Oxford University Press, 1985), 221–33.

[19] Ibid., 224–5.

[20] So an architectural façade would qualify, and the interior of a freely accessible building, but not the interior of a private house; see Idil Boran, 'Diversity, Public Good, and Fairness', in Kymlicka and Patten, *Language Rights and Political Theory*, 194, where she lists the following features as characteristic of public goods: jointness, non-excludability and indivisibility.

add the façades of fine buildings, public monuments and large complexes such as valuable cities).[21] The arts might, however, be regarded as 'mixed public goods' owing to their spill-over benefits to non-participants. Yet, from the economic perspective, even as mixed goods they exact too high a price to justify a high level of public support.[22] And indeed for many people the cost of mixed goods in other countries, even in other cities, will be prohibitive because of the cost of entry (air or rail fares, hotel accommodation, etc.).

Dworkin's special reason for taking a non-neutral approach to the arts was that "a rich cultural structure... multiplies distinct possibilities or opportunities of value" and it is "better for people to have complexity and depth in the forms of life open to them".[23] We should regard ourselves as the trustees of our (particular) cultural structure, protecting it on behalf of those who live their lives after us. Not to do so would deny to future generations opportunities that we ourselves have. In a formulation that echoes both Herder and Hegel, Dworkin considered cultural structures to be based on shared tradition and convention, embodied in forms of language:

For the structural aspect of our artistic culture is nothing more than a language, a special part of the language we now share. The possibilities of art, of finding aesthetic value in a particular kind of representation or isolation of objects, depend on a shared vocabulary of tradition and convention. This part of our language could have been much poorer.[24]

If, in any particular language, no one had found value in narrative invention, there would be no means to distinguish between a novel and a lie, and therefore no one could set about writing a novel. "The same point, obviously enough, can be made about painting and sculpture and music".[25] Critics and artists do indeed often speak about the arts in terms of languages, as in 'the language of painting', and I have done so

[21] Raz gives Oxford as an instance of a common good (Oxford Colleges restrict access to non-members at certain times and some are open by appointment only, but he evidently refers to the value of the city as a whole); Joseph Raz, *Ethics in the Public Domain: Essays in the Morality of Law and Politics* (Oxford: Clarendon Press, revised ed., 1994), 52.

[22] Dworkin, 'Can a Liberal State Support Art?', 224–5.

[23] Ibid., 229.

[24] Ibid., 230–1, where he argues that languages are neither private nor public goods because they generate our ways of valuing and so are not themselves objects of valuation.

[25] Ibid.

myself.[26] For example, one might say that works such as Gong Kai's *Zhongshan quyu tu* richly manifest the expressive capacities of visual language, in this case the languages both of Chinese painting and calligraphy, as does *Guernica* for the language of European painting. Music is also rule and convention-bound (building on the physics of sound and the architecture of the auditory system). But I now prefer to describe visual and musical 'languages' more directly as practices – with rules, conventions and expectations of use guiding their transmittal. Perhaps this is only a difference of nomenclature, where cultural languages, cultural practices and cultural traditions are interchangeable terms.

Dworkin concluded that, in order to maintain the culture's structure, state support can indeed be given to the arts. To avoid the charges of paternalism and elitism, funding shouldn't promote any particular content ("excellence in particular occasions") but seek instead to promote "the diversity and innovative quality of the culture as a whole".[27] Aid should be provided by tax exemptions for charitable giving rather than through direct subsidy, except in the case of expensive forms of the arts or humanities that private market transactions can't reasonably sustain, such as comprehensive collections of paintings or comprehensive programmes of studies ("like much of the programs of the great universities") even when they only directly benefit a "relatively few people".[28]

Kymlicka emphasises that Dworkin's 'cultural structure' should be understood as a primary (public) good in Rawls' sense, just because it represents the context of choice from which we make our life plans.[29] And whether state subsidy for specific instantiations is indeed paternalistic or elitist hinges on how we understand the relationship between cultural practice and individual autonomy, a question to which I shall return below. For now I'll repeat an earlier comment on art forms, namely, that they comprise not only 'ways of going-on' but also individual works, significant examples of which ("excellence on particular occasions") are the very conduit for innovation in the arts.[30]

[26] In the first edition of the present work. Besides Dworkin, Charles Taylor also uses the phrase 'languages of the arts' in arguing for a politics of recognition; see Neus Torbisco Casals, *Group Rights as Human Rights: A Liberal Approach to Multiculturalism* (Dordrecht: Springer, 2006), 177.

[27] Ibid 233.

[28] Ibid.

[29] Will Kymlicka, 'Dworkin on Freedom and Culture', in Justine Burley, ed., *Dworkin and His Critics* (Oxford: Blackwell, 2004), 116–19.

[30] See Chapter 4, Section 3 of the present work.

If Dworkin represents cultural languages principally in terms of rules, conventions and expectations of use, Kymlicka is inclined to see them in action. Spoken and written languages represent the dominant vehicle for cultural stories, conveying values and virtues. He argues that the courses of action we follow have significance only because common language makes vivid their point to us, and the way in which they do that "is a matter of our cultural heritage, "our traditions and conventions":[31]

> Different ways of life are not simply different patterns of physical movements. The physical movements only have meaning to us because they are identified as having significance by our *culture*, because they fit into some pattern of activities which is culturally recognized as a way of leading one's life. We learn about these patterns of activity through their presence in stories we've heard about the lives, real or imaginary, of others. They become potential models, and define potential roles, that we can adopt as our own... We decide how to lead our lives by situating ourselves in these cultural narratives, by adopting roles that have struck us as worthwhile ones, as ones worth living (which may, of course, include the roles we were brought up to occupy).[32]

Laitin and Reich see several virtues in Kymlicka's approach to the relationship between culture and personal autonomy, among which is the rejection of "notions of cultural essentialism or purity while giving due weight to the significance of one's native tongue beyond mere communication".[33] However, they question the universal desirability of maintaining our culturally inherited languages, both for ourselves and our children: "It may be true, of course, that *most* members of *most* national minorities do seek to retain their mother tongue and transmit it to future generations. But the point is that we cannot assume this as a matter of course".

Jeremy Waldron, observing some similarity between MacIntyre's and Kymlicka's arguments (both of which emphasise the significance of cultural narratives), thinks that Kymlicka brushes too closely against a

[31] Kymlicka, *Politics in the Vernacular*, 209–10, and 'Dworkin on Freedom and Culture', 118. A similar position is taken by Joseph Raz and Avishai Margalit on the relationship between individual well-being and worthwhile goals and relationships that depend on shared expectations, traditions and conventions; 'National Self-Determination', reprinted in Raz, *Ethics in the Public Domain*, 133–4. Timothy O'Hagan also posits that "cultural identity or cultural patrimony... is expressed or embodied in a shared language", opposition to which idea would commit the holder to an impoverished instrumental view of language; 'The Idea of Cultural Patrimony', 151.

[32] Will Kymlicka, *Liberalism, Community and Culture* (Oxford: Clarendon Press, 1989), 165.

[33] Laitin and Reich, 'A Liberal Democratic Approach to Language Justice', 89–90.

purist version of culture, and strongly disputes the claim that there are cultural structures, the integrity of which underpins meaningful choice.[34] Waldron can agree with Kymlicka on the importance of access to a variety of stories and roles but not on the importance of cultural membership. He agrees that we need cultural meanings, but not homogenous frameworks. Instead he argues that cultural materials are available from all over the world and enter into people's lives often long separated from their original context: "To put it crudely, we need culture, but we do not need cultural integrity".[35] In responding to Waldron, Kymlicka writes that no liberal can endorse a notion of culture which sees interaction as a threat, as opposed to an opportunity for enrichment (in the sense of personal growth). However, rather than defending a cosmopolitan form of liberalism that promotes "a *mélange* of cultural meanings from different sources", we should look at what Dworkin suggests forms the basis of cultural structures: the common language.[36]

For his part, Waldron believes that in order to evaluate cultural roles effectively, there has to exist the possibility of compromise or the erosion of allegiances. But if identity is not secured by Kymlicka's cultural structures, what then is its nature? Waldron proposes that the 'I' should be regarded like an association of friends, within which there are various, sometimes competing commitments. The accommodation of Buddhist practices and neo-Confucian literati practices by Guan Daosheng and Zhao Mengfu comes to mind here, made easier by the division of labour in Yuan China between Buddhism's occupation with metaphysics and Confucianism's concern with affairs of state and social relationships. By transcribing the story of Miaoshan, in which filial child and compassionate Bodhisattva were one person, Guan underlined her own dual commitments (whether anyone can successfully manage more than two potentially competing ideologies is moot). Self-governance for Waldron will not be without conflicts, but these should lead to a healthier, not a schizophrenic character. Thus each (cosmopolitan) person "can have a variety, a multiplicity of different and perhaps disparate communal allegiances".[37] This version of the 'I' is less an exercise in the anthropology

[34] Waldron, 'Minority Cultures and the Cosmopolitan Alternative', 781–93.

[35] Ibid., 786.

[36] Kymlicka, 'Dworkin on Freedom and Culture', 121–3. He uses an example given by Waldron to support the case for common languages: *Grimm's Fairy Tales* have become a part of English-speaking cultures only because they were translated and widely distributed in English.

[37] Waldron, 'Minority Cultures and the Cosmopolitan Alternative', 789.

of cultures as in the anthropology of individuals, which, as Joseph Sax observes, cultural heritage debate has to confront in the end:

> Jeremy Waldron urges that there is a deep tension between the cosmopolitan and communitarian accounts of the good life, and that the latter, out of which arise the currently popular claims for preservation, needs to provide answers to some momentous questions.[38]

Waldron is right about this tension, which I tried to represent in my hypothetical debate between Reason and Treason (albeit with Treason placed towards the libertarian end of the spectrum). However, there is surely a narrower gap between liberal cosmopolitans and liberals who believe that individuals are dependent on socially sustained valuable practices. Kymlicka promotes the culturalist case for language rights for members of minority cultures because of his concern that in some circumstances liberal neutrality can negatively affect well-being.

Samuel Scheffler points out that, other than "extreme" cosmopolitans, all liberals practice a form of particularism, since citizenship itself generates obligations to one's fellow citizens which don't hold beyond the nation-state. He recognizes the conflict between past and future in all but the most constrained societies, suggesting a moderate cosmopolitan project that is sympathetic to cultural allegiances and also – "given the inevitability of cultural change, and given the mutual influence that diverse cultures are bound to exert on each other" – concerned about maintaining not the purity but the *integrity* of traditions. Scheffler notes that moral isolation is a potential peril for free-wheeling cosmopolitans, cutting them off from "the forms of social support that structure and sustain individual responsibility".[39] Indeed, Raz reminds us that individuals often seek a balance between innovation and "normality", accommodating the needs for both self-expression and the inter-generational transmission of cultural forms.[40]

I do agree with Kymlicka and Dworkin that well-being is increased by access to rich and textured cultural narratives and practices. People require valuable practices through which to express themselves and

[38] Joseph L. Sax, 'Introduction', (1992) 25 *University of Michigan Journal of Law Reform* 539–40.

[39] Samuel Scheffler, *Boundaries and Allegiances: Problems of Justice and Responsibility in Liberal Thought* (Oxford: Oxford University press, 2001), 69–70, 111–30.

[40] Joseph Raz, *Engaging Reason: On the Theory of Value and Action* (Oxford: Oxford University Press, 1999), 192.

engage with the excellent expressions of others. Some of these valuable practices will be local, some national and some common to several nations. Others are truly global, such as sports and games with internationally agreed upon rules: chess, or soccer for example. And as we saw in Chapter 4, and typical of the major world religions, forms may be local but their content widely shared, Kwame Anthony Appiah noting the ever-growing ways in which cultural practices intermingle, overlap or simply co-exist. His account of current accommodations of modern Western and traditional Asante practices in his father's native Ghana compellingly cautions against any presumption of 'pure' culture.[41]

Outside very restrictive cultures, each of us has some licence to choose the practices that we engage with. Martin Hollis sees us as rational actors, subject to the enablements and constraints of the social positions we inhabit; an understanding that emphasises personal interpretation of often-conflicting roles.[42] Thus, in following the rules of social life and acting out our various roles, we shall (perhaps often) misinterpret cues and make errors of judgment. Conversely, our decisions may be appropriate and judicious, and our performances will exceed the expectations of others. The point is that in liberal democracies we are encouraged to insert ourselves into community life as individual choosers rather than automata: deciding to maintain, reject or radically reinterpret rules, roles and narratives. In theory at least, each of us has to decide the extent to which we embrace or reject the particular world into which we are born.[43] Autonomy is a core value for liberals, embraced by Finnis under the value of practical reasonableness "which is participated in precisely by shaping one's participation in the other basic goods, by guiding one's commitments, one's selection of projects, and what one does in carrying them out".[44]

Hollis's untimely death prevents us, as O'Hagan puts it, from knowing the final destination of his 'Enlightenment Trail', but "we can be

[41] Kwame Anthony Appiah, *Cosmopolitanism: Ethics in a World of Strangers* (New York: Norton, 2006), 87–94.

[42] Martin Hollis, *The Philosophy of Social Science: An Introduction* (Cambridge: Cambridge University Press, 1994), 171–3; and Chapter 4, Section 2 of the present work.

[43] Steve Smith believes that Hollis overemphasised the actual capacity of the majority of people freely to interpret their roles, 'Many (Dirty) Hands Make Light Work: Martin Hollis's Account of Social Action', in Preston King, ed., *Trusting in Reason: Martin Hollis and The Philosophy of Social Action* (London: Frank Cass, 2003), 145.

[44] John Finnis, *Natural Law and Natural Rights* (Oxford: Clarendon Press, 1980), 100.

sure that it would have passed through some of the country described by Raz".[45] A part of that landscape includes questions about personal and group identity, about "who I am". Some elements of our identity are given, whether through biology or involuntary association, whereas others are freely chosen.[46] Importantly, our roles are sources not only of meaning but also of responsibilities.[47]

As Raz frames the issue, groups too have an identity "defined by their culture, by their collective memory, and by their common responsibilities, and arising out of them," yet collective identities "like individual characters, tend to be a mix of the good, the bad, and the indifferent". Raz's interest lies not in group identities *per se*, but in their role within individual life:

This is no group-fetishism, no valuing of mystic collective entities at the expense of concern for humans. It is recognition of the dependence of personal identity and personal meaning on people's membership of, and identification with, a wide range of groups, national, religious, professional, and more.[48]

3. Collective Rights and Cultural Membership

It is clear that there are parallels between Merryman's 'two ways of thinking' (free-market cosmopolitanism versus particularism/nationalism) and these two strands of liberalism (liberal cosmopolitanism versus a liberalism that recognises the importance to personal autonomy of social practices). But there are also differences. It may indeed be, as Alan Scott puts it, "that the social and the individual, the singular and the plural, are in a constant tension within social institutions, within the interactions of actors, and, perhaps most importantly, within each self".[49] Yet all liberals focus on individual flourishing, not on the well-being of groups *per se*. Whatever advantages people derive from group membership, the proper subject of heritage debate from a liberal perspective is the individual's association with cultural roles, practices and stories.

[45] Devised to help us understand forward-looking reasons for action. Timothy O'Hagan, 'Hollis, Rousseau and Gyges' Ring', ibid., 67.

[46] See Chapter 3, Section 5 of the present work.

[47] Joseph Raz, *Value, Respect, and Attachment* (Cambridge: Cambridge University Press, 2001), 34.

[48] Ibid., 35.

[49] Alan Scott, 'A Quick Peek into the Abyss: The Game of Social Life in Martin Hollis's *Trust Within Reason*', in King, *Trusting in Reason: Martin Hollis and The Philosophy of Social Action*, 204.

With these thoughts in mind, let me come again to a question posed throughout this book but not yet answered: do cultural groups have property rights to works of art, architecture and other artefacts with which they are associated, but to which they have no legal title? Claims that, as Kent Greenawalt puts it, rest "on the significance of cultural property for the lives (now and in the future) of members of the nations".[50] What circumstance might warrant endorsing a collective right to certain things that "simply belong in the country of origin"? For Greenawalt, "Such an argument alone seems highly implausible for most cultural property, but it may have force for a very few items that are central to national identity". The key question for me remains the relationship between personal autonomy and valuable works of art, whether national treasures or other instances of excellence. For liberals, the justification for group claims, of the sort adumbrated in Chapters 1 and 2, has to be that restitution contributes in some meaningful way to individual freedom and well-being.

Surrounded by the remains of the classical world, many Greek citizens will surely be familiar with the artistic and narrative conventions of Hellenic and Hellenistic sculpture and, from Moustakas's perspective, will find the Parthenon/Elgin Marbles more relevant to their lives than, say, Song Buddhist sculpture. They may not wish to engage with Chinese art, or with art in general (preferring other goods), but, as I suggested in Chapter 1, they will probably see the Parthenon as symbolic, especially of self-determination. A further reason why Greek citizens find the Parthenon important might be a general respect for ancestral practices, including those that are no longer practised, which I would venture forms part of Rawls's "social bases of self-respect".[51] To Moustakas, for whom the sculptures are a manifestation of the *personality* of the Greek people, their absence affects all Greeks by "irreparably diminishing an integral part of the celebration of 'being Greek'". It is vital to him that groups should control resources necessary for group constitution. Thus the personhood of individual Greek citizens is diminished because they cannot enjoy the sculptures in Athens.[52] Yet is it truly the case that the

[50] Kent Greenawalt, 'Thinking in Terms of Law and Morality', (1998) 7 *International Journal of Cultural Property* 14–16.

[51] That assumes of course that such practices were not associated with tyrannies. There are other reasons for ancestral respect, like filial piety and reciprocity in China; see Chapter 4, Section 2 of the present work.

[52] A new museum for the Parthenon marbles and other antiquities opened at the Acropolis in 2009; see Chapter 1, Section 3 of the present work.

Marbles' absence has a deleterious effect on citizens' personhood? Many
sculptures which existed in Periclean Athens are absent from present-day
Greece because they have been eroded or destroyed.

The most convincing existing grounds for group rights lie in the arena
of self-determination and language opportunities, and we need to ask
whether a related case can be made for collective rights to cultural
objects. Within a discussion of the value of self-determination, Joseph
Raz and Avishai Margalit make it clear that their pragmatic, instrumen-
talist approach to group rights should not be confused with "an aggre-
gating impersonal consequentialism".[53] The reason why the group right
to self-determination may be considered legitimate by liberals is because
such a right has instrumental value to all members of the relevant group.
It is not derived from aggregating preferences across the group, or from
those who speak on behalf of the group. For Raz, group membership is
important because

social practices are interlaced with each other... Such conglomerations of inter-
locking practices which constitute the range of life options open to one who is
socialized in them is what cultures are. Small wonder, therefore, that membership
in cultural groups is of vital importance to individuals.[54]

Cultural groups that claim a collective right to property will presum-
ably have the same characteristics as those who would qualify for self-
determination, having "a common character and a common culture that
encompass many, varied, and important aspects of life". National groups
are expected to have "national cuisines, distinctive architectural styles,
a common language, distinctive literary and artistic traditions, national
music, customs, dress, ceremonies and holidays, etc.". These are all typ-
ical (but not necessary) features that "characterize peoples and other
groups that are serious candidates for the right to self-determination".[55]

Now Kymlicka has sought to justify a narrow range of collective rights,
with a special focus on language rights, which he sees as a crucial gateway
to understanding the rights of minorities within pluralistic democracies,
whether poly-ethnic or multinational.[56] It is important to understand

[53] Raz and Margalit, 'National Self-Determination', 138.
[54] Raz, *Ethics in the Public Domain*, 177.
[55] Raz and Margalit, 'National Self-Determination', 129.
[56] Multinational states are those like the U.S., Canada, Australia and New Zealand which
have incorporated nations that inhabited the countries before colonisation, but they are
also poly-ethnic in having absorbed other cultures through waves of immigration (as
have most European countries); Kymlicka, *Multicultural Citizenship*, 11–26, 79–80 and

them as rights to which particular communities of language users may be entitled, on the grounds that in certain cases they can equalise unfairness of opportunity in education and the democratic process, hence his phrase "politics in the vernacular".[57] But are there similar rights to language-like practices ('languages of the arts')?

I would think the strongest argument for instrumentally grounded group rights to art forms (rule and convention-bound practices), and to particular works as instances of excellence, is one that parallels Kymlicka's case for rights to language. Yet Kymlicka is surely justified in presenting spoken language (and, in literate societies, writing) as the principal vehicle through which we act: "how can 'the people' govern together if they cannot understand one other?"[58] And although they may contribute forcefully to the political process though imagery of various sorts, it is evident that these other practices do not represent the primary forum for participation.[59] As powerful an example of political resistance as it was, *Guernica* cannot be as potent a force for articulating the need for basic liberties as speech or writing. The case for rights to other distinct cultural practices (visual and performing) is therefore a weak one. Even were we to accede to rights to these practices, it is far from obvious that such rights pertain to particular instances of expression. A right to Greek art cannot propel governments to provide access for Greek citizens to every major example of Greek sculpture from classical times. Then there is the question of general interest in these 'other' cultural practices. Members of a well-defined culture may agree that all such practices are good, but will they agree that familiarity with them all is *necessary* for individual well-being? I doubt it, except perhaps where acquiring skill in a particular art form – singing for example – is a requirement for participation in religious ritual.

Kymlicka allows a case for collective rights to common goods such as languages and political self-determination, both of which contribute to the autonomy of individuals by allowing full participation in democratic processes. The absence of the Parthenon/Elgin sculptures does not

107–30, and *Politics in the Vernacular*, 54–5 and 156–9. See also Yael Tamir, *Liberal Nationalism* (Princeton: Princeton University Press, 1993), 42–8, and also O'Hagan, 'The Idea of Cultural Patrimony', 154.

[57] Kymlicka, *Politics in the Vernacular*, 213.

[58] Kymlicka, 'Liberal Theories of Multiculturalism', 239.

[59] Boran, 'Diversity, Public Good, and Fairness', 195–6, suggests that aesthetic needs in themselves do not generate obligations (as, for example, does the need to have one's basic liberties protected).

diminish democratic options for individual Greek citizens, however, or limit their educational opportunities. It is not clear that their presence in London significantly diminishes the opportunities of Greek citizens to understand their culture, in the way that denying access to spoken Greek would. So, setting aside the important issue of good title which is beyond the scope of the present work, there is not an obvious case for a collective right to the Parthenon/Elgin Marbles. Such a right would have to be justified by the proposition that Greek citizens require proximity to the art forms of ancient Greece in order to achieve full cultural membership and democratic participation: a right that holds legal owners to a duty of restitution. Many Greek citizens may be denied educational opportunities that are afforded by seeing the sculptures 'in the flesh' within the British Museum, but they are not thereby denied the opportunity of acquiring a good education in general, or of learning about the achievements of Greek culture, or of cultural membership, or of democratic participation. All of which is not to say that there may not be a partnership agreement between property-holding institutions, if such an arrangement is considered desirable.[60]

It is indeed legitimate to argue that because many Greek citizens have an interest in the Parthenon, and because they strongly wish to have all its sculptures united in Athens, and because cultural membership is important to them, the return of the Marbles would contribute positively to their lives. People of Greek descent (including those living in other countries, such as Australia) may certainly be angry that they remain in London and greatly regret that they cannot enjoy them in Athens. Yet this is simply not strong enough an interest to create a right underwritten by an international convention, and it is not strong enough to create a duty of return, unless the Trustees of the British Museum chose to see it as a duty. If the Trustees made that choice, they would then have to seek a change in the law, since the British Museum Act tightly constrains deaccessioning.[61]

[60] *The Three Graces* is jointly held by the Victoria and Albert Museum and the National Galleries of Scotland.

[61] On 27th May 2005, Sir Andrew Morritt V.-C. ruled in the High Court that, notwithstanding their desire to do so, the trustees of the British Museum were prohibited by law from returning to the heirs of the late Arthur Feldmann four Old Master drawings in the Museum's collections stolen by the Gestapo in 1939; *Attorney General v. Trustees of the British Museum*. Norman Palmer notes that the introduction of the Regulatory Reform Act 2001 has provisions for allowing ministers to relieve persons (including corporations) of a disproportionate burden imposed by the existing law. See interview with Norman Palmer, 'How the British Museum Could Give the Elgin Marbles back to Greece', *Art Newspaper* (October 2001).

At present, the director and trustees do not see it as a duty to return the Marbles. They judge the purpose of the institution better served by the continuing presence of the Marbles alongside exceptional works from many other cultures. That having been said, I share Appiah's opinion that the British Museum has an ongoing responsibility to provide good access to, and abundant information about, the sculptures and their history, as have other institutions with regard to works in which there is a strong interest.[62]

If a culture was demonstrably dying out but could be revitalised by the return of a particular material thing – such as a highly valued image belonging to a museum in another country – would that justify a right? Radin suggests that the personhood perspective can help adjudicate claims where one group stands to lose "one of its few opportunities to express personhood and the other does not".[63] A return might indeed assist in restoring cultural identity to individuals within that group, because it enabled them to revivify religious practices that would otherwise cease, and thereby considerably increase their life options. This circumstance may constitute a good reason for others to act, but even here I see no ground for a collective right. The trustees of the museum in question might nonetheless wish to return the image, because they see such an action as having value not only to the group in question but also to themselves. Why might they act so? Perhaps, for them, increasing "the social bases of self-respect" (Rawls) is an important instrumental value of museums, and they have come to believe that the self-respect of every member of the petitioning group will be enhanced by returning the object. They might feel a moral duty to act in this way. In other words they would do it because it suits their mission to do it, and their universe of supporters would agree to it for that reason. There would not be justification for a collective right to restitution, but there may be a reason for it if and only if the owners wished to make it *their* reason. Certainly it would be more palatable if such claims were accompanied by offers of fair market compensation, which is the premise of eminent domain, but that concept has been constructed within the context of domestic legislation. There are special cases, and here I am thinking particularly about claims involving human remains which museums have valued for their

[62] See Appiah, *Cosmopolitanism*, 130. Neil MacGregor decisively rejected the possibility of return in an interview with the *Sunday Telegraph*, 23 February 2003.

[63] Margaret Jane Radin, *Reinterpreting Property* (Chicago: University of Chicago Press, 1993), 70.

potential contribution to anthropological or scientific research. These can be adjudicated on the Kantian grounds of respecting the value of a human being *qua* human being, and I think it is not unreasonable for them to be returned to cultural groups. We increasingly respect these claims because of the respect we have for the integrity of persons.

The claim that complexes should be re-integrated because aesthetic appreciation and knowledge is greater when material is seen in its original form, or as close as possible to that, may be answered in a similar way to the claim about collective rights to heritage. The integrity of complexes is instrumentally valuable, serving other, intrinsic values, such as aesthetic experience and the value of knowledge, friendship and religion. There is no strong justification for a collective right to integrity, but there may be good reasons for re-integrating a complex or a collection. These may become good reasons for action, overcoming reasons for title-holders to maintain the *status quo*. Yet, if they become duties that we wish to fulfil at the expense of our property rights, they must be of our own choice, not imposed duties corresponding to another's rights.

In summary, Dworkin and Kymlicka make a strong argument for the importance of common languages as a means of sustaining the context of choice for citizens, an idea with precedents in the writings of Herder and Hegel. On the basis that culture provides the density of meanings from which individuals make life-choices, a case has been made by Kymlicka (and others) for appropriate state support of minority languages. I considered whether this case might be applied, by extension, to Moustakas's claim for the return of the Parthenon/Elgin Marbles. However, the practices that Kymlicka is concerned to protect – because they give access to democratic participation – are written and spoken languages, not forms of art (or 'languages of the arts'). I concluded that there is not a compelling case for rights to visual practices. There are strong reasons to respect them, and to respect individual instances of expression created through them.

Similarly, there is no strong argument for moral rights to the integrity of complexes, other than the positive moral rights invested in authors and heirs by copyright laws. But there are strong reasons to respect things of artistic and architectural value. We may not always choose to keep things as they were (think of the adaptation of buildings in Europe over centuries), but in making changes we will want to pay attention to aesthetic value and the value of knowledge. I am doubtful about Merryman's cultural property policy, which ranks the instrumental preservation of cultural properties over truth and access, because, as I argued in Chapter 2,

it is up to individuals and institutions to assign relative weight to the intrinsic but incommensurable values of knowledge, aesthetic experience and religion. Since engagement with intrinsic values justifies the instrumental value of preservation, one can't in *general* trump intrinsic values with preservation (and it is worth recalling here that Zuni religion demands War Gods not be preserved).

4. Valuable Practices: Support and Intervention

We can engage with valuable practices as both audience and practitioners. To express oneself successfully often involves expense (in some cases at considerable cost). Nonetheless we can enjoy most of them either at no cost (publicly accessible architecture, or music and drama on public television and radio, for example), or at relatively low cost (through museums, etc.). The entrance charges to cultural institutions may well be low, but only because they have already received substantial contributions from the state either through direct subsidy, or indirectly from tax regimes that encourage philanthropic giving. This thought brings us back to Dworkin's question: should liberal democracies subsidise cultural institutions devoted to valuable practices and forms of expression?

If the anthropology to which we subscribe gives us, as individuals, a capacity to achieve well-being with relatively little regard to surrounding social forms, then the case for subsidy and regulating the export of art and designating historic buildings is weak. But if liberals are willing to embrace a 'thicker' conception of individualism, as do Kymlicka, Dworkin, Hollis, O'Hagan and Raz, where well-being depends on available social practices, then the case becomes strong. In this second scenario, far from requiring protection against cultural goods, individual well-being depends on them. Here I accept the case made by Joseph Raz, in *The Morality of Freedom* and other works, that personal autonomy is secured by the availability of a wide range of options for engaging with values.[64] Raz's liberalism, and its relevance to valuable objects and practices, attracts me for three reasons. The first is his version of value pluralism, which encourages individuals to determine and pursue their own life goals (as much as possible), choosing among competing and often

[64] Joseph Raz, *The Morality of Freedom* (Oxford: Clarendon Press, 1986). For a discussion of Raz's linkage of autonomy and cultural forms, see Stephen Mulhall and Adam Swift, *Liberals and Communitarians* (Oxford: Blackwell, 1992), 272–80; also O'Hagan, 'Hollis, Rousseau and Gyges' Ring', 67.

incommensurable values. An autonomy-based doctrine of freedom requires that we positively encourage "the flourishing of a plurality of incompatible and competing pursuits, projects and relationships".[65]

Autonomy means that a good life is a life which is a free creation. Value-pluralism means that there will be a multiplicity of valuable options to choose from, and favourable conditions of choice.[66]

The second is that value is socially dependent; values are supported by particular sustaining practices which are necessarily social and shared.[67] The relevant idea for 'heritage' is that valuable objects and valuable performances emerge through sustaining practices (Chinese calligraphy, Florentine furniture, European painting, etc.), although the objects themselves, and associated values, may well outlast their original sustaining practices and communities of practitioners. This social dependence thesis is not an innately conservative one, for while our well-being does indeed depend "to a large extent on success in socially defined and determined pursuits and activities" we're still left with room for interpretation and innovation. The relationship between value and practice should be regarded as necessarily loose to accommodate re-interpretations (providing a bridge between old and new).[68]

The thesis that comprehensive goals are inevitably based on socially existing forms is meant to be consistent with experimentation, and with variations on a common theme and the like. It is no more possible to delimit in advance the range of deviations which still count as based on a social form than it is to delimit the possible relations between the literal and the metaphorical use of an expression.[69]

And, *contra* Roger Sandall, thinking of value as dependent on social practices doesn't commit us to a relativism in which anything is worthwhile, so long as it is valued by someone, which points to the third reason: Raz's insistence on the importance of genres. Genres have their own standards of excellence, worked out and revised over time, allowing us to judge the excellence or otherwise of works within a particular context, and they vary from culture to culture, as we saw in Chapter 4 using examples from late medieval China. Gong Kai's painting was, and is, judged by different standards from *Luohans laundering*, and also *Guernica*, the Bamiyan

[65] Raz, *The Morality of Freedom*, 425, and *The Practice of Value*, 43–4.
[66] Raz, *The Morality of Freedom*, 412.
[67] See Raz, *Engaging Reason*, especially 144–60; and Raz, *The Practice of Value*, 20–2, 33.
[68] "The contours of value are vague and their existence in flux", Raz, *The Practice of Value*, 21 and 58.
[69] Raz, *The Morality of Freedom*, 309.

Buddhas and the Badminton Cabinet. The interpretative nature of valuation, the test of value being in argument ("using the full range of concepts, information, and rules of inference at our disposal"), coupled with its dependence on genres, calls for a "greater toleration of diversity than is common".[70] Governments should support cultural activity because, as Raz puts it, they have an obligation to create environments that provide individuals with an adequate range of valuable options, on account of our interest in having autonomous lives. But only the adequacy of the range is required, and decisions about which goods to promote must therefore be a matter for local interpretation.[71] This seems nicely to address liberal cosmopolitans' concern about cultural purism, a concern answered by state support for a sufficient and diverse range of intrinsically and instrumentally valuable practices (which can be encouraged as much by tax incentives as subsidies).

It is my view that in choosing what to promote, and consequently what to leave to free markets, policy makers should take into account the fact that opportunities to engage with the value of aesthetic experience generally exist through unique instantiations. Dworkin disavowed specific state subsidies (except in the case of expensive forms which left to themselves markets won't sustain, such as comprehensive collections of paintings) because he was worried about paternalism and elitism. But if opportunities to engage with value are important for autonomy, then individual works and performances shouldn't generally be excluded from state subsidy since they're as much a component of valuable cultural practices as art forms, cultural institutions and practitioners themselves.

There will be easy cases and difficult cases. Where there has been an especial focus on the culture of one dominant group, citizens would benefit from opportunities to engage with excellent forms of expression originating in minority cultures, or cultures in other parts of the world. Governments should promote these goods not to preserve 'national heritages', but in order that we can become more autonomous and fulfilled

[70] Raz, *The Practice of Value*, 44 and 57.

[71] Raz, *The Morality of Freedom*, 417–18, 425. See also *Ethics in the Public Domain*, at 34–5, where he argues that governments and other public authorities have duties to protect the common goods of a community. William Galston suggests that liberal states commit to a limited perfectionism in regard to exposing children to ways of life other than their own, on the grounds that such commitment encourages a more tolerant society or that it benefits individual flourishing; see *Liberal Pluralism: The Implications of Value Pluralism for Political Theory and Practice* (Cambridge: Cambridge University Press, 2002), 97–8.

individuals. We may not always personally like what government funds from tax revenues, but that is an inevitable consequence of living in a society that promotes autonomy. It is for this reason that state and regional governments may control the export of works of art, or what is done to the fabric of fine buildings. Such regulations are justified by the relationship between autonomy and valuable practices.[72] Libertarian resistance to governmental support and regulation of works, buildings, and so forth should be challenged by the thesis that liberal democratic governments have a duty to promote the conditions of autonomy for citizens, from which their well-being derives.

The British system of temporary estoppels tries reasonably to balance the advantage of a liberal property rights regime with the benefit of supporting institutions that make it possible for individuals to engage with a wide range of valuable cultural practices and forms of expression. The system of regulating historic buildings seeks a similar balance. The Waverley system doesn't seriously disadvantage owners by denying them access to the international market place, but it does create additional time for British institutions to fund the purchase of excellent works. Purchases for the most part will also increase opportunities for British citizens to engage with value, simply by transferring significant objects from the private to the public domain. This is not about maximising utilities but providing opportunities for individuals to engage in particular with the values of aesthetic experience and knowledge. The same holds for historic buildings: in an unregulated environment, more opportunities to engage with the value of fine architecture will be lost than gained. Accepting that rules for 'going on' are not fixed as they are in chess, we are thus compelled to interpret how best to conserve and develop the built environment. Designation does, however, require experienced officials who can review each case with knowledge, judgment and taste.

Thinking about 'loss of heritage' (the Badminton Cabinet, the Lansdowne Portrait, *The Dream Garden*, etc.) cuts two ways, because we should also be thinking about how best to promote and diversify the valuable practices and forms of expression that we, as individuals with personal interests, require to flourish. Heritage is important not because of what it is 'in itself', but because it embraces goods that are important to individual well-being. The logic of Raz's thesis about the social dependence of value has a fighting chance of convincing other liberals, as does

[72] Through purchase grants, in lieu of tax schemes, lottery grants or building regulations, etc.

that of Dworkin, Kymlicka and Hollis. Yet, even allowing for Scheffler's accommodation of "traditionalism with a cosmopolitan inflection", all liberals remain resiliently loyal to the conviction that the individual, not the community, is the primary cultural actor.[73] This will not satisfy non-liberals who see heritage as a good in itself, distinct from its role in promoting good for any particular individual. Perhaps the best that liberals can hope for, as O'Hagan suggests, is indeed a "minimal, but peaceful, *modus vivendi*".[74] But since religious belief plays rather a large role in matters of culture, we must also hope that the worst doesn't repeat the tragedy of Bamiyan.

[73] Scheffler, *Boundaries and Allegiances*, 129.
[74] See O'Hagan, 'The Idea of Cultural Patrimony', 155.

Index